Postcolonial Media Culture in Britain

Edited by

Rosalind Brunt

and

Rinella Cere

palgrave
macmillan

First published 2011 by
PALGRAVE MACMILLAN

Palgrave Macmillan in the UK is an imprint of Macmillan Publishers Limited, registered in England, company number 785998, of Houndmills, Basingstoke, Hampshire RG21 6XS.

Palgrave Macmillan in the US is a division of St Martin's Press LLC, 175 Fifth Avenue, New York, NY 10010.

Palgrave Macmillan is the global academic imprint of the above companies and has companies and representatives throughout the world.

Palgrave® and Macmillan® are registered trademarks in the United States, the United Kingdom, Europe and other countries

ISBN 978–0–230–54530–4 hardback
ISBN 978–0–230–54531–1 paperback

This book is printed on paper suitable for recycling and made from fully managed and sustained forest sources. Logging, pulping and manufacturing processes are expected to conform to the environmental regulations of the country of origin.

A catalogue record for this book is available from the British Library.

A catalog record for this book is available from the Library of Congress.

10 9 8 7 6 5 4 3 2 1
20 19 18 17 16 15 14 13 12 11

Printed and bound in Great Britain by
CPI Antony Rowe, Chippenham and Eastbourne

POSTCOLONIAL MEDIA CULTURE IN BRITAIN

Contents

Preface

This collection considers postcolonial media culture in Britain from two main perspectives: what is created and what is represented. First, it looks at the ways black and minority ethnic groups have created art, music and film and also participated in particular types of broadcast and digital media. Second, the book is concerned with how these minorities are themselves represented in news, current affairs and documentary, in media policy and in fictional and other artistic forms.

The research examining the specific media artefacts is presented both through close-up detailed case studies and through historically broader overviews. It is bookended by two chapters analysing postcolonial theories and raising significant questions about their relevance for the study of media culture.

In between, each chapter demonstrates postcolonial research-in-action, showing how it can be applied to concrete media forms, whether the emphasis is on change-making cultural practice or on careful examination of individual media texts. The main objective of the whole collection is to introduce a new interdisciplinary dimension to the analysis of media in Britain.

From this viewpoint, the book addresses the tangled histories of postcolonialism and their impact on Britain. It bears witness to newly emerging practices and discourses that deserve to be both celebrated and rigorously analysed. But it also does not shy away from confronting the colonial legacies that continue to produce marginalization and exclusion. Hence the book's concern to scrutinize equal opportunity policies of multiculturalism and diversity as applied to media and to pick apart contemporary textual representations of ethnic community cultures that bespeak racist rhetoric – however unwittingly deployed. Drawing on postcolonial theory throughout, the book takes to heart its crucial insight that, while 'another world is possible', the dominant culture in Britain continues to draw on repertoires of restrictive and racially oppressive discourse.

Figures

Notes on Contributors

Rosalind Brunt is a visiting research fellow in media studies at Sheffield Hallam University. She is currently researching racism and representations of postcolonialism in the media and recently worked with Sheffield Council on media strategies for asylum seekers and refugees. She is the founding chair of the Women's Media Studies Network for the Media, Communication and Cultural Studies Asssociation, UK (MeCCSA).

Gary R. Bunt lectures in Islamic Studies at the University of Wales, Lampeter and has written widely in the area of Islam and the media, Muslim urban culture and Islam in cyberspace. Recent publications include: *Islam in the Digital Age: E-Jihad, Online Fatwas and Cyber Islamic Environments* (2003); '"Rip.Burn.Pray". Islamic Expression Online', in *Religion Online: Finding Faith on the Internet* (2004); *iMuslims: Rewiring the House of Islam* (2009).

Rinella Cere lectures in media studies at Sheffield Hallam University. She teaches European and international media, globalization and the media, and postcolonial media cultures. She is author of a book on national and European identities in the media (*European and National Identities in Britain and Italy: Maastricht on Television*) and of many articles on Italian media culture, on the internet and on museums of cinema. She has just completed an international study of museums of cinema (*'The Love of Cinema': An International Study of Musuems of Cinema and Their Audience*, Routledge, 2010).

Myra Macdonald was previously a lecturer in media and communication at Glasgow Caledonian University, principal lecturer in media and cultural studies at the University of Sunderland and reader in film and media at the University of Stirling. She is the author of *Representing Women: Images of Femininity in the Popular Media* (1995) and *Exploring Media Discourse* (2003).

Sarita Malik researches, writes and lectures in the area of race and representation within the context of television, cinema and the creative industries. She is based in the School of Social Sciences at Brunel University, London. Her recent research on cultural identity and screen representation is related to cultural policy, diversity and public service broadcasting. She is the author of *Representing Black Britain: Black and Asian Images on Television* (2002) and numerous articles on racial and cultural identities – both in relation to media representation and social change.

Caroline Mitchell is senior lecturer in radio at the University of Sunderland and an independent community media trainer and consultant. She has been active in community radio for the past 20 years and in 1992 co-founded Fem FM, the first women's station in the UK. Her research and practice is in the area of innovatory, participatory and community radio with a particular interest in women's, feminist and minority radio. She is editor of *Women and Radio: Airing Differences* (2000) and co-author (with Brian Lister and Tony O'Shea) of *Managing Radio* (forthcoming).

Peter Morey is a lecturer in English literature at the University of East London. He is the author of *Fictions of India: Narrative and Power* (2000); *Rohinton Mistry* (2004); co-editor of *Alternative Indias: Nation, Literature and Communalism* (2005); and has written numerous essays and articles on postcolonial literature and theory.

Christopher Pawling was formerly principal lecturer in communication studies and is now an honorary research fellow at Sheffield Hallam University. He has published books and articles on popular fiction, cultural history and literary theory and he has edited, introduced and contributed to *Popular Fiction and Social Change* (1984); authored *Christopher Caudwell: Towards a Dialectical Theory of Literature* (1989) and co-authored with John Baxendale *Narrating the Thirties* (1995). His most recent work on Fredric Jameson and Georg Lukács is in a collection of essays on Jameson, edited by Sean Homer and Douglas Kellner (2003).

Amir Saeed lectures in media and cultural studies at the University of Sunderland. His research interests are in the area of race and ethnic studies and media power. Recent publications include 'Musical Jihad: Hip Hop Music and British-Muslims Jihad Musical? Musique Hip-hop et Musulmans en Grande-Bretagne et France', in *Minorités ethniques anglophones et francophones: études culturelles comparatives*; '9/11 and British Muslims' in *Anti-Capitalist Britain* (2003).

Chi-Yun Shin is senior lecturer in film studies at Sheffield Hallam University. She has co-edited *New Korean Cinema* (2005) with Julian Stringer, and her articles have appeared in anthologies such as *Seoul Searching: Identity and Culture in Korean Cinema* (2007), *Horror to the Extreme: Changing Boundaries in Asian Cinema* (2009) and journals such as *Paragraph* and *Jump Cut: A Review of Contemporary Media*. She is also a member of the editorial board of the *Journal of Japanese and Korean Cinema*.

Leon Wainwright is a reader in history of art at Manchester Metropolitan University, a visiting scholar at the Yale Center for British Art and a member of the editorial board of the journal *Third Text*. His recent publications include contributions to the journals *Wasafiri*, *Radical History Review*, *Small*

Axe, Third Text; Visual Culture in Britain and *Beyond Borders: Cross-Culturalism and the Caribbean Canon* (2009); *A Black British Canon?* (2005); *Shades of Black* (2005). His forthcoming monograph explores the theme of art and the transnational Caribbean.

Postcolonial and Media Studies: A Cognitive Map

Rinella Cere

My aim in this chapter is to suggest how postcolonial theory is relevant to the interpretation and study of contemporary ethnic minority media cultures and to demonstrate how they relate to the 'metropolitan centre' of Britain. I intend to do this by tracing a 'cognitive map' of postcolonial perspectives and suggesting how they could contribute to media studies.

The notion of cognitive mapping I am using here is adapted from Frederic Jameson. He, in turn, derived it from the cultural geographer, Kevin Lynch (1960) who took the metaphor to describe how people impose their own conceptual geographies onto the physical worlds of time and space. Transferring it to 'the realm of social structure' (1991: 416), Jameson uses the metaphor to propose various transformative projects that could start by mapping individual experience onto wider cultural and political grids.

In his essay, 'Cognitive Mapping', he suggests that this would require a kind of 'dual thinking': an awareness at one and the same moment of the individually specific, the psychic, the local, together with an understanding of how these aspects link, overlap and intersect with broad social totalities – and ultimately with the global. Thus Jameson refers to a 'new and historically original dilemma, one that involves our insertion as individual subjects into a multidimensional set of radically discontinuous realities, whose frames range from the still surviving spaces of bourgeois private life all the way to the unimaginable decentering of global capital itself' (1988: 351).

In presenting a cognitive map of 'the mediascape' in order to indicate how it might be transformed by postcolonial perspectives, I want to start by drawing on one of the issues Jameson highlights in his essay. Referring to his earlier notion of 'the political unconscious' (1981) and connecting it to people's everyday lives in modern metropolitan countries he notes:

> The phenomenological experience of the individual subject...becomes limited to a tiny corner of the social world, a fixed-camera view of a certain

1

section of London or the countryside or whatever. But the truth of that experience no longer coincides with the place in which it takes place. The truth of that limited daily experience of London lies, rather, in India or Jamaica or Hong Kong; it is bound up with the whole colonial system of the British Empire that determines the very quality of the individual's subjective life. Yet those structural coordinates are no longer accessible to immediate lived experience and are often not even conceptualizable for most people. (1988: 349)

In this passage, Jameson indicates how cognitive mapping can chart the psychological workings of the political unconscious while also locating them on both temporal and spatial grids. Hence, contemporary London is linked to widely dispersed nations through shared, still resonant, histories. When it comes to studying British media cultures and how they are produced, this insight encourages researchers to move from the 'fixed-camera' point of view of the present to take account of how its urgent immediacy is constantly shaped by its past and how the metropolitan experience remains shaped by the colonial.

Spreading Jameson's chart wider, the impact of colonialism on the contemporary and the metropolitan leads to two immediate considerations: the relationship between the study of colonialism and the study of post-colonialism; and the relationship between the metropolitan and so-called Third World or majority nations.

The question of temporality is taken up by Hall in his influential piece, 'When Was the "Post-colonial"? Thinking at the Limit' (1996b) to which he unhesitatingly answers that it is here and now, but also there and then and always different:

One of the principal values of the term 'post-colonial' has been to direct our attention to the many ways in which colonization was never simply external to the societies of the imperial metropolis. It was always inscribed deeply within them – as it became indelibly inscribed in the culture of the colonized. (246)

Hall is not dismissive of the postcolonial, as he wishes to highlight the 'transformative' process which results from the effects of the relationship between colonizer and colonized and at the same time maintain the distinction between the two: 'The difference, of course, between colonising and colonised cultures remain profound. But they have never operated in a purely binary way and they certainly do so no longer' (1996: 247). It is this process and the move from one to the other which not only mark temporally the postcolonial but underline media and cultural production of ethnic minorities in Britain.

For Shohat the temporal explanation about the 'post'[1] has to be understood alongside the spatial reconfiguration of the 'colonial' space in the metropolitan empire nations: Shohat acknowledges that postcolonial theory is not exclusively applicable to 'Third World countries which gained independence

after World War II', but also about its 'diasporic circumstances of the last four decades – from forced exile to "voluntary" immigration – within First World metropolises' (1992: 102). Her understanding of postcolonial theory and her extension to contemporary diasporas and immigration is particularly important today, as it is no longer possible to ignore the movement of people who have settled in the empire nations of which Britain is a prime example and it is a necessary link between the two, the colonial and the postcolonial.

My cognitive mapping of key concepts of postcolonial theory on the other hand attempts to establish the missing link between postcolonial and media studies. The development of postcolonial studies so far has tended to privilege the analysis of literature, and to a lesser extent film. It has concentrated on the circulation of narratives and representations of 'other' colonized cultures and paid relatively little attention to popular culture and contemporary media practices. Conversely, media studies has always been concerned with issues of representation, stereotyping, identity formation and ideological workings of popular media cultures. Its emphasis has been primarily on the new and the now and it has paid little attention to the historical and to the intersection of the metropolitan with the colonial and postcolonial.

I want therefore to suggest that the adoption of postcolonial concepts by media studies could allow for a new engagement with contemporary discourses of ethnic minorities in Britain and rescue media studies from cultural and political inertia in relation to postcolonial experiences and representations. I will make a start in this direction by recognizing the relevance for the British 'mediascape' of writers directly formed by their experience of colonialism who were influential in setting the direction of postcolonial studies.

My cognitive map for media studies and media practices begins, then, with some of the key concepts they developed originally to analyse the features of colonialism and goes on to consider how these can now be applied to the contemporary metropolitan situation. Hence, the first concept I consider, the dual notion of *colonizer–colonized*, is a reflection on the conditions of the French Empire during a period of widespread struggles for national independence. The very ferocity of the conflict in this period lends a heightened intensity to the analysis. In itself this offers a sharpness of focus for mapping the consequences of empire not only in the case of France but for all European colonial powers.

Colonizer–colonized

Albert Memmi's *The Colonizer and the Colonized*, first published in 1957 and translated into English in 1965, was one of the first to develop an extended theory of colonizer–colonized. His book examines the consequences of colonialism and centres on the psychological condition of both the colonizer and colonized and on the long-term outcome of their relationship of dominant and dominated: a relationship which protracts itself into contemporary postcolonial relations and representations within former empire nations.

Central to the binary figure of colonizer–colonized, Memmi suggests, is the

way in which we cannot think of either the colonizer or colonized as one single homogeneous entity. Although Memmi sums up the character of the colonizer in terms of profit, privilege and usurpation, he introduces two additional distinctions as part of the colonizer: the colonial and the colonialist. The *colonial* – the white worker – is described as not having particular privilege 'whose living conditions are not higher than those of a colonized person of equivalent economic and social status' ([1957] 2003: 54), but even this equivalence is ultimately relative in a colonial context because 'the colonial so defined does not exist, for all Europeans in the colonies are privileged' (*ibid.*: 54). The *colonialist* is seen as the crux of the colonial system; the body, which governs, as well as the economic power, which drives it. It is the governor, the industrialist and the landowner, all those who are benefiting extensively and who agree with the colonial system in its entirety but most importantly who consider themselves and their culture superior to the colonized. The *colonizer* – the administrative force – also comes in different forms: those who accept and actively participate in the system of oppression and those who refuse it.

This intricate psychological description of the different manifestations of the colonizer has added depth to the history of colonialism by demonstrating its multifaceted effects as well as connections to its bearing on the present. Memmi's argument centres around the fact that despite these three groups being placed at different levels of the colonial hierarchy they are nonetheless all placed in relation to the colonized in an advantaged position:

> If the privileges of the colonizer are striking, the lesser privileges of the small colonizer, even the smallest, are very numerous. Every act of his daily life places him in a relationship with the colonized, and with each act his fundamental advantage is demonstrated. If he is in trouble with the law, the police, and even justice will be more lenient towards him. If he needs assistance from the government, it will not be difficult; red tape will be cut; a window will be reserved for him, where there is a shorter line so he will have a shorter wait. (*ibid.*: 55–6)

This description provides an insight into the continuing psychological superiority in white British people which generated from colonial power and can be directly linked to contemporary racist institutional practices of exclusion.

On the other hand in his portrait of the colonized Memmi touches on three areas: 'Mythical portrait of the colonized', 'Situations of the colonized' and 'The two answers of the colonized'. In the first he argues that a mythical portrait is constructed on a dialectic of good and bad, where the good always generates from the colonizer and the bad from the colonized. Nothing the colonized can do can alter this myth, for example, Arab hospitality which can hardly be seen in a negative light, is turned on its head by the colonizer; it comes to be seen as 'the colonized's irresponsibility and extravagance, since he has no notion of foresight or economy' (*ibid.*: 128). The mythical portrait of the colonized's laziness, indolence and ingratitude is moulded into the

colonizer's hegemony: 'it is common knowledge that the ideology of a governing class is adopted in large measure by the governed classes' (*ibid.*: 132).

Similarly in the second account of the 'Situations of the colonized', the colonized is dispossessed of everything, from history to citizenship and even language. Finally in the 'The two answers of the colonized' Memmi envisages what options are left to the colonized: either assimilation or revolt; both carries a high price as the first meets with the colonizer's rejection. The colonizer is not capable of incorporating the Other, as the incorporation of the Other would entail its own destruction:

> To say that the colonizer could or should accept assimilation and, hence, the colonized's emancipation, means to topple the colonial relationship...In other words the end of the colony as a colony, and the end of the mother country as the mother country. To put it bluntly the colonizer would be asked to put an end to himself. (*ibid.*: 170–1)

Revolt is the only way out, but the period of revolt needs to be superseded in order to break the colonizer–colonized relationship. Memmi's original suggestion is that the 'colonial condition' is complex and one that is not easily 'liquidated' by either assimilation or revolution. Nonetheless, he still suggests that only through the 'liquidation of colonization...[that] complete liberation and self-recovery' will come about (*ibid.*: 195).

The concept of alienation in the psychological relationship between colonizer and colonized is taken up in Fanon's *Black Skins, White Masks* (1952) where he discusses the 'workings of racism' at a deeper psychological level than Memmi. For Fanon, racism working at the psychological level masked the 'subjection' of the black person to the white man and culture. The direct consequence of this process generated alienation in the consciousness of the black person (internalization of racism). As with Memmi, however, the colonial process was key to this subjection.

Central to the psychological study of the subjection of individuals by colonialism, is the question of the use of 'imperial' language. Fanon himself had been educated in the French language – the language of the colonizer – and this was another way in which colonization entered the oppressed/colonized consciousness. The very first chapter of *Black Skin, White Masks* is entitled 'The Negro and Language' and addresses the nature of the relationship between language and colonization: 'The Negro of the Antilles will be proportionately whiter...in direct ratio to his mastery of the French language...A man who has a language consequently possesses the world expressed and implied by that language' (Fanon 1968: 18). But the adoption of the colonizer's language does not automatically remove cultural barriers and in some instances it adds to the psychological problem of the colonized.

Speaking the language of the colonizer brings the internalization of oppression into consciousness, since this language is based on a culture which sees white as good and black as evil. How can the black person then ignore this correlation? Hence the white-mask concept: by slipping on a white mask the

'black man' can see himself as part of humanity, on equal terms with the 'white man'. Once the liberal construct which states that all human beings are equal *despite* cultural difference and visual appearance has been internalized it leaves 'the black man's consciousness' separate from his body and hence alienated from himself. For the actual message of liberalism is that to be equal is to be white.

In his later speeches and essays Fanon links the psychological and phenomenological experience of racism more explicitly with the political and economic inequalities imposed by colonialism. Writing in the context of the bitterly protracted struggle for Algerian independence from France, Fanon's words are literally 'fighting talk' frequently urging the legitimacy of revolutionary violence. In his 1961 preface to *The Wretched of the Earth* Sartre notes the shockingly harsh directness of the new post-war address of the colonized to the European colonizers: 'Fanon hides nothing...He is not afraid of anything' ([1961] 2004: xlvi–xlvii). Fanon's texts are a kind of ground-clearing exercise: the situation is too urgent to continue with cultural misapprehensions and old deferences. Hence he provides a clarifying and sharp-eyed perspective that remains relevant for both colonial and postcolonial periods. Indeed, in many ways Fanon prefigures Jameson's transformative project for relating the local to the global, the psychic to the social – as when he refers in his essay 'Racism and Culture' to the 'virtualities' and 'latencies' which are carried 'by the life-stream of psycho-affective, economic relations' (1970: 51).

In this essay, based on a speech he made in 1956 to the First Congress of Negro Artists and Writers in Paris, Fanon argues against the idea of racism as being a mere mental quirk, some accidental chance occurrence. Nor is it to be understood as hidden beneath a culture or as a 'super-added element' of a culture. He proposes instead that racism is an inextricable dimension of all cultures borne out of the military and economic oppression of colonialism: 'Racism stares one in the face for it so happens that it belongs in a characteristic whole: that of the shameless exploitation of one group of men by another which has reached a higher stage of technical development' (*ibid.*: 47).

In providing his own polemical take on the effects of racism both *on* and always-already *in* culture Fanon charts a cognitive map at once complex and graphically highlighted that ranges, like Jameson's, across all cultural practices from the routines of everyday life to artistic production: 'Racism bloats and disfigures the face of the culture that practises it. Literature, the plastic arts, songs for shopgirls, proverbs, habits, patterns, whether they set out to attack it or to vulgarize it, restore racism' (*ibid.*).

From this totalizing perspective, even apparent hostility to racism can still fuel racism. 'Films on race prejudice, poems on race prejudice, messages on race prejudice': for Fanon, all these examples are 'spectacular and futile condemnations' of a race prejudice that inevitably obeys the 'flawless logic' which states, 'a country that lives, draws its substance from the exploitation of other peoples, makes those peoples inferior. Racial prejudice applied to those peoples is normal' (*ibid.*: 49–50). Fanon's polemics on culture serve as an injunction for contemporary media practice. It is not adequate to produce

texts that only serve to condemn racism. To be successfully anti-racist, textual strategies require a full recognition of the histories and material realities that *produce* subjection and inequality, that actually 'make' people economically, socially and psychologically inferior.

Few empirical media studies of race have to date drawn on this complex connection with the exception of studies which have subjected 'whiteness' rather than blackness to critical textual strategies by introducing 'genealogies' of whiteness. This discussion started by Richard Dyer (1997)[2] in film and media has continued with Gabriel (1998) who sought to link history to unconscious superiority and political and economic power as 'it played out through the media' (*ibid.*: 40), all the while acknowledging the shift from 'hermetically sealed versions of ethnic origin and difference' (*ibid.*: 2) to a more complex status of hybridity, perhaps one of the most influential postcolonial perspective to arise in recent years.

Hybridity and mimicry

The exploration of the concepts of hybridity and mimicry and the critical attempt to move beyond the colonizer–colonized and Orientalism–Occidentalism's binaries are at the heart of postcolonial theory. These concepts were first introduced by Homi Bhabha when to unpick the 'interstices' of the relationship between the colonizer and the colonized and to show the 'insecurity' of the colonizer. Not, however, the insecurity which may result from revolutions of colonized people but a psychological insecurity which result from the colonizer proximity to and need of the colonized.

Taking up earlier theorists' concepts of the unconscious in the colonizer–colonized relationship Homi Bhabha suggests two new configurations in that relationship: 'hybridity' and 'mimicry'. In 'Signs Taken for Wonders' he states: 'Hybridity...unsettles the mimetic or narcissistic demands of colonial power but reimplicates its identifications in strategies of subversion that turn the gaze of the discriminated back upon the eye of power' (Bhabha 1994: 112).

In this subversive return of the gaze the colonized subject should be able to perform her resistance and thereby undermine the colonizer's authority. Therefore there is much more at stake in this reading than the colonized psychological empowerment and it is to do with the collapse of the colonial authority in the process of '*production* of hybridization' (*ibid.*). Hybridity, coupled with the '*menace* of mimicry' (*ibid.*: 88) and the ambivalence of colonial discourses are important concepts to understand the non-dialectical nature of colonial power: 'Hybridity... is not a third term that resolves the tension between two cultures... is a problematic of colonial representation' and cannot 'be resolved as an issue of cultural relativism.' (*ibid.*: 114). In this cognitive mapping, the concept of hybridity offers (a) a critical reading of essentialist discourses of race which are in media representations and (b) a proposition for interpreting social and cultural changes in the postcolonial British context.

Criticism of Bhabha's postcolonial theories has suggested that his emphasis on contradiction and complicity in the colonizer's position has brought about the opposite effect. It may have destabilized the 'imperial persona' but lost sight of the deep-seated inequalities which colonial empires either reinforced or brought about anew. The other criticism has been directed at his overestimate of the power and agency of the colonized and his omission of empirical evidence for it (Moore-Gilbert 2005).

Nonetheless his concept of 'hybridity' has proved a workable concept for reading relations and representation in postcolonial media cultures. Stuart Hall in particular has defended Bhabha against what he described as 'politically correct grapeshot' in his piece 'When was the "Post-Colonial"?'; while at the same time acknowledging that Bhabha's theoretical project needs always to be read against imperial power: 'Hybridity, syncretism, multidimensional temporalities, the double inscriptions of colonial and metropolitan times, the two-way cultural traffic characteristic of the contact zones... always [have] to be set against the over-determining power–knowledge discursive relations by which imperial regimes were stitched or laced together' (Hall 1996b: 251–2). Postcolonial media and cultural practices are emerging as a hybrid 'Third Space' against a backdrop of 'over-determining power–knowledge' discourses of post-imperial Britain. As Bhabha stated in an interview with Jonathan Rutherford:

> [H]ybridity is the 'third space' which enables other positions to emerge. This third space displaces the histories that constitute it, and sets up new structures of authority, new political initiatives, which are inadequately understood through received political wisdom. (Bhabha, in Rutherford 1990: 211)

This 'third' or diasporic space transcends national and ethnic binaries yet constantly comes up against them in its effects on the real world, for example in the process of 'othering', such as Orientalism.

Orientalism

The concept of Orientalism is extremely important to media studies for its introduction of the process of 'othering' in textual and discourse analysis. Although textual and discourse analysis is widely practised in media studies, Edward Said is widely reputed as the theorist who first addressed the legacy of colonialism in terms of specific discursive and textual practices of 'othering' rather than in terms of economic and structural processes.

Although his examples are mainly literary,[3] his book *Orientalism* ([1978] 1991) and his account of the various ways in which the Orient is constructed by the western colonial powers opened up interpretative avenues for media studies, which he further encouraged with a subsequent book *Covering Islam* ([1981] 1997) where he provided a critical analysis of the coverage of Islam in the news and the many essentialist attempts to associate all Muslims 'deterministically...with terrorism, violence and "fundamentalism"' (*ibid.*: xxi).

In particular, what characterized the main study was a delineation of a view of Orientalism distant (and distinct) from Occidentalism:

> Now one of the important developments in nineteenth-century Orientalism was the distillation of essential ideas about the Orient – its sensuality, its tendency to despotism, its aberrant mentality, its habits of inaccuracy, its backwardness – into a separate and unchallenged coherence. ([1978] 1991: 205)

Said argued that Orientalist scholars distilled ideas of the Orient into an essentialist view of what constitutes the Oriental character and even what makes up the Orient as a whole; the Orient becomes a unified system of thought and geography which elides the fact that it is composed of large regions and many different cultures. This formula is crucial to the West's colonial mission and its political rationale. For Said nineteenth-century Orientalism went hand in hand with colonialism and imperialism, he states unequivocally that 'Orientalism is fundamentally a political doctrine willed over the Orient because the Orient was weaker than the West, which elided the Orient's difference with its weakness' (*ibid.*: 204).

But the successful establishment of the Orientalist worldview was also steeped in a dual condition which Said refers to as latent and manifest Orientalism. By latent Orientalism he meant an unconscious process whereby the Orient was a fixed negative entity that could never transform or enter into dialogue with modernity. This unconscious process relied on an untouchable certainty by Orientalist scholars about what the Orient is. Its basic content is static and unanimous. The Orient is seen by the western world as separate, eccentric, backward, silently different, sensual and passive. It has a tendency towards despotism and away from progress. It displays 'feminine penetrability' and 'supine malleability'. Its progress and value are judged in terms of, and in comparison to, the West, so it is always the Other, the conquerable, and the inferior (*ibid.*: 206). Manifest Orientalism, on the other hand, entailed 'various stated views about Oriental society, languages, literature, history, sociology, and so forth' (*ibid.*). It was the manifestation in language and actions of what was already present in latent Orientalism.

Surviving Orientalist ideas, both latent and manifest, are at the centre of many stereotyped versions in the media of oriental female and male, from veiled women to men praying in mosques to the 'Muslim' terrorist. Media representations of the British 'mission' in Afghanistan or in the 'exoticization' of the figure of the Arab and/or Muslim can also be read against this tableau of manifest and latent Orientalism. In this configuration Orientalism is also therefore the 'willing partner' of racism: the coupling of ideas about 'oriental backwardness, degeneracy and inequality with the West' with nineteenth-century ideas 'about the biological bases of racial inequality' (*ibid.*).

In *Reporting Islam*, Elizabeth Poole finds 'that the discourse of Orientalism has a continuing actuality, which finds different forms of expression according to its location' (2002: 32). In her study she argues that new and different forms

of Orientalism are to be found in anti-Islamic media discourses in British media, which she goes on to analyse empirically in some detail in a sample of three main British newspapers. Although her findings show that complexity is introduced in press representations between British Muslims and 'global' Muslims, some of the findings for the latter appear not so dissimilar to Said's: when she states that: 'Persistent ideas have found their expression in coverage of British Islam: that Islam is static and that Muslims are resistant to progress, engage in antiquated and repressive practices that abuse human rights, and often use their religion to manipulative ends' (*ibid.*: 250). Also the coverage is dissimilar in sheer quantity, which also prevents complexity to surface: 'The limited coverage of British Muslims is outweighed by the vast amounts of global coverage with which it must compete' (*ibid.*: 258). Binary representations are still a powerful methodological and critical tool to unravel British-centric media representations of contemporary events and perceived conflicts about Islamic culture and identity in metropolitan nations.

Said's analysis of Orientalism has been accused of relying on Foucault's notions of 'power–knowledge' to the extent of constructing a monolithic discourse which does not account for resistance and counter-hegemonic discourses; yet Said has argued against 'techniques of domination' and stated that 'Foucault ultimately becomes the scribe of domination. In other words, the imagination of Arab people is really an account of the victories of power dominating them. The site of resistance is eliminated. As opposed to that, I would say people like Gramsci and Raymond Williams take a much less systematic view. I feel much closer to the latter' (Said in Sprinker 1992: 240). It is this less systematic view that is at the heart of Gramsci's concept of the subaltern, and the final key concept on my postcolonial cognitive map.

Subalternity

The final key concept of postcolonial theory which my cognitive mapping will mobilize for reading postcolonial media culture in Britain is *subalternity*. The most influential work 'Can the Subaltern Speak?' (Spivak 1988) was steeped in research undertaken by the Marxist-inspired collective 'Subaltern Studies', a group of Indian intellectuals, Spivak being one of them, described more recently by Chakrabarty as 'a "postcolonial" project of writing history' (Chakrabarty 2005: 468). The Subaltern Studies group drew their cue from Gramsci's writing on the subaltern which he defined in terms of subordinate social groups and classes. Gramsci was interested in identifying these groups, as well as studying their histories and representations which eventually would bring about a transformation of their consciousness and their material living condition.[4]

Spivak's adoption of the Gramscian term 'subaltern' is a central key concept in the answering of questions about today's dispossessed cultures and contemporary modes of resistance as well as answering where and how their 'speaking' is taking place in the media. This would account for the negation of agency but also the reclaiming of agency for and by ethnic minorities in the media.

Her writings, like similar works coming out of subaltern studies, appropriated the term in order to give voice to the constituency of the colonized. With one important difference, the subaltern in her study is the Indian woman in particular and the example of the silencing is literal: the sacrifice of the widow in Hindu society who is burned alongside her husband (a Hindu ritual known as Sati, a 'good wife').

This text on the female subaltern in colonial India, although not addressing contemporary cultural practices, is revelatory for the connections it provides about the shortcomings of western feminism, which, although central to the critical rereading of media and society and the identification of women as subaltern, has not extended the critical work to women and race in the media.

Spivak is clearly one of the first writers to combine feminist and postcolonial critique in her reading of the predicament of the marginalized female. In her work she takes to task both western women for being complicit in the patriarchal values of colonialism and western feminism for its failure to 'decolonize' itself: 'woman' here is implicitly understood to be white, heterosexual and middle class – hence not so different from the position of man in traditional humanism.[5]

Spivak also argues that the contemporary presumption that the subaltern 'can speak for themselves' is as problematic as its opposite, that the subaltern cannot speak for themselves. Spivak's critique in 'Can the Subaltern Speak?' extends to the present and especially to western intellectuals such as Deleuze and Foucault, who although seemingly championing the oppressed (at least in the sense that they turn their attention towards the oppressed and marginalized in western society) argue the opposite of Spivak, that indeed the subaltern 'can speak and know their condition' for themselves.

The importance of this debate here, in this book, many decades after it was first articulated, lies in the fact that all 'speaking' or 'silencing' in the circulation of cultural production and representation of women from ethnic minorities, and not only women, at least in Britain, is still not largely done by them. Furthermore, it clearly still has referents in a colonial past which hasn't quite 'vanished' into the present postcolonial condition but which is in fact constitutive of the postcolonial condition. The media and cultural silencing of ethnic minorities or its misguided appropriated representation is an issue which resurfaces from time to time, especially in times of crisis or dramatic events but is very rarely interpreted in media studies in terms of postcolonial readings of the powerless subaltern. We need to seek out the view of the subaltern or account for its absence if we are to retain emancipatory ideals in a mediated society.

In fact, assimilation and emancipation for the descendants of former colonized people remains problematic in modern metropolitan centres. Recent rereading of empire makes it all the more important to return to postcolonial critical categories of colonizer–colonized, hybridity, orientalism and subaltern to reverse media representations which unwittingly sustain the ongoing hegemonic project to rewrite history from the western viewpoint and as a successful 'narrative of capitalism': 'Western intellectual production is, in many ways, complicit with Western international economic interests' (Spivak 1988: 271).

One such revisionist rereading about the British Empire has been put forward by the historian Niall Ferguson in his TV series and accompanying book for Channel 4, *Empire. How Britain Made the Modern World* (2003) where he advances the thesis of the 'goodness of empire' and where he argued that it is difficult to imagine a world without the British Empire: 'Without the British Empire, there would be no Calcutta; no Bombay; no Madras. Indians may rename them as many times as they like, but they remain cities founded and built by the British' (Ferguson 2003: xxi).

The programme commentary throughout is extremely problematic in the way it frames 'colonizer and colonized' and it ultimately comes across as an apologia for the undertakings of British imperialism, essentially represented as the pinnacle of achievement and modernity. The programmes themselves, six in total, with their use of visually rich archival material and making extensive use of early photography and film footage (as well as print archival material), are actually of much value in recognizing the 'unequal relations in pictures'. They are also extremely revelatory about the 'awkward moments' of 'servitude' fixed by the camera between the colonizer–colonized, which contradicts, visually at least, Ferguson's own argument.

This notion of the 'goodness of empire' is also questioned by Linda Colley in her review piece of Ferguson's book: 'Enquiring whether this (British) or any other empire was a "good" or a "bad" thing is historically bogus, because answers to this question vary so much according to when, what and who you choose to look at, and, critically according to who you are' (*Guardian*, 10 January 2003). More powerful still is Memmi's question 'How do we know? Why must we suppose that the colonized would have remained frozen in the state in which the colonizer found him? We could just as well put forward the opposite view. If colonization had not taken place, there may have been more schools and more hospitals' (Memmi [1957] 2003: 156–7). It is the silencing of this view in empire which still fuels debates about whether British culture has 'tamed' the colonizer within and/or the colonized has risen above the colonized status. I would argue that the focal point of the postcolonial condition in Britain still carries the psychological alienation which divides people and society, first proposed by Memmi in his binary, paradoxically now taking place in the context of formal equality and in programmes arguing about the benefits of empire.

Concluding remarks

I first introduced this 'cognitive map' in my Postcolonial Media class, a class composed of both descendants of the colonized (the majority) and colonizer. The original motivation behind it was to move racism out of its void and beyond the refrain 'I am not racist but…' and onto the terrain of the postcolonial with its combined historical, psychological, cultural and economical explanations: a 'third space' which students recognized as the only valid position to speak from; one which did not produce invisible 'whiteness' or hypervisible 'blackness'. This brought about students' reflections on their own

'postcolonial relationship' and the resultant engagement with the reading of postcolonial media texts.

It is my contention here that without postcolonial theory's crucial concepts it is not possible to 'recognize' and read critically the cultural production generated in postcolonial contemporary media cultures, national and transnational. By way of conclusion it is worth reiterating that postcolonial perspectives are important to media studies because they are not about a break with the past (either spatially, temporally or epistemically) but in a similar fashion to what Jameson argued about postmodernism as being the 'cultural logic of late capitalism' (1991) I think postcolonialism is the cultural logic of late colonialism. This attempt to draw a 'cognitive map' which identifies key concepts: colonizer–colonized, Orientalism, hybridity and mimicry, subalternity and diaspora, as appropriate critical tools to analyse contemporary media public spheres, can, it is hoped, provide a new trajectory for media studies.

Notes

1 Shohat also adds on the same page that 'the final consecration of the term came with the erasure of the hyphen' (1992: 102). It is this latter form that I use here.
2 White and whiteness has of course been central in Fanon's work *Black Skin, White Masks* and his analysis of the 'desire' to be white.
3 Said argued that all the nineteenth-century writers he looked at in his study rarely diverged on what they saw as the basic content of the 'Orient, although they may have put this forward in different styles; what they shared was the view of the Orient as a locale requiring Western attention, reconstruction, even redemption' ([1978] 1991: 206).
4 Subaltern studies is now a wide field of study, which goes well beyond the historiographic field. Subaltern studies is also the title of the group's journal. For a history and trajectory of subaltern studies and its relationship with postcolonialism, see Chaturvedi 2000.
5 See also writings by Trin T. Minh-ha (1989) and Chandra Talpade Mohanty (2003a, 2003b) on this topic. Also ch. 5, 'Postcolonialism and Feminism', in Leela Gandhi (1998).

The Politics of Hip Hop and Cultural Resistance: A British-Asian Perspective

Amir Saeed

Picture the scene: summer 1996, an anti-racist festival in Finsbury Park, North London. Loudspeakers are broadcasting a recorded speech from Malcolm X:

> Our religion teaches us to be intelligent, be peaceful, be courteous, respect the law...But if anyone puts their hands on you send them to the cemetery!

Three male figures appear; two of them are wearing PLO headscarves and only their eyes are visible. The loudspeakers suddenly change to chants of *'Allahu Akbar'* ('God is Great'), accompanied by heavy drums and hip-hop beats. My heart is racing. This is my first encounter with the British-Muslim band, the hip-hop pioneers Fun^Da^Mental. The predominantly white crowd is relishing the performance and appears to appreciate and empathize with the Islamic politics. What I am seeing on stage is all my youthful frustration, anger and sense of helplessness translated into a medium that my white peers can also relate to.

Suddenly it's cool to be Asian. It's hip to be Muslim. I had grown up aware of a British popular culture that made it cool to be black. But no one appeared to want to be a 'Paki'. Before I came across Fun^Da^Mental it had been black hip-hop music that entertained me, educated me and both expressed and influenced my political outlook. But now I saw that hip hop could have a multi-ethnic and global reach – rather like Islam itself, indeed, while at the same time being just as misunderstood and misrepresented.

In this chapter I will explore that analogy with Islam further while

discussing the political outlook of young British Asians and Muslims and considering how it is reflected in the genres of popular music and hip hop/dance music in particular. I will go on to reflect on the role of Fun^Da^Mental as an Asian band which is influenced by both religious and nationalist politics (Sharma *et al.* 1996). But I will also consider their contemporaries, notably the electronica band, Asian Dub Foundation, whose music is also closely identified with anti-racist struggles but draws more on community-based politics in Britain as well. I will first demonstrate how, through its articulation with black American politics and music, British-Asian hip hop developed its politics.

Political origins of hip hop

Hip-hop is the focus of a developing global counter-hegemonic youth culture which combines diasporic and local elements and has come to fuse Arab, Islamic, black and Hispanic features. This global outlook is essential to understand the narratives of political hip hop and how they attempt to challenge imperialism and white hegemony (Kalra *et al.* 1996: 153–4).

These narratives owe much to earlier black consciousness movements, such as pan-Africanism, which advocated greater political unity among the various black populations of the Americas while evincing a strong interest in the growing independence movements in Africa (Van Deburg 1992; Moses 1988; Lincoln and Mamiya 1990). The pan-African campaigns, influenced by the work of many Muslim intellectuals, encouraged a confident belief in black cultural identity and were important antecedents of the emergence of the American black power movement in the 1960s.

Black power enabled young black people to display solidarity and gain strength from the images of black assertion embodied by Malcolm X, the Nation of Islam and sports stars such as Muhammad Ali (Saeed 2003). The figure of the black Muslim in this period again testifies to the fusion of Islamic and Africanist elements in the black consciousness movements of the 1960s and 1970s (Moses 1988; Lincoln and Mamiya 1990; McCartney 1992). Indeed, their ideological influences could be traced back to the Moorish Science Temples and the many black nationalist and Islamic movements inspired by the early twentieth-century Jamaican campaigner, Marcus Garvey who founded the Universal Negro Improvement Association and African Communities League (UNIA–ACL), the first black mass organization (Gardell 1996; Lincoln 1995; Egg 1998).

These historical associations infused black power with a social and cultural dynamic that gave a new political vigour to the black communities of America:

> Black Power energized and educated black Americans, introducing many to the concept of political pluralism... newly sensitized to the political nature of oppression, Black Power converts set out to remedy the[ir] situation by forming numerous political action caucuses and grass roots community associations. (Van Deburg 1992: 206–7)

In the black power period a younger generation of black men, such as H 'Rap' Brown (Jamil El Amin) and Stokely Carmichael (Kwame Toure) started to feature more strongly in the US civil rights movement. These people demonstrated a new militancy and reflected a growing pride in representing and expressing 'blackness' and black culture. Influenced strongly by the political philosophies of Malcolm X and the independence movements emerging in former colonial countries, they formed new political organizations such as the Black Panther Party. These had a wide cultural influence, for instance, involving soul artists such as James Brown and Sam Cooke directly in civil rights campaigns (Werner 1998; Ward 1998).

Black consciousness movements have been described as having the effect of 'a psychic conversion' on the black communities of America enabling them to express 'a healthy self-regard in a legal and social climate that reinforced [their] inferior political status' (Dyson 1995: 80). But forms of black consciousness also posed the cultural challenge of a psychic conversion beyond the USA. In this sense, the black power movement in particular offered the appeal of an 'imagined community' to subordinated ethnic minorities – and majorities – across the world (Anderson 1996).

Originating in the USA and imbued with the cultural and political influences of black consciousness, the music of hip hop similarly comes to transcend its geographical bases to create a passionate and brash counter-culture that forms a global imagined community for disenfranchised and stigmatized groups. Detailing the social, economic and political influences that helped inform and create the origins of hip hop, Tricia Rose (1994) coined the term 'Black Noise' in her book of the same name which explores the genesis of hip-hop culture in the USA in the 1970s and 1980s. The book argues that Reaganomics and the cultural hybridization of the South Bronx led many black and Latino youths to create musical sound systems, dancing, rapping and graphic art forms that reflected their surroundings and voiced their aspirations and fears. Noting how the origins of hip-hop music lie in the rich cultural diversity of the South Bronx, Rose writes:

> North American blacks, Jamaicans, Puerto Ricans and other Caribbean people with roots in other postcolonial contexts reshaped their cultural identities and expressions in hostile … multiethnic, urban terrain. (*ibid.*: 34)

Linked to overt political influences in hip hop, the 'ghetto politics' of this period in the USA had a major impact on the development of youth counter-culture beyond the States.

Thus, within a decade, researchers were also introducing the concept of 'Asian Noise' to address the booming British Asian dance music scene which was heavily influenced by hip-hop culture (Sharma *et al.* 1996). But we also need the concept of 'universal or global noise'. Hip Hop's presence in countries as diverse as Egypt, Brazil and Japan has demonstrated its rise as a popular music form in youth culture across the world (Mitchell 2002). Despite the neo-Orientalist assertion that 'West vs. East' must result in confrontation,

hip-hop culture has from its origins been an amalgamation of cultures. Islam has had a potent influence on hip hop from its beginnings; pioneer rappers like Afrika Bambaataa belonged to Islamist organizations. Furthermore, rap pioneers have constantly paid homage to the Nation of Islam and figures such as Mohammed Ali.

In summary, my point is that, for all its emphasis on black politics and identity, hip-hop music has always also had a global appeal from its outset – an appeal which can then be inflected by particular national cultures and group identities. Lusane comments that hip hop has a resonance with powerless groups around the world:

> Following the historical example of the cultural modes of the civil rights and Black Power movements, rap has had an international impact. Just as the Vietnamese sang civil rights freedom songs, so have the political imperatives of rap traversed the globe and found cultural expression in venues from Mexico to India. In Czechoslovakia, local rappers rap about the struggle of being young and penniless. Wearing baseball caps and half-laced sneakers, youth in the Ivory Coast have found a bond in the music. Australian rappers kick it about the mistreatment of the Aborigine people. Tributes to the victims of US atomic bombs form the substance of local rappers in Japan. (Lusane 1993: 42)

In other words, just as the African-American civil rights movement provided inspiration not only for various ethnic groups in the USA but also constructed role models for oppressed and powerless people globally, hip hop had a parallel global appeal for disenfranchised groups. In many respects what has been termed the 'hip-hop generation' in the USA has now truly become a 'global hip-hop generation' (Mitchell 2002).

But I also emphasized the important Islamic influences on hip hop and I now want to return to the specific Muslim aspect of the development of British-Asian music. To start with, the very global nature of hip hop that can be seen as analogous to the central Islamic concept of *ummah* – the global Islamic community that supersedes nationality. Muslims see their identity in terms of two tiers: one related to faith, the other to country: but faith overrides any other feature of identity. Thus, Jacobsen argues that young British Asians 'are likely to feel that, although within British society they are members of a relatively small and weak minority, their religious beliefs and practice traverse the globe and history and are thus components of what is a vast and (potentially at least) powerful force' (Jacobsen 1997: 245).

Through the *ummah*, therefore, young British Asians can draw strength from an Islamic identity that offers solidarity with other Muslims – as well as an escape from being constantly identified in negative terms. The ability to create a positive (re)conceptualization of Islamic identity shares with the black consciousness movements an assertion of self-respect and empowerment that transcends exclusion and marginality. From this starting point, I now want to

explore in more detail the apparent contradiction of how a specifically British-Asian identity can be asserted through the global cultural phenomenon of hip hop.

Popular culture and British-Asian identity

The pattern of Asian migration to the UK mirrors a general post-war pattern of migration across the world. Like other former colonial subjects of European nations, Asians set out to migrate to the very country that had previously exerted social and political control over them. What are the personal and political implications of this postcolonial 'return'?

The migratory process highlights both identity and culture as key issues for the postcolonial West. The contemporary multicultural world necessarily subjects collective belonging and identity to scrutiny because it highlights both the current processes of globalization and the historical legacies of colonialism which together create migration and diasporic populations. In this process identities become complex constructions even when they are represented as a single category. Hence 'British Asian' can never be a simple homogenous entity. Rather, I want to suggest that 'Asianness' comes to operate as a reference point to explore culture in dynamic and assertive ways (Hyder 2004). Thus, the social fact of Asians now living in the UK can never mean simply the relocation of a group from one country to another.

Recent debates on cultural identity emphasize instability and fragmentation. Identities are theorized in terms of increasingly hybridization, convergence and overlap and no longer conceived as fixed or bounded (Mercer 1994: 251–4). It is important to recognize identity as historically situated, relational, interdependent and always incomplete. Hall (1990) argues that our identities are never as transparent or as unproblematic as we may like to think. He goes on to contend that identity formation is never a complete or an accomplished fact. Rather, identities are produced and continually 'in process'. In considering the effects of migration and diaspora on identity he writes:

> These 'hybrids' retain strong links to and identifications with the traditions and places of their 'origin'. But they are without the illusion of any 'actual' return to the past... There is no going 'home' again. (Hall, 1993: 362)

Applying these ideas to the notion of British-Asian identity, we could start to characterize the process of hybridization as not just 'British' and 'Asian' but as also having global implications:

> This process takes on further transnational nuances when the South Asian lexical and cultural elements are introduced into these syncretic processes. The modes of expression that are produced possess a kind of triple consciousness that is simultaneously the child of Africa, Asia and Europe. (Back 1996: 185)

Cultural hybridization is often represented as politically and culturally liberating. But any 'freedom' from former cultural constraints is bought at a price: the determinations of past colonial subordination live on in the postcolonial present. As Hall recognizes, there can be no real return 'home' again. But migration to the home of the former colonizer also enforces an encounter with the racist attitudes born of colonization.

In this context, when it comes to the resonance of modern British popular culture, Asian representation can still be dominated by surviving colonial stereotypes of submission and passivity. As Huq argues:

> Asians have simply never assumed a principal place in *Top of the Pops*/MTV youth culture mythology. Instead they have perennially been considered unhip. Western popular culture has long been over-endowed with stereotypical images of Asians as submissive, hard-working, passive and conformist. (1996: 63)

I would argue that British Asians appropriated hip hop or rap music as one important means to undermine such stereotypes. Different ethnic groups take the music of the dispossessed of America and articulate it to express their own grievances. These are similar to those of urban America but have their own specificity (Cannon and Saeed 2004: 3). Thus hip hop achieves at the same time both a universal appeal and a particular local relevance for all the diverse groups it comes to 'represent'.

In the case of British-Asian music, hip hop has only really entered the mainstream since the 1990s and its breakthrough has involved few commercially successful bands. Nevertheless, those bands which have won major recording deals have not been afraid to use their mainstream platform to raise awareness about issues of racism in society. To mention three examples of hit-making bands: first, the Leeds-based band, Black Star Liner was formed in 1994 and named after the steamship company Marcus Garvey and the UNIA set up as an alternative black-run commercial venture. Black Star Liner has managed to represent part of the 'Asian Underground' musical scene while also gaining mainstream recognition with such awards as 'single of the week' from the *New Musical Express* and 'album of the week' from the *Guardian*.

The band has worked with Cornershop, our second example and another northern English group. Cornershop reached the top of the UK charts in 1998 with their song about an Indian star, 'Brimful of Asha'. But the band first came to media attention back in 1991 when they challenged Morrissey, the former lead singer of the ultra-'English' band, The Smiths, for his apparent celebration of dubious aspects of skinhead culture. The band's name offers a tongue-in-cheek reference to the racist term 'Paki' used by white British people to describe Asian stores and shops. As the band's frontman Tjinder Singh says, 'We wanted to take on the negative connotations of Asian people. I think "Cornershop" is a whole lot more positive' (*Independent on Sunday*, 1 March 1998). Finally, the techno-pop band White Town reached number one in the charts in early 1997 with a sampled 1930s hit, 'My Woman' from the EP

Abort, Retry, Fail? It is mainly a one-man band run by Jyoti Mishra, who came to the UK from India as a young child. A former Marxist, his music, including his one commercial hit and the albums, *Socialism, Sexism and Sexuality* (1994) and *Women in Technology* (1997) are imbued with political references and the band's name is a reference to the apartheid-designated all-white cities of South Africa. Hyder's wide-ranging book, *Brimful of Asia* (2004), offers a comprehensive discussion of these bands.

But the two bands I want to concentrate on here, Fun^Da^Mental and Asian Dub Foundation (ADF) have not had the same commercial success. Unlike the other three bands, they have never broken through to the mainstream or reached a mass audience in the UK, although they've both had more success in continental Europe. At the same time, they have received considerable critical recognition and consequently were able to work with a number of established artists worldwide (Hyder 2004). In my view, the lack of breakthrough success in Britain is directly related to their music's being much more explicitly political and intensely articulated than is the case with the other three bands I mentioned. I have chosen Fun^Da^Mental and ADF to look at in more detail because I want to explore the implications of their politics and also because, in exemplifying two quite different types of hip hop, they testify both to the flexibility of the genre and the heterogeneity of British-Asian identity.

Fun^Da^Mental, anti-racism and Islamic politics

Fun^Da^Mental is a techno band which originated in Bradford, a de-industrialized northern British city with a large South Asian population. The band started in 1991 and its name both evokes a controversial reference to stereotypes of militant Islam while also playfully alluding to notions of combining pleasure with serious reflection.

The 'fun' part of the band draws on danceclub electronic themes mixed with music from popular Indian films or worldbeat. This is often combined with such 'mental' material as sampled speeches from a wide range of black and Asian leaders such as Mahatma Gandhi, Louis Farrakhan or Malcolm X. Thus the band works to 'articulate eclectically a kind of militant Islamic-influenced, pro black anti-racist identity politics' (Sharma *et al.* 1996: 51). The lines of their track, 'President Propaganda' demonstrate this eclectic mix:

> I'm the soldier in the name of Allah
> So put down the cross and pick up the 'X'....
> Back in the days of the slave ships
> You had us whipped, raped and lynched
> Took away the Qur'an, you gave us the Bible.
> (Nation Records, 1994)

This track comes from the band's first album, *Seize the Time*, a title derived from the most famous slogan of the Black Panthers. Whether looking back to

the movements of black consciousness and Indian nationalism or forward to the alternatives proposed by current anti-globalization activism, the band sets out to create a dialogue with those it sees as having similar musical and political inheritances. Thus Fun^Da^Mental's aims to provide a cross-cultural exchange that gives recognition to what Lipsitz (1994) has termed 'families of resemblance'. Forging alliances in this way, their music offers a symbolic *ummah* of political possibilities. Yet while the band aims for unity, its messages may sound highly uncompromising. As Swedenburg has argued:

> Rap practitioners assert an identity politics that often seems essentialist, separatist and even supremacist, while simultaneously working effectively to forge new transitional identities and solidarities. (Swedenburg 1989: 64)

Fun^Da^Mental's militant political outlook is a direct response to the racism the band's members see and face in Britain. This leads to a forceful and challenging assertion of Muslim identity. The band's leader, Aki Nawaz declares on the track 'Meera Mazab' (trans. 'My Religion'), 'I was born a Muslim and I'm still living as a Muslim. My spirituality determines reality'. His rap continues, 'I'm in jihad...So I'll be coming around the mountain with my Islamic warriors'.

Nawaz has adopted a number of stage personas: Aki-Strani, Righteous Preacher and, most frequently, Propa-Gandhi. The band's insistent self-definition in their performances has attracted much controversy. When 'Dog Tribe', the first track on *Seize the Time*, was released as a single the accompanying video featured a fictional, but highly graphic scene of Propa-Gandhi being attacked by a skinhead gang while he rapped: 'Skin-headed warrior fightin' for the country, killing black children, burning Bengalis. Enough is enough'. The track opened with a sample of an actual voice message from a member of the British fascist group, Combat 18 threatening to burn and kill members of the organization, Youth Against Racism in Europe. But whilst some audiences have reacted negatively to the confrontational 'extremism' of Fun^Da^Mental's lyrics and visuals, Nawaz has responded by pointing out that, 'the politics of Fun^Da^Mental is not a fashion statement, nor an attempt just to make it big in the music business. The music provides a platform for a statement' (Sharma *et al.* 1996: 165).

In 2006 Fun^Da^Mental's album, *All is War* (*The Benefits of G-had*), provoked controversy with the accusation that the band supported terrorism. A number of the tracks refer to conflict in Afghanistan, Iraq and the Middle East and it has been argued that one of the tracks, 'Cookboy DIY', supports suicide bombing. Another track, 'Che Bin', makes a provocative comparison between Osama bin Laden and the Argentinian/Cuban revolutionary Che Guevara.

The band's website starts with the confrontational statement: 'We are hard politically, uncompromising musically and we won't be led by marketing angles'. But it continues in a more conciliatory vein: 'We try to give people a bit of confidence. People have to start educating themselves, respecting

themselves'. Nawaz also states on the website, 'We have always been about information and not messages – discussion and debate as opposed to ranting' (www.fun-da-mental.co.uk).

In this context, then, I would argue that Fun^Da^Mental's assertion of an Islamic identity does not necessarily, or only, imply a monolithic essentialism. Rather, the repeated self-defining statements on both the tracks and the webpages can be perceived as a starting point for a powerful anti-racist politics that involves and invokes alliances and coalitions. While drawing on a heritage of American black consciousness and linking it to South Asian nationalist movements, Fun^Da^Mental has also established a wide following among white British students. Nawaz co-founded the band known as Imp-D and created Nation Records as an Asian-black label with an African-Caribbean businesswoman.

Thus Fun^Da^Mental's musical output creates and draws on a multi-ethnic appeal while retaining strong roots in Islamic traditions and politics. The band exemplifies a hip-hop activism which aims to combat racism and Islamophobia by articulating Islamic concepts through new media for a variety of constituencies. For young Muslim audiences the music can provide a differently inflected understanding of their religion and culture than that traditionally accessed through the guidance of parents or the mosque. And for non-Muslim audiences hip hop can offer an introductory route into Islamic beliefs and how they can be articulated in anti-racist politics. This mixed approach to audiences has been picked up by the musical inheritors of Fun^Da^Mental. One of them, the young band Blakstone, provides a vivid exemplar of an appeal to the fanbase through the invocation of Islamic concepts.

The band's tracks highlight a politics that addresses the Iraq War, the Gaza Strip and corrupt dictators in Asia and Africa. They also voice concerns about the way Muslims have been singled out for attack throughout the decade. Blakstone's website starts with a direct address to the fans: 'We're just people like you, fed up of being branded criminals for their belief, tired of the barrage of insults toward our Deen, beloved Prophet, sisters and brothers'. The reference to *Deen* evokes a complex range of tradition and scholarship expressing how Islam offers not just a religion but a comprehensive system of beliefs that includes all aspects of humanity and posits a 'true' way of life for believers. Blakstone also links the *Deen* to the radical Islamic notion of a 'return home':

> We do not believe in compromise or violence. We believe that the way out is to concentrate our efforts in re-establishing a home for Islam...It is on us, the youth of Islam, to carry the call for Islam to be re-instated in all its glory...so that we can make Allah's Deen the highest, so we can protect our children from the humiliation and slaughter we face today.

For Blakstone, hip-hop music can give Muslim youth education and information in an entertaining format that aims to increase awareness and self-esteem. Their website statement concludes by evoking *Dawa*, meaning the summons to prayer and the invitation to seek knowledge about Islam. They recognize

that hip hop has a different function from *Dawah*; at the same time they see a metaphorical similarity:

> Hip Hop is not Dawah, but when it is used as a rally cry it touches the youth, our youth, from places the imams can't reach or fear to tread. Our love for this Deen can be expressed in new and exciting ways...Blakstone is not a person or a group. It's a struggle. (www.blak-stone.com)

Throughout Europe, Muslim artists like Fun^Da^Mental and Blakstone are attempting to create cultural, social and political spaces for themselves as ethnic and religious groups while also being at the forefront of anti-racist and anti-imperialist mobilizations. Besides hip-hop activism, Muslims have made major interventions in more conventional campaigning politics. The European anti-war movement received a massive boost from the contribution of a wide range of Muslim communities. And in the UK some of the diverse groups involved in the Stop the War coalition were involved in the formation of RESPECT – the Unity Coalition Party in 2004. The Party, its title an acronym for respect, equality, socialism, peace, environmentalism, community and trade unionism, involved members of the Muslim Association of Britain and the Muslim Council of Britain alongside various socialist and communist organizations, including the largest, the Socialist Workers Party (Harman 2007).

The subsequent history of RESPECT has included factionalism, internal and external accusations of opportunism, and a split in 2007. But it did represent a new attempt at a multi-ethnic politics aiming to bring different Muslim and non-Muslim political traditions together in the 'Coalition' of its founding title – and with a name that is not only an acronym but relates directly to black awareness raising. Since its formation, RESPECT has gained one (white Scottish Catholic) Member of Parliament and a number of both Muslim and non-Muslim local councillors and has engaged the support of young people alienated by established party politics. Nevertheless, RESPECT remains within conventional political frameworks and some of its strategies have played to sectarianism rather than to unity. Thus there has remained a space and a place for hip-hop activism to engage with politics through the less conventional routes of popular culture and black consciousness movements. In this context I want, finally, to look at the work of Asian Dub Foundation and its attempt to create 'alternative' community structures to engage young people.

Asian Dub Foundation: rebel warriors and community politics

Asian Dub Foundation (ADF) is not so much a musical group as a sound system collective. Formed out of a community music project, the group embodies the global diasporic musical influence that encompasses traditional Indian music, punk, reggae, soul and hip hop (Cannon and Saeed 2004; Sharma *et al.* 1996).

ADF started in 1993 as a community rap organization following a series of summer workshops providing skills in music technology for Asian young people. It was based in East London and included both tutors and students. As their line-up changed and expanded, they recorded their first EP, *Conscious* in 1994 on Aki Nawar's Nation Records label. This was during a period of heightened racial tension in the UK as the global 'war against terror' produced increased local violence against Asian communities. ADF rapidly gained a following among clubbers and also anti-fascist and Stop the War groups with their strong anti-racist statements and lyrics. As the success of their 1995 single, 'Rebel Warrior' demonstrated. The chorus of the song is the rap:

> Ami bidrohi!
> I the rebel warrior
> I have risen alone with my head held high
> I will only rest
> When the cries of the oppressed
> No longer reach the sky.

The song shows the group intensely aware of past colonial struggles. It was inspired by the 1920s poem 'Bidrohi' ('The Rebel') by the Bengali writer, Kazi Nazral, who called for the unity of Muslims and Hindus and was imprisoned for his advocacy of Indian independence. In making the poem relevant for contemporary times the track calls for:

> A radical fusion
> Strange alliance
> The siren and the flute in unison
> Cos it's a part of my mission
> To break down division...
> I'll be sowing the seeds of community
> Accommodating every colour, every need
> (*Community Music*, compilation album, 2000)

'Sowing the seeds of community' has been a continuing theme of ADF's work. In 1998 the group launched ADFED as their educational wing. This is a project based in Tower Hamlets, East London which offers short course training to 'under-represented youth communities' through music technology workshops. Each course concludes with a sound system event allowing students to showcase their newly acquired skills and network with more established musicians. ADFED is now part of Sound Connections, a consortium of music-making projects which manages the London Youth Music Action Zone (LYMAZ) and is part-funded by Arts Council England.

Any attempt to create new community networks that involves public money inevitably raises issues around ownership and control of 'alternative' provision. ADF has walked the difficult line of insisting on a forcefully

independent stance and uncompromising political approach while also seek-
ing to maintain 'strange alliances'. One of the founders of ADF, Pandit G,
turned down the offer of an MBE (Member of the British Empire) award in
2002 for his community music work telling the *New Musical Express* that he
had never supported the honours system and 'bringing people into the estab-
lishment' wouldn't help the music projects; only prioritizing funding would
(www.nme.com). The lyrics of the early track, 'Jericho' exemplify ADF's
attempt to make coalitions work while also asserting a militant stance that
addresses a number of audiences. The song first appeals to young Asian musi-
cians urging them to raise their game:

> The music we make it cuts across borders
> We never make music to someone else's orders
> Plenty of issues on the agenda...take a chance
> Turn the tables
> We know you're able
> Don't just consume
> Make your own tune.

But the song goes on to address white liberals and public bodies, insisting
they change their limited mindsets:

> We ain't ethnic, exotic or eclectic...
> An Asian background that's what's reflected
> But this militant vibe ain't what you expected
> With your liberal minds you patronise our culture...
> With your tourist mentality
> We're still the natives...
> (*Facts and Fictions*, album, 1995)

The Campaign Against Racism and Fascism (CARF) has argued that 'the
musical output of groups such as ... Asian Dub Foundation has the potential
to disrupt the racial status quo' (Kalra *et al.* 1996: 149). But by invoking a
plurality of 'we's' and 'you's' ADF's tracks attempt to be both disruptive and
dialogic. I would argue that the lyrics of ADF contribute to a reconceptual-
ization of the relationship between cultural identity and the appropriation of
rap music. To think of hip-hop activism in dialogical terms is to allow a new
consideration of how music and cultural forms can enable the reworking and
rearticulation of identity.

Asian Dub Foundation's track 'New Way New Life' challenges the divisive
racial status quo to insist that British Asians are part of the fabric of British
life. But it also declares that this identity was not achieved without a struggle
and involved a forging of new identities in the encounter between traditional
values and modern opportunity:

> Stayed and we fought and now the future's open wide
> New way new life...
> Never abandoned our culture
> Just been moving it along
> Technology our tradition
> Innovation inna the song
> Now the struggle continues
> To reverse every wrong
> New heroes and heroines
> Inna da battle we belong
>
> (*Community Music*, album, 2000)

Identity is a process, always involving a fluid and changing development that depends on contexts and experience.

Concluding remarks

The American black activist and academic, bell hooks has described the act of dialogue for postcolonial groups as one of 'talking back':

> Moving from silence into speech is for the oppressed, the colonized, the exploited and those who stand and struggle side by side a gesture of defiance that heals that makes new life and new growth possible. It is the act of speech, of 'talking back', that is no mere gesture of empty words, that is the expression of our movement from object to subject – the liberated voice. (hooks 1989: 211)

In this chapter I have tried to show how 'the liberated voice' has emerged in hip hop as British-Asian groups have 'talked back' against oppression and alienation through their music and politics. Expressive cultural forms and practices are important to any articulation of ethnic identity, and music is perhaps the most vivid and dynamic of these forms (Gilroy 1993a; Back 1996). This process of cultural creativity can be witnessed throughout Europe whenever, for significant numbers of second- and third-generation Muslim youth, 'rappers speak with the voice of personal experience, taking on the identity of the observer or narrator' (Rose 1994: 2). I have argued that rappers in contemporary British society have been observing and commenting on the ways Muslims 'live' the impact of social, economic and political alienation. As their experiences are narrated through hip hop, a form of cultural resistance is created. What I've aimed to demonstrate here is how that cultural resistance has worked both to affirm Muslim beliefs and Islamic politics while simultaneously communicating with wider aspects of society and creating the grounds for dialogue and understanding.

Chapter 3

Alien Nation: Contemporary Art and Black Britain

Leon Wainwright

In this chapter I intend to raise the issue of how to examine critically the art made by black British practitioners – and also to celebrate it. My approach will be to consider notions of 'art' and 'media' as both interrelated and yet distinct and then to analyse some of the far-reaching implications of this position. The following discussion sets out what I think is at stake here. It aims to make clear why a focus on the art–media nexus should come to be so significant in the arena of contemporary debates in Britain on postcolonialism. It asks: why have certain artists and artworks been identified so closely with the concepts of media and postcolonialism? What have been the consequences for art production and display and for the ideals germane to the liberal arena of art-making? How has the writing of art criticism and the historiography of art changed? How have the changes affected all those artists who reject the status of 'the derivative and provincial' in favour of creative authorship and metropolitan or national belonging? Currently, contemporary artists of many different ethnic and creative backgrounds are working on aesthetic and philosophical projects that entail the critical questioning of pre-formulated models of cultural practice. It is therefore important to appreciate why those artists specifically described as 'black' or 'postcolonial' are finding that the current focus on art as media is becoming another aspect of their struggle.

Art as media: displaying 'Alien Nation'

A touring exhibition that moved between London, Manchester and Norwich during 2006–7 provided an opportunity to think about these questions. 'Alien Nation',[1] was an exhibition mounted by the Institute of Contemporary Arts and the Institute of International Visual Arts (the ICA and inIVA). It aimed to

show that art and media are simultaneously entwined and separable. The exhibition explored the relationship between the interests of certain artists, grouped together for the purpose of this display, and certain images drawn from films. It included clips of sequences from popular film titles, and the advertising posters that promoted them when they were first released during the 1950s and 1960s in cinemas across the anglophone world. The 'exhibition identity' for the purposes of marketing was an adaptation of the original poster used for the distribution in the USA of the film *Invasion of the Body Snatchers* (1956). In the style of a movie billing, it listed the names of its 12 artists and three curators against a blood-orange ground on which an aquatint of two figures, a startled couple dressed in 1950s fashion, are shown fleeing crowds of crazed pursuers.

'Alien Nation' collected examples of film art in order to take a critical stance on the contribution of image-making to the ways in which outsiders, aliens and racial others have been imagined. By tackling the proximity of visual culture to everyday practices of social and cultural alienation, it offered a transparently provocative case for asking about the historical roots of present-day global fear and insecurity. The exhibition drew together diverse strands of the filmic and the 'foreign', the visual and the spectral, including sculpture, photography, painting and multimedia installation. As the exhibition's curators explained, the artists had 'adopted the figure of the extraterrestrial and the alien(ated) landscape in order to comment upon the fantasies, fears and desires that lie, barely suppressed, beneath the surface of contemporary culture and society' (Gill and Tawadros 2006: 11).

To employ a cinematic metaphor, from this perspective the exhibition was like a sudden judder out of the comfy seats from which western subjects have watched ethnic and racial differencing move across the silver screen. It was designed as if to have audiences spilling the fizzy drinks of critical reflection onto the velour cushions of a hegemonically constructed visual culture. The exhibition certainly helped me to think through some of the implications of twentieth-century narratives and pictorial traditions of differencing and the way they have evolved into the twenty-first century.

To understand the circumstances which produced the staging of 'Alien Nation' it is helpful to recall recent history and how a wide variety of commentators, artists, archivists, curators, promoters and arts organizers in Britain came to view 'art' and 'media' as occupying identical spheres of attention. The attempt to conflate these two otherwise distinct categories of cultural practice first came about in the 1980s as part of the overall effort to establish and 'make visible' a community of black British artists who had been restricted to the margins of British public memory. The discipline of history of art largely continued to neglect such artists and relegate them to its footnotes. But the adjacent fields of museum and gallery curating and the emerging disciplines of cultural and media studies were beginning to work with models of cultural representation that would break with the dominant mechanistic and official language of 'ethnic minority arts'. Curators and scholars who adopted these models were able to exert particular influence on national organizations

such as the Arts Council of England, as well as local galleries. Meanwhile, many black British artists began to engage with an interpretation of art as media, specifically reflecting on the notion of 'art as text'. This helped them to articulate a rationale for their practices and to affirm their value as the products of complex histories of migration, settlement, exclusion and resistance. As a spate of exhibitions attested, artists, arts organizers, theorists and critics alike energetically grasped the potential of grouping together and defining themselves with a 'black', and subsequently, a 'diaspora' identity.[2]

The explicit linking of creativity with theories of textuality was strikingly encapsulated in new concepts such as 're-presentation'. Deliberately hyphenated, this notion announced the processual nature of media practices through an analogy to language. As the cultural critic Stuart Hall put it:

> Re-presentation is a very different notion from that of reflection. It implies the active work of selecting and presenting, of structuring and shaping; not merely the transmitting of an already-existing meaning, but more the active labour of *making things mean*. (Hall 1982: 64)

By the end of the 1980s, the approach to visual analysis opened up by models of 're-presentation' was entering the narratives and theoretical explanations proposed for much of what black British artists put on public display. It contributed to their political mobilization as a group by defining their experiences of marginalization and exclusion from the environment of contemporary art at large. It emphasized a style of thinking, combined with a new interest in linguistics, whereby art making and display offered a 'site' for the 'making of meaning'. As Kobena Mercer put it in 1994:

> The philosophy of language...provides an analytical vocabulary which can be re-used for 'making sense' of the struggles of the sign inscribed in the artistic text of the black diaspora. (Mercer 1994: 254)

Such textual and linguistic perspectives drawn from cultural and media studies came to predominate in the ways visual phenomena and black/diasporic identities were theoretically examined as well as how they were promoted in galleries and other public art spaces. Embracing the new politics of identity, first- and second-generation African, Asian and Caribbean artists in Britain made the connection with a notion of art as eminently 'readable' and thereby approached their own work in much the same way as a cultural theorist would approach media texts. It was this development which served to encourage a new public awareness of their art as a significant cultural presence – one that was based on experiences of cultural differencing, exclusion and diaspora rooted in a British context. It provided a critical apparatus that became both an organizing principle of black art practice and the preferred grounds on which to organize its patronage, inform its reception and structure its historiography.

It is from this foundational cultural studies perspective that I want now to

look in more detail at the exhibition 'Alien Nation'. The exhibition's choice of artists and works for display showed ample evidence that the emphasis on notions of art-as-media and art as a site of 're-presentation' had been carried over into the twenty-first century. Much of the art included uses of 'found objects': manufactured or mass-distributed items which are combined or adapted in order to construct novel meanings and associations. For example, the memorable works of assemblage or installation by the sculptor Hew Locke serve to 're-present' elements such as mass-produced plastic toys, dolls and animals, artificial flowers, beads and decorations. These become the surface decoration for large objects that resemble bulky flying vessels, a fleet of battle-ships or spaceships entitled *Golden Horde* (Figure 1), in reference to the Mongol forces that dominated much of Central Asia during the mid-thirteenth to fourteenth centuries. This connotation is lent weight by the assortment of children's toy weapons and the polished plastic armour that provides a shell or carapace for Locke's series of sculptures, suggesting a battalion prepared for victorious attack, armed to the teeth with harmless machine-guns. All glue-gunned into place, the result is a 'making of meaning' from disparate materials, a six-piece fleet of spacecraft manned by luminous reptiles and dirty-faced dolls.

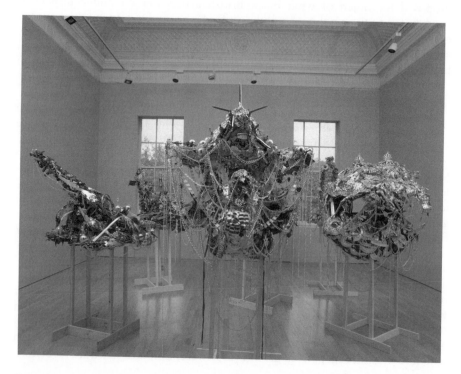

Figure 1 *Golden Horde,* by Hew Locke

Locke grew up in Guyana, South America, and settled in Britain in his late teens where he began a career as an artist. Focusing on sculpture, his works were on a large scale but often in temporary or vulnerable forms. At London's Brunei Gallery, at East International, Norwich, and more prominently at the entrance hall of the Victoria and Albert Museum, he worked with cardboard and black-and-white poster paint to create shapes that were specific to their venues.[3] Built on wooden frames that are clearly visible from their basic supports, these sprawled out and appeared to sail across the floors of these various spaces, seeming to push apart columns as they went. By contrast Locke's *Golden Horde* was constructed on narrow upright pedestals, elevated as if to suggest flight, and appearing to hover against the gallery floors and walls. Locke's early work drew attention to a history of transport and travel, and considered the role of ships as facilitating communication across the Atlantic Ocean. The rationale for this focus was explained by exhibition curators who made much of the fact of his upbringing in Guyana, a country deeply implicated in the history of plantation slavery. These ship shapes were emblazoned with the single word 'EXPORT', as if to indicate the human cargo vessels that forcibly transported Africans to the Americas, and also made reference to the production of goods such as sugar, cocoa, tobacco and cotton, carried on the Atlantic for consumption in the European and metropolitan market. Locke's contribution to the 'Alien Nation' exhibition allowed visitors to draw on their knowledge of this earlier work, while also interpreting the hulking cardboard vessels of *Golden Horde* in present-day terms of the high-tech ships sent to protect trade or threaten military invasion and territorial expansion.

The elements of retelling and appropriation and the notion of artworks as readable references to one another that featured in Locke's pieces also appeared in another made-for-the-moment work, a painting entitled *Brown and Proud* by Mario Ybarra Jr. Placed on the gallery wall in first view from the entrance, it looked like a theatrical backdrop. In contrast with the striking technicolour of much of the rest of the exhibition, the work was monochromatic but on the scale of a film hoarding and with a profusion of figures larger than life-sized. Making for a very busy composition, the painting riffed on the general theme of otherworldly visitations and the monster horror figures of science fiction. It included a leering, simian Chewbacca and a female form loosely resembling Princess Leya of *Star Wars*. Ybarra's rendering of the fleshy contents of a push-up bra became a camp allusion to the same galactic bawdiness as Mel Brooks's film spoof *Spaceballs*.

Ybarra's figurative painting was flanked by the more modestly scaled *Merk* by Kori Newkirk (Figure 2), a veil of luminescent glass 'pony' beads tacked against the bare gallery wall. The beads are ingeniously strung on artificial hair extensions to depict a column of bright celestial light, a feature that divides into two to present a suburban road. The houses are pictured at nighttime when curtains are drawn and all are asleep. The suggestion is one of various sources of alienation: homeowners cherishing their privacy and property while screening themselves off from contact with their neighbours; the

domestic setting as a refuge from public space and the working day; and a reminder that home entertainment such as television has served as a typical site of encounter with science-fiction narratives. This idealized image of orderly and tended buildings, boundary walls, fences and garden plots has also frequently been used to hysterically alarmist ends. It implicitly references the fear of what might be lost through 'swamping' by immigrants or those seeking asylum. This is the ideological background to the image of an uninvited flying saucer which hovers above the rooftops of the 'respectable' neighbourhood. The use of motifs from science-fiction genres was a common thread throughout the exhibition. And in this case the extraterrestrial glow of Newkirk's beads is a presence more threatening than *Star Trek*'s Scotty, beaming down among retirement bungalows and their tidy, moonlit lawns.

These works, whether their contexts are those of film, television, photography, painting or sculpture, serve as examples of 're-presentation'. They indicate the appropriation of forms and images from genres of cinema, historical documents or memoirs of slavery now translated into the art gallery and other sites of display. My own visit to the 'Alien Nation' exhibition was in March 2007 when it came to Manchester. It evoked other transpositions of meaning for me and in particular a memory of visiting the cinema at the arts centre, Rich Mix in Shoreditch London earlier that same year. The experience of

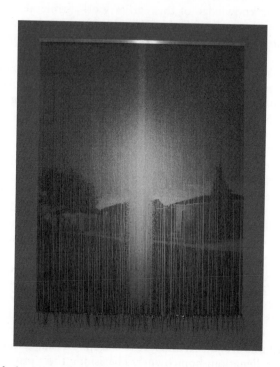

Figure 2 *Merk*, by Kori Newkirk

visiting an art gallery has some similarities with cinema-going and Rich Mix happens to be a multi-use space where you can do both activities.

Visiting 'Alien Nation' recalled for me an evening at Rich Mix spent with a friend from Taiwan. We had come to see *Ghosts*, Nick Broomfield's 2006 documentary-styled film drama about an impoverished Chinese mother, smuggled into Britain to work for brutal 'enforcers'. It is inspired by the 18 Chinese cockle-pickers who drowned in the rapidly rising tide at Morecambe Bay in Lancashire in February 2004. In the film, after a series of degrading jobs the heroine is given the fatal final choice of working in a massage parlour or of cockling on the treacherous North Sea coast. When we discussed the film afterwards, my friend broached what was an awkward but important question for her: how did I feel about hearing that Chinese people describe westerners, indeed, all non-Chinese, as 'ghosts'? She pointed out that the title of Broomfield's film was intended as a tribute to the lives and memory of the victims at Morecambe Bay. It was also an investigation of the possible tragic consequences of being perceived not only as an outsider in Britain, but also as a non-person, without any official status.[4] But the film also referred to the social significance of the word 'ghost' from a Chinese perspective: a derogatory term for all foreigners, including those who had attempted to colonize and oppress the Chinese.

Even so, in responding to my friend's question I had to admit to feeling not especially harshly caricatured by the 'ghost' label. For me, the term evoked childhood memories of comic films: the jolly and mesmerizing image of Dan Ackroyd's character in *Ghostbusters* for instance, energetically tearing up Manhattan in a jumpsuit to his signature tune, 'If there's something strange/In your neighbourhood/Who you gonna call?'. For me, ghosts were friendly creatures who had been tamed. As Ebenezer Scrooge put it to the Ghost of Jacob Marley in *The Muppet Christmas Carol*,[5] there was 'more gravy than of grave' for me in the gravity of my friend's searching question. She was responding both intellectually as a university researcher in Taiwan but also from her own life experience to the harsh implications of the dual oppressor–oppressed associations of Bromfield's *Ghosts*. But for myself, from the comfortable context of western privilege and able to recall the hegemonic seductions of ghosts from popular culture, I could make light of her question. In doing so, I was dissociating and distancing myself from the full impact of the disturbing meanings of 'ghost' that the film explored.

As with the effects of popular film, so with mainstream art history and gallery visiting. The comfortable perspective of the spectator who has come only to be entertained is attained by distraction and dissociation from the outsider position. This approach derives from marking out those who are always the 'other' people and not 'us', and hence who become the community's 'aliens'. 'Alien Nation' set out to explore the practices of othering in popular culture. In this exhibition the historical and geographical roots of these practices are demonstrated to be, after all, not that dissimilar from those that resulted in the Morecambe Bay drownings. For example, some of the repercussions of alienation were explored in the cut-and-mix photography of

Figure 3 *People*, by Henna Nadeem

Henna Nadeem's *People*, made in 2006 (Figure 3), which the exhibition featured prominently.

The artwork focuses purposefully on Britain, presenting and questioning aspects of 'timeless' folk fantasy: in this case, showing English women apparently enjoying one another's company in a picturesque landscape. Lacemakers from northern England are garlanded and meticulously dressed in cotton skirts and pinafores, joining hands around the maypole, or clapping to the tambourine. The way the images are fractured and overlaid on one another is a central motif of Nadeem's art practice. In her essay, 'The Truth is Out There', she writes:

> My early experiences as a British Muslim growing up in semi-rural Yorkshire determined the cultural and stylistic motivation of my practice. Nature and landscape formed the backdrop to my childhood, but it was nature viewed through a window rather than experienced directly. Experiencing life indoors and through a window manifested itself in an obsessive collecting of ephemera ... culled from magazines, papers and general stuff bought and found. A marked incongruity about my collection has been the absence of figurative imagery (Islam discourages figurative representation) and my collection reflects that through an emphasis on pattern and landscape. (Nadeem, in Hoffmann 2006: 37)

The artist is ironic about her taste in ornamented surfaces transposed to picturesque outdoor scenes. Her choice of the term 'semi-rural' implies a halfway house for the countryside, an inauthentic status for Yorkshire which disavows its popular description as the quintessential 'heart' of rural England. She goes on to suggest that notions of rural tradition in this country are forever being reified. For her as an artist, tradition is continually to be reinvented through modes of photographic picturing and only ever viewed as if through a window, forever 'framed' and re-presented.

Nadeem's view of the role of photographs in triggering nostalgia and in celebrating the mythic 'timelessness' of the British landscape was elaborated in another exhibition in 2006: 'Henna Nadeem: A Picture Book of Britain'.[6] Taking a randomly discovered 1966 edition of *Country Life's Picture Book of London*, Nadeem modified its pages with hand-cutting and pasting complemented by digital techniques. The popular *Picture Book* series ran from1937 to the late 1980s and offers an apparently palliative and reassuring view of a stable Britain in the face of rapid social and cultural change. When Nadeem reframes these already problematic images in her artwork she succeeds in emphasizing the ambivalence and confusion over what should and should not be pictured as British. Benedict Burbridge and David Chandler have written in their prefatory essay to the catalogue for her exhibition: 'In these collages 1960s Britain seems in the grip of parallel realities, not just an unstable, evolving place but one going through a gradual and at times nightmarish metamorphosis' (2006: no pagination). Their response raises the question: just whose 'nightmare' do these photographs signal? For Nadeem, these 'found objects' in the *Picture Books* become the raw material for a delicate pictorial stitching, and an overlay of templates derived from linear principles in Islamic and Moorish traditions. The result is a series of artworks that produce an extraordinary patterning and adopt the tactics of defamiliarization. The resulting continuous images, more kaleidoscopic than fractured, are seen as if through a second lens. A carefully designed pictorial space is created from a harmonious assemblage of photographic surfaces, cut and combined so as to embellish its chosen subject matter. Thus from an ostensibly 'outsider' position Nadeem offers an 'embroidered' reworking of Britishness that challenges the complacency of its hegemonic imagery.

Issues of 'difference' and 'diversity' in diasporic art

In exploring and commenting on the 'outsider' motif, whether by referencing the folkloric or the world of science fiction, 'Alien Nation' served to highlight recent developments in the uses of the terms 'cultural difference', 'national community' and the 'exotic'. These terms have become central to the demands for radical change in the arts first championed by critical commentators and artists who had tired of marginality, racial exclusion and 'invisibility'. But therein lies a true *Tale of the Unexpected* for our times. Those same demands are also becoming part of the very processes whereby techniques of alienation are being reproduced. As the artist, curator and writer Olu Oguibe explains:

At the turn of the twenty-first century, the struggle that non-Western contemporary artists face on the global stage is not Western resistance to difference, as might have been the case in decades past; their most formidable obstacle is Western obsession with an insistence on difference. As some have already pointed out, it is not that any would want to disavow difference, for we are all different one way or another, after all. The point is that this fact of being ought not to constitute the crippling predicament that it does for all who have no definite ancestry in Europe. (2004: xiv–xv)

Oguibe suggests that in the contemporary climate artists are themselves often hurriedly complicit with forms of differencing: a sort of self-objectification, a 'xeno-' or 'ethno-spectacle' that the marketplace and public patrons now demand. In art criticism, curating, programming and historiography, as well as in the practice of many artists themselves, it would seem that we are trading in the commodity of difference, like *Star Wars* Klingons with Federation dollars. In what has been described as 'the carnival of hetero-culture now at large in the metropolis' (Gilroy 2004c: xix), ours may well be a time when difference in the arts is being as manically embraced as the little green men of old movies.

Exhibitions such as 'Alien Nation' serve to reveal some of the operational language and the complexities of Britain's current politics of multiculturalism. In arts programming and the art market appetites have lately sharpened for ethnic, racial and cultural 'difference and diversity'. It appears then as if the pleas for inclusion from those who were at the traditional margins of mainstream art history have finally been heard. These market-led developments have put artists under increasing pressure to provide an explicit codification of accepted forms of difference in their practice. The artist and researcher Sonya Dyer has described in her report on 'artistic autonomy' for the campaign group, the Manifesto Club, 'the unhealthy pressure on artists and curators from non-white backgrounds to privilege their racial background above all else in relation to their practice'.[7] This raises a serious concern that apparently radical terms of cultural analysis have achieved a popular currency without thereby achieving any real substantive change.

However, in the case of 'Alien Nation', I would argue that the exhibition transcended the need to privilege the 'racial background' that Dyer refers to. The goal of the exhibition was more about calling upon artists themselves to present a visual commentary on the legacies of exclusion and marginalization in the hegemonic spaces of art and film. Artists were not required to foreground or embody 'race' so much as to highlight and undermine the *racism* implicit or explicit in popular imagery. Yet although this stance is to be preferred over the more obviously market-led version, could 'Alien Nation' still be considered just another, if not so intense, 'unhealthy pressure' on artists? I would answer this question by looking at whether black British artists are also exhibited in ways that succeed in decoupling them from the terms of both racism and 'race'. Such exhibitions are unfortunately rare in comparison to the abundant opportunities available to signify cultural or

diasporic 'difference'. The artist, curator and writer Rasheed Araeen described this situation as a sort of 'tyranny'. It emerges from modes of viewership that:

> have very little to do with the specificity of art and which have now been appropriated by art institutions that use them to reinforce their colonial idea of the Other. This has helped them redefine postcolonial artists as the new Other, but also predetermine their role in modern society. With the result that any art activity which does not conform to or defies this new definition is looked upon as inauthentic and is suppressed. (Araeen 2000: 11)

In Araeen's view those who occupy spaces of migration and diaspora live and work persistently within the limits set by their viewers and are forced to negotiate official sources of support and institutionalized practices of art reception. Further, concerns about modern aesthetic criteria have been raised in relation to specific artworks generally only when their makers are white. Such criteria are ignored in preference to applying the tools of cultural and media studies for any art by black British practitioners. As I've been arguing, the vocabulary of cultural analysis has fully penetrated the promotion of black British artists and has served to challenge their marginal status. Nevertheless, their exclusion from the mainstream of art has continued. Those artists in Britain who had readily identified as 'diasporic' or 'postcolonial', and so subscribed to a cultural studies notion of art as media and text, have had to cope with some significant circumscribing of their practice. The expectation that black British artists make works that are best viewed merely as *cultural evidence* of their diaspora or postcolonial experience may have contributed to undermining their very aesthetic status *as art* and hence to the reinstatement, however unintended, of ethnic and racial hierarchies. What results then is an unsatisfactory form of inclusion and the very pervasiveness of models of cultural and media studies have made it difficult to see a way out of this insider–outsider predicament.

Concluding remarks

One approach to the dilemma might be to develop a new, vital role for cultural studies which attempts to understand more clearly how and why artists could positively transcend a reading of their art as only a medium for cultural and ethnic differencing or as merely a visual litany of 'diversity'. What is the sovereign place of art in the otherwise overdetermined landscapes of visual meaning that the artists in 'Alien Nation' inhabit? An answer can be traced through the exhibition's puzzle of elements, from Manhattan to Morecambe Bay and the dark side of Saturn. 'Alien Nation' provided a complex visual presence that seized on irony in order to turn current demands for 'alien' art on their head. Locke's series of sculptural pieces *Golden Horde* invites a humorous challenge to current fears about organized 'incursions' from the East. Ybarra takes the same tone, indicating how to undermine science-fiction xeno-types

and stereotypes through camp images. Newkirk locates a kind of group para-noia generated within orderly domesticity and again, makes references to science fiction; while Henna Nadeem's photographic works explore how prac-tices of national nostalgia might be confronted with an 'outsider' defamiliar-ized transparency. Each of these artists operates in a common mediascape which helps to circulate hierarchical terms of difference. Yet they borrow, re-present and articulate visual meaning with a view to resisting those dominant codifications, aiming to 'making sense' in contrary ways.

There is still room to ask however to what extent these artworks fully succeed in their intentions of staging or prompting resistance to dominant imagery, and whether the intended ironies of the exhibition are enough to sustain its overall critical purpose. Winner of the 2003 Turner Prize, artist Grayson Perry has indi-cated that: 'There seems to be a very new Labour idea that if we rigorously ensure a numerically fair proportion of BME (black or minority ethnic) practi-tioners, then that will automatically facilitate social justice in wider society. Hmm' (2007: 16). His suggestion is that the multicultural 'mainstreaming' of attention to art is not the same as more widely-reaching social, political and economic change. This assessment is similar to Martha Rosler's description of the situation in the USA during the 1990s, of 'an art world version of multicul-turalism (and where more appropriately situated than in the realm of culture?), necessary but sometimes painfully formulaic, which produces a shadow constel-lation of the identities of the wider society but without the income spread'.[8] These observations on the limited effects, both within and beyond the arts, of initiatives of social equality and cultural inclusion suggest that the critical use of vocabularies of diaspora, difference, postcolonialism and blackness have not fulfilled the ambitions of historically alienated artists. Indeed, considering how black British artists have negotiated these categories, much stands in the way of them finding the place they seek in the art mainstream.

It might be argued that the participation of black British artists in the contemporary art environment can never be guaranteed by the contribution of cultural and media theory. Indeed, this would explain why despite the ener-getic insistence on the value of paradigms of art as media and 'cultural text', black British artists have remained frustrated in their ambitions. The historian of philosophy Martin Dillon has named the indiscriminate use of such para-digms 'semiological reductionism', a conceptual apparatus whose ascendancy has brought regrettable outcomes. As he provocatively suggests, 'One way not to see the world is to read it as text' (Dillon 1995: 104). By coupling the area of visual art with the categories of ethnicity and difference (such as in concerns with 'blackness', or accounts of 'diaspora' consciousness), the continuing investment in reading the world as text has become deeply problematic. I therefore suggest that a more promising approach to resistance would be the emergence of alternative ways of relating to works of art. We need those works to be encountered as greater than a visible illustration of 'issues' for market promotion or for postcolonial study. So how might we apprehend the art of black Britain beyond its troubled significance as a medium of cultural mean-ing and a visual token of cultural inclusion?

A decisive break from the current situation will not be achieved by simply aiming to avoid the familiar terms of description and the newly orthodox vocabulary of cultural and media analysis. Rather, we need greater care in our efforts to understand how works of art serve to mediate the political, ethnic and cultural economy of difference and postcoloniality. They act as mediators but also enjoy the status of creative projects capable of being detached, definable and distinct from media processes. It follows that studying the art of black Britain involves both acknowledging the usefulness of the analytical formulations of 're-presentation' and 'language, textuality, and signification' but also risking breaking away from dependence upon them (Hall 1996c: 1–17). If such paradigms have formed the stock-in-trade for postcolonial commentary and criticism they have also become the basis of current public expectations about this art, with often adverse results. Yes, art *is* textual, linguistic, signifying, representational, mediating, connective, codifying and context producing. But still art objects also have the ability to enable special kinds of outcomes by attracting and holding human attention in ways that are peculiar to their materials and historical milieu. In the case of the art of black Britain, works of art have generated room of their own for philosophical and critical work while stubbornly refusing the reductionism of being treated as material signs of difference. In any debate on the art of black Britain and postcolonial media there is a growing urgency to ask why art has a historical presence that media texts, signs and language may not.

Notes

1 'Alien Nation' was an ICA/inIVA exhibition curated by John Gill, Jens Hoffmann and Gilane Tawadros, at ICA London, 17 November 2006–14 January 2007, Manchester Art Gallery, 17 March 2007–7 May 2007 and Sainsbury Centre for Visual Arts Norwich, 2 October 2007–9 December. Contributing artists included: Laylah Ali, Hamad Butt, Ellen Gallagher and Edgar Cleijne, David Huffman, Hew Locke, Marepe, Henna Nadeem, Kori Newkirk, Yinka Shonibare MBE, Eric Wesley and Mario Ybarra Jr.

2 See Wainwright (2005, 2006). Examples of exhibitions that have focused on a historical surveying/assembling of diaspora artists include: Beauchamp-Byrd *et al.* (1997); Araeen (1989); Chambers (1988).

3 These works by Locke appeared in 'Routes: Five Artists from Four Continents', at the Brunei Gallery, London (22 January–26 March 1998), the V&A (1999) and East International, Norwich (2000); see Robinson and Marsden (2005).

4 In his *Guardian* film blog, 'Modern Slaves without a Ghost of a Chance', director Nick Broomfield makes a direct link between the abolition of slavery in America and what he features in his film *Ghosts*: '*Ghosts* is a film about modern slavery and the Morecombe Bay cockling disaster. This year officially marks the 200th anniversary of the abolition of slavery, yet there are currently three million illegal migrant workers in this country who can be classified as modern-day slaves. The government's attitude towards these people is hypocritical. They pretend they don't exist and refuse to recognise them. At the same time the UK economy would collapse without this pool of cheap labour'.

5 *The Muppet Christmas Carol*, 1992, directed by Brian Henson and starring

Michael Caine as the miserly moneylender, Scrooge is one of the many film and musical adaptations of Charles Dickens's classic ghost story.

6 The exhibition was staged at Charleston Farmhouse, Sussex, 6–29 October 2006, in association with the Brighton Photo Biennial.

7 To quote Sonya Dyer in full: 'Today, the institutionalisation of diversity policies means that art is being sidelined, and in many cases black artists are first and foremost regarded as black. This is clearly shown by the unhealthy pressure on artists and curators from non-white backgrounds to privilege their racial background above all else in relation to their practice. Black artists and curators are often expected to produce projects that are geared towards attracting a black and minority ethnic audience. One young British Asian curator I spoke to about this said that he had never felt "othered" until he began working in public galleries. It goes without saying that white artists and curators do not generally feel the same kind of pressure to appeal specifically to white audiences' (Dyer 2007: 11). See also: Dyer *et al.* (2007: 19–30).

8 Rosler (1997: 20–4), quoted in Stallabrass (2004: 21). The first chapter of Stallabrass's study explores in further depth correlations between neo-liberal agendas such as these in the arts and those of the wider political economy. See also Žižek (1997: 28–51).

Mainstreaming Cultural Diversity: Public Service Policy and British Reality Television

Sarita Malik

Ethnic and racial consciousness is an important aspect of postcolonial media culture. It connects issues of citizenship, pluralism and the role of community. It also highlights the ways in which ethnic minority groups generate media practices and bid for recognition. Such consciousness generally emerges in situations where groups that share common cultural concerns, such as a religion, language or ethnicity, organize to defend their collective interests or influence the exercise of state power. This article will focus on the two largest and most 'visible' ethnic minority communities in contemporary Britain which I will categorize using the familiar shorthand of 'black and Asian'. The aim of the chapter is to address broader issues of ethnic minority representation in relation to recent developments in public service broadcasting and reality television.

Despite the surge in new media formats and multichannel viewing options, traditional terrestrial public service broadcasting (PSB) remains a significant feature of the British mediascape. PSB is an important aspect of everyday practice in terms of public debate, private domestic rituals and consumer patterns. It relates to both citizen interest and national order, addressing how the national community is imagined, organized and addressed.

In the first part of this chapter, I want to consider how changes in political and media discourses around black and Asian representation relate to changes in PSB policies. I will outline the critical shift that has taken place away from the idea of 'multiculturalism' and towards a reconstruction of assimilationist-style policies. I go on to discuss how this shift relates to the politics of media

recognition and representation for ethnic minority groups. In examining the interface between political and media discourses around 'race' I will argue that the recent pervasive criticism of what Stuart Hall has called the 'multicultural principle' (2007: 152) has been problematic on two levels. First, because arguments that multiculturalism has now served its purpose or 'gone too far' manage to overlook and even conceal the structural and political racial inequalities that continue to exist in postcolonial Britain. And, second, because criticism of multiculturalist policies can deny the stubborn racialized continuities of how black and Asian communities are still (under)represented on- and off-screen. I will demonstrate that the assimilationist ideal is that of the 'absolute citizen', which, just like the recent corporatized project of the 'global media citizen', is based on new aspirations and fantasies of equality. Whereas what it actually serves to emphasize is how far such an ideal is from being realized: an assimilationist approach can in fact highlight the very dilemmas that persist as we negotiate how to live with difference today.

In the second part of the chapter I will go on to describe how the intensifying retreat from multiculturalism has manifested itself on-screen. Recent developments in ethnic minority representation, far from being the result of strategic interventions by cultural producers and policy makers, have largely been the result of shifts in programme production and marketing. Specifically, it has been the rise of the aspirational-lifestyle television genres in the 1990s and their migration from daytime programming to the weekday early evening television schedules (Brunsdon 2003) which has constituted the primary route, along with the reality television phenomenon in general, through which black and Asian images have became 'mainstreamed' for a broader range of viewing audiences.

At the same time, there has been a demise in programmes targeted at specific ethnic minorities on public service terrestrial channels. These have, in any case, been rather overtaken by new forms of diaspora media as satellite television and the internet vie for minority consumer attention. As I will outline in the concluding part of the chapter, the transnational broadcasting marketplace is another site in which themes of commonality and the proliferation of difference are currently being negotiated both by broadcasters and audiences. This has inevitably had further impact, both on how UK public service broadcasters are caught up in questions of ethnic minority representation and also on those ethnic minority audiences that engage with them, hence producing a 'new kind of media culture that has become de-linked from a singular national reference point' (Aksoy and Robins 2000: 343).

Policy challenges to multiculturalism

A political–cultural approach to understanding the relationship between ethnic minorities and PSB is useful because media regulation, civil society and public discourse are all indicative of how the underlying social–political processes and practices of broadcasting all operate. However, the prevailing emphasis in studies of race and the media has been on analysing textual

representation rather than on the politics of policy development. But what this latter approach involves is a means of looking beyond on-screen representation to consider the critical relationship between two trajectories: (a) the threat to traditional public service delivery; and (b) the claims of ethnic groups for 'better representation' and greater influence within state institutions. The predicament here is how the tension between changes in the mediascape and alterations in the politics of recognition and identity are reflected in the structuring of PSB with regards to ethnic representation in postcolonial Britain.

This question gets us to the heart of debates around distributive rights, empowerment and social inclusion which are, in any case, a strategic objective of existing 'social engineering' strategies, as laid out in, for example, the policies of UK bodies such as the Office of Communications (Ofcom), the main regulator of UK broadcasting and the Department of Culture, Media and Sport. In the twenty-first century these concerns had not only been a critical aspect of New Labour's public promotion of 'social cohesion', but also a growing theme in scholarly analysis. In his discussion of four key 'moments' in cultural studies sociologist Chris Rojek highlights, alongside the 'national–popular', 'textual–representational' and 'globalization/post-essentialism', the new leading area of 'governmentality and policy'. He says of this fourth 'moment' that it relates to an emerging debate about 'how resource allocation can function equitably through a politics of difference' (Rojek 2007: 65). From this perspective, black and Asian textual representation needs to be situated within the context of governmentality and policy so that urgent questions of political economy, such as the conditions of cultural production and reception can be considered and then linked to an understanding of some of the broader issues around postcolonial media culture – including questions of cultural power, cultural pedagogy and cultural practice.

Multicultural broadcasting policy typically recognizes specific cultural representation within universal provision. I am defining 'multiculturalism' here as both an ideological principle and a practice of addressing various forms of ethnic marginality through legislation and through cultural and social policies so it can offer ways into celebrating difference. But at the same time it aims to challenge inequality through proposing quantifiable measures of achievement, such as targets and goals and specific policy requirements like 'positive action'. From the 1970s to the early 1990s, and as part of a broader regime of cultural governance, UK broadcasting positively acknowledged Britain's multicultural lived experience by taking a range of initiatives designed to broaden the representation of marginalized groups and viewpoints, for instance, through recruitment policies and the creation of specialist departments and programme slots.

The foundations of multicultural broadcasting had been laid by black and Asian cultural campaigners and practitioners for several decades, but it peaked in the mid-1980s when the focus of anti-racist campaigning began to shift from political concerns around issues such as policing and immigration towards cultural, religious and social issues. One of the aims of establishing multicultural departments and policies during the 1970s and 1980s was

explicitly to place black and Asian representation on the media agenda (Malik 2002). PSB was positioned in this period both as a contested space and central to the workings of democratic culture.

However, during the 1990s the public service case for multicultural programming was undermined by the emerging cultures of commercialism triggered through increasing competition, lighter-touch regulation and technological developments. New levels of commercial pressure were apparent during the 1990s. For instance, the BBC's African-Caribbean Programmes Department was disbanded in 1991 and then recreated as the BBC Multicultural Programmes Department in 1992 also incorporating Asian programming. This change signalled the beginning of a different, more mainstream definition of 'multiculturalism' on UK screens. Much of the Department's output demonstrated a drive to attract bigger audiences and '*sell* blackness' in sensationalist ways by foregrounding topics such as rent boys, prostitution, polygamy and pornography.

The most symbolic moment of the redistributive project occurred when Channel 4's Multicultural Programmes Department closed in 2003. As the only terrestrial channel to have been established with multicultural programming as part of its infrastructure and core practice, Channel 4 repositioned multicultural representation as part of a broader 'diversity' agenda in which ethnic diversity was just one component alongside gender and disability, for example. This move fitted with an ethos of viewers as simply 'viewers' rather than conceived as specific and 'particular' audiences (Aksoy and Robins 2000). On a practical level, the nuances of this shift removed certain requirements around the quantity and source of minority-based output, something that the Multicultural Programmes Department was designed to help systematize.

The new political agenda became about embedding cultural diversity as a more general part of everyday programming rather than something that needs to be made separate. It signalled, in the main, the end of any 'special treatment' for ethnic minority groups and replaced it with a more universalist principle of representation for all (O'Loughlin 2006). One of the arguments made at the time against multicultural special treatment was that, while it made it easier to measure the extent of black and Asian representation in broadcasting, the process might also support a kind of cultural marginalization that could both externalize difference and obscure a more natural and meaningful representation of the cultural variety of Britain.

But the new all-inclusive 'mainstreaming' approach also brought its own problems. In the first place, the policy could imply that all kinds of citizens, even those with extreme racist politics, should be considered equally entitled to on-screen representation. For example, the BBC's major report on safeguarding impartiality, *From Seesaw to Wagon Wheel*, commends an interview by David Dimbleby in 2006 with Nick Griffin, the leader of the British National Party. The report states that, 'refusing to give airtime to "unpleasant" parts of the democratic process creates resentment among sympathizers, drives the support underground, and may well strengthen it. It is certainly not

impartial' (BBC 2007: 40). The appeal here is to the liberal notion of 'freedom of speech'. But the difficulty is, if this approach involves giving a platform to racist views, that there are clearly limits to liberalism's 'impeccable' credentials. In my view, public service broadcasters need to consider what are the *exceptions* to impartiality and 'free speech' – especially as modern regulatory frameworks require that they oversee how cultural sensitivities towards minority communities are managed.

The first indication of the move from an explicit multicultural principle towards a new emphasis on 'diversity' was registered in 1988 when the Arts Council entitled its new report on the work of ethnic minority groups as *Towards Cultural Diversity*. The policy shift was accelerated during the 1990s by the intensifying backlash against 'political correctness' (Dunant 1994). In the new climate, multicultural policies were presented as divisive and as having the potential to give 'unfair advantage' to minorities. This thinking chimed with notions of commonality, integration and community cohesion which were emerging in the same period as part of a broad New Labour politics of citizenship (Shukra *et al.* 2004). These views were highlighted for example in the 2004 Home Office Report: *Strength in Diversity: Towards a Common Cohesion and Race Equality Strategy*. At the same time, Trevor Phillips, the New Labour politician and media entrepreneur who became head of the Commission for Racial Equality in 2003, was voicing strong criticism of multiculturalist policies, seeing them as effectively resulting in the segregation and ghettoization of British cities (Phillips 2004). By contrast, the emphasis on cohesion in 'diversity' policies was seen as representing a new drive towards the idea of a new citizen, whereby individual subjects are represented as being as equal as their fellow citizen-neighbours and equally charged, whether black or white, with the requirement to recognize our society as culturally diverse.

Nevertheless, the politics and policies of 'diversity' have not prevailed without challenge. For instance, Phillips's views met with frequent criticism from campaigners, academics and the Mayor of London for giving possible succour to racist views. And the publication in 1999 of the Macpherson Report into the Metropolitan Police's handling of the 1993 racist murder of the student, Stephen Lawrence offered a restatement of earlier multicultural concerns. The Report presented a strong condemnation of the police's inertia and inability to assemble adequate evidence for a successful prosecution. It described this failure in terms that popularized the notion of 'institutional racism' within the UK and made 70 recommendations, including urging a rapid increase in the recruitment of black and Asian police, and methods for improving race relations both within the service and between the police and the public (Macpherson 1999).

The impact of the Macpherson Report's multiculturalist approach was widely felt in other organizations. Greg Dyke, the Director General of the BBC became famous for his assertion in 2001 that 'the BBC is hideously white'. He compared the Corporation's institutional bias with Macpherson's findings on the British police when he stated:

The BBC is a predominantly white organisation. Quite a lot of people from ethnic backgrounds that we do attract to the BBC leave. Maybe they don't feel welcome...You can have all the equal opportunities policies you like, but if actually the gateman doesn't let blacks through the gates, you've got a problem, haven't you? (Nicholas 2001)

Greg Dyke also became chair of the Cultural Diversity Network set up in 2000 by a group of UK broadcasters in order to promote cultural diversity on, and behind, the screen. In this role he emphasized that, 'diversity is an issue no broadcaster – public or commercial – can afford to ignore'. He went on to point out that, 'For young people in this country today multi-culturalism is not about political correctness, it is simply a part of the furni-ture of their everyday lives' (Dyke 2002). In my view, however, to think of multiculturalism as an already taken-for-granted social fact may have the unintended consequence of downplaying the need for continued active intervention to combat the effects of institutional racism. For instance, one of the key problems the Cultural Diversity Network identified was the lack of ethnic minorities in senior management positions in UK broadcasting. But throughout the decade the white-dominated culture that operates at the senior decision-making ranks remained stubbornly intact. In 2007 the BBC had achieved a black and minority ethnic (BME) level of senior staff of 4.38 per cent, while aiming for a BME recruitment level of 7 per cent.

Hence the actual impact of cultural diversity policies has been called into question by various black and Asian media professionals. In 2008, one of Britain's best-known black television entertainers, Lenny Henry delivered a lecture to the Royal Television Society entitled, 'The road to diversity is closed: Please seek alternate route'. In the lecture he set the scene thus, 'When I started, I was surrounded by a predominantly white workforce. Thirty-two years later, not a lot has changed'. His particular concern was the lack of ethnic minority decision makers within terrestrial broadcasting and he reiterated the multiculturalist notion of 'affirmative action' in call-ing for a stronger BME recruitment policy: 'And I'm not talking about cleaners, security guys, scene-shifters: I am talking about decision makers.' The implications here are that while the broadcasters remain within the predominantly qualitative mindset of 'cultural diversity', which, after all, may simply imply an acknowledgement of the basic fact of the coexistence of different ethnic, racial or cultural groups – a fact which holds true for all societies (Todd 2004), they cannot then adequately address important quantitative evidence and critiques of the inequity of actual institutional practices, such as poor levels of BME recruitment. In the rest of the chap-ter I will go on to discuss how the policy shifts I've discussed relate to on-screen representation, and work towards a conclusion that proposes that ethnic minorities are still disconnected from mainstream broadcast media in critical ways.

Postcolonial Britain on reality television

Despite the demise of specialist ethnic programming at the end of the last century, everyday terrestrial television began to give the appearance of a more diverse Britain. This was not the result of strategic policy intervention but related to commercial priorities and specifically to the rise of reality and lifestyle programming.

The growth of lifestyle programming in the late 1990s became a turning point in the relationship between ethnic minorities and television – later to be accelerated by the considerable expansion of the reality television genre. Traditional genres of authored documentary broadcasting in the 1970s and 1980s were reinterpreted and updated in the form of docu-soaps, video diaries, makeover and lifestyle shows, giving a high public profile to a larger range of cultural and social 'types' (Malik 2002). The growing commercialization of broadcasting rendered programmes with political campaigning goals less popular with commissioning editors and advertisers than those which transmitted 'talk' and 'chat' around lifestyle and personal identity issues. This new emphasis bore on themes already familiar from the tabloid press, such as crime, property, health, celebrity and family. Hybrid lifestyle formats – such as the travel show cum documentary cum cookery programme – were viewed by producers as offering greater audience 'user-friendliness'. The 'reality' trend was accelerated by television's increasingly close relationship with other forms of media, from the expanding weekly magazine market covering both 'real confessions' and the lives of the rich and famous to the newspaper supplements on travel, property and self-improvement and from advertising-led internet developments to the music industry's promotion of commodified leisure – all contributing to the growth of a celebrity-led mainstream entertainment culture.

The meaning of this for ethnic minority representation has been significant. There has been a glut of different reality television modes: the talent show, such as *The X Factor* (ITV-1, 2004–), *Fame Academy* (BBC-1, 2002–) and *Strictly Come Dancing* (BBC-1, 2004–); the self-improvement show like *Celebrity Fit Club* (ITV-1, 2002–) and *How Clean Is Your House?* (Channel 4, 2003–) and the turn-your-life-around series such as *Wife Swap* (Channel 4, 2003–) and *Supernanny* (Channel 4, 2004–). All these lifestyle formats have come to feature, quite routinely now, people from a range of ethnic and class backgrounds. By the late 1990s, reality television was thriving and the overall look of terrestrial programming had become increasingly diverse and pluralistic, bearing witness to newly emerging confident generations of black and Asian communities and a steadily growing ethnic minority workforce at non-senior levels in the media industries.

As Charlotte Brunsdon notes, 'through their choice of participants, [reality television] programmes...make a considerable contribution to changing ideas of what it is to be British' (2003: 13). This hyper-visibility of multi-ethnic Britain has produced an interesting dynamic between on- and off-screen contexts. The positioning of ethnic minorities in these programmes is relatively

straightforward. Because the reality genre is largely unscripted it mostly escapes those major accusations of misrepresentation, lack of authenticity or stereotyping which scripted television formats such as the sitcom and soap opera have had to contend with (Malik 2002). Thus the inclusion of ethnic minorities in these programmes is less politically charged and not likely to attract concerns about 'political correctness'. In lifestyle programmes such as *Homefront, Ground Force, Changing Rooms, What Not to Wear* (BBC-1) *You Are What You Eat* and *10 Years Younger* (Channel 4) the formulas became so interchangeable, that it was just as easy for producers to select an Asian family, Caribbean woman or mixed-race couple as it was to choose their white equivalents. At the same time, the visual 'difference' of black, Asian or non-white participants did produce a kind of textual synergy with the aspirational, modern and energetic tone that is typical of these programmes.

The very familiarity of the lifestyle format has also made it amenable for covering more challenging programme content where cultural, ethnic or religious difference is actually foregrounded. *Arrange Me a Marriage* (BBC, 2008) examines a topic widely misunderstood within the majority ethnic communities of the UK – but presents it in a non-threatening manner adopting the conventions of lifestyle television through their predictable pattern of dilemma, transition and transformation. Similarly, *Make Me a Muslim* (Channel 4, 2007) adopts a makeover–life-change narrative to present key features of Islam by following the stories of a group of non-Muslims being taught by an imam to observe Islamic teachings for several weeks.

Thus, reality television is 'casting' ethnic minorities as properly representative of the 'lived' experience of diversity – whether BME citizens are used routinely as participants in reality television or whether predictable lifestyle formats are used to reflect on 'difference' in an audience-friendly way. However, this is where an element of the utopian assimilationist fantasy may creep in. Reality television can function as a metaphor for a society in which racial difference no longer matters because the assumption is made that the imaginary 'absolute citizen' now actually exists. Take reality game shows like *The Apprentice* (BBC, 2005–) and *I'm a Celebrity Get Me Out of Here* (ITV, 2002–). In these, contestants compete in an apparently 'flat hierarchy' for a prize, be it money, survival, a job or a partner. Symbolically, what underpins the point of the exercise is the desire to change one's life, with personal transformation as the ultimate prize. Here reality television is required to neutralize racial difference in order to put all contestants on an apparently level playing field and thus simulate a world where meritocracy rules and common humanity and sameness are emphasized over difference. On the one hand this 'colour-blind' approach offers what I believe can be an overoptimistic sense of achievement and progress. On the other hand, it indicates a certain social advance and may offer positive inspiration and confidence for some ethnic minority viewers because it suggests racial power structures can be broken down.

To give some examples of how this positive, aspirational aspect of reality television is occasionally realized. When Tim Campbell, an ambitious, hard-working young black man, won the first series of *The Apprentice* in 2005 to

gain a new managerial post, it was an important and positive example of how ethnic minorities can be included in a peak-time terrestrial series watched by many millions. Similarly, Channel 4's *Big Brother* has consistently cast BME participants to live and compete together in the *Big Brother* House. In 2005, Series 6 of *Big Brother* presented its most culturally diverse cast up to that date with five participants out of a total of 13 coming from 'visible' ethnic minority groups, all with an equal chance to win the prize money. These were: Derek, Makosi, Science, Kemal and Vanessa – not tokenistic black or Asian housemates but a noticeably broad range of black 'types' which demonstrated the heterogeneity that exists within black and Asian communities. Moreover, they had clearly been selected to function as 'anti-stereotypes' to traditional on-screen portrayals of black people. Hence Kemal was announced as a Muslim cross-dresser; while Derek introduced himself to his fellow housemates by declaring that, 'I'm black. I'm gay. I'm a Conservative and a Master of Foxhounds'. Later, he revealed in the *Big Brother* diary room that he felt no pressure to hide from a majority white audience political and personal disagreement with another black housemate when he declared, 'In Science, I have found the first black person who makes me want to become a member of the BNP [the anti-immigration British National Party]'. But another housemate, Makosi Musambasi, a spirited Zimbabwean woman, was mocked on the show for her Afro hair and told by a fellow contestant, 'You lot always have a chip on your shoulder ... and you wear a fucking wig on your head'. For all its appeal to diversity, *Big Brother* 6 also saw a clear divide develop between the white and non-white housemates who, as the series continued, retreated into two racially organized camps.

My point here is that a textual device like the selection of a diverse cast with everyone tasked to do 'the same thing' does not automatically counter modes of racial typing, or the production of racist narratives and processes. Later series of *Big Brother* highlighted more explicitly that ethnic minority inclusion does not, in and of itself, mark a breakthrough in the representation of race. Indeed, it can also open up the possibility of revealing patterns of racialization and racial inequality. Take the brief sojourn of housemate Shahbaz in *Big Brother* 7 (Channel 4, 2006). Shahbaz was obviously cast for his non-stereotypical image, introducing himself as 'a wacky Paki poof without a corner shop'. Many viewers subsequently commented that they felt uneasy about the way he was bullied by the other housemates. However, few commented on the racially inflected nature of the taunts, such as 'Shahbaz – Sharm-el-Sheikh – whatever his name is'.

Such moments mark a challenge to the idea that British society has simply risen above racial difference and that reality television is merely indicative of broader social patterns of meritocracy. What in fact they reveal is the actual practice of racial discrimination that exists 'out there'. Moreover, these programmes can help legitimate a widening chasm between those black people who are so publicly, if briefly, celebrated in reality television and those who continue to be excluded from basic levels of opportunity in British society and, for that matter, from television's own professional and institutional structures.

The notorious *Celebrity Big Brother* (Channel 4) of 2007 crystallized many of the issues I've been addressing around ethnic minority representation, communication rights and the politics of recognition. This series attracted international attention when the Bollywood actor, Shilpa Shetty, was bullied and racially taunted by fellow 'celebrity' housemates and most visibly by the white, working-class reality television star, Jade Goody. The Channel's bungling treatment of the ensuing 'race row' raised public concern about exactly where the Channel's priorities lie: whether with the market by deliberately heightening audience involvement, or whether with its own liberal credentials of cultural awareness and sensitivity. Channel 4's non-intervention as the gang-bullying of Shetty intensified was defended by its management at the time using the alibi of some kind of genre 'etiquette' – namely that the producers could not be seen to 'intrude' and spoil the 'natural' order of things in the house.

The actual conventions of reality television demand of course that it is *constantly* subject to the manoeuvring of the programme *'makers'* who devise tasks, edit strategically, interview provocatively, and so on, in order to generate interest. This became apparent when the subsequent damning verdict of the regulatory body, Ofcom, ruled, among other things, that Channel 4 had broken broadcasting codes by not declaring knowledge of (unbroadcast) racist footage, including film showing some of the *Celebrity Big Brother* housemates discussing using the word 'Paki' in a limerick (Ofcom 2007a). A transcript of untransmitted footage was later released showing 'Big Brother' (as voiced by a member of the production team) clearly warning some housemates that what they were saying could be regarded as racially offensive. Channel 4 was thus actively involved in political arbitration, arguably seeking to protect those housemates whose behaviour it should have more explicitly and publicly challenged. The *Celebrity Big Brother* 'race row' exposed the weakness of the Channel's public project and its need to be seen as anti-racist and uphold its public image as a liberal, tolerant and diversity-friendly broadcaster. In these ways, what Channel 4 did, what it should have done and what it wanted to be seen as doing all revealed a complex set of relations around its supposed ability to challenge racism and how the illusion of 'impartiality' within public service broadcasting actually operates.

The 'race row' incident demonstrated how forceful the public can be when claiming their communication rights (see Malik 2008). The audience response to the racist bullying in *Celebrity Big Brother*, as Channel 4 discovered when an unprecedented number of complaints were made to Ofcom, served as a sharp reminder that audiences have communication rights and cultural sensitivities that need to be recognized by broadcasters. Channel 4's Chief Executive, Andy Duncan, admitted the Channel had failed to see the viewers as 'real people, rather than ratings' (*Guardian*, 28 May 2007). It is easy to see how *Celebrity Big Brother* undermined Channel 4's public service credentials for championing diversity because it actively manipulated a culturally sensitive situation and heightened conflict between the housemates in order to boost ratings and in so doing both underestimated and depoliticized its audience. As

Tessa Jowell, the Government Culture, Media and Sport Secretary at the time put it, audiences were offered little more than 'racism being presented as entertainment' (*Guardian*, 19 January 2007).

While the diverse range of active participants in reality programmes involves a process of 'pluralling up' (Brunsdon 2003: 18), in which a more pluralistic representation of society is foregrounded, it cannot be assumed that this provides anything more than the kind of quick-fix, 'papering-over-the-cracks' promise of transformation. In my view, ethnic inclusion within these genres only succeeds in 'boosting the numbers' – and manages this *precisely* because of the adoption of successful global formats that are practically guaranteed ratings-winners. The delivery of any meaningful cultural diversity and the achievement of communication rights across the board will require far more wide-reaching intervention in broadcasting.

I am suggesting therefore that public service television is at a critical juncture here. Ethnic minority representation in drama serials and comedy remains marginal – although there have been some outstanding exceptions.[1] Meanwhile, deliberate attempts to produce 'good ethnic representation' in soap opera and comedy indicate that many programme makers still tend to approach representing diversity as a problem rather than an opportunity. For example, *The Crouches* (BBC1, 2003–5), a sitcom about three generations of one close but contentious family was a clear attempt by the BBC to produce and air a black (Caribbean) comedy. But like many 'ethnic sitcoms' that had come before it, the series simply flaunted ethnic diversity without working through how to develop the humour and characterization. The BBC1 Controller, Lorraine Heggessey, promised in the BBC publicity that, 'This vibrant comedy will showcase the talent of some Britain's best black actors and introduce new faces to a mainstream audience'.[2] However, *The Crouches* was heavily criticized by black viewers and described by Michael Eboda, the editor of the black newspaper *New Nation* as 'about as funny as being carjacked' (*Guardian*, 10 September 2003). The black commentator, Darcus Howe, in his scathing review of the series, stated:

> This is an attempt to denigrate the Caribbean community on a scale I have never seen before. The drama department seems to be saying that since the director general, Greg Dyke, wants more blacks on the screen, we will offer up some nigger behaviour for all to see. Does the department resent Dyke's challenge in some way? This is not what the West Indian community is, but what the BBC drama department thinks it ought to be. (2003)

The widespread criticism of the series arose for two major reasons. First, because, like so many other representations of black and Asian people in scripted television, it had a white writer, Ian Pattison. Although not necessarily problematic, this opened up the series, already considered to have misfired in its humour and audience address, to comments that it was unrepresentative, inauthentic and out of tune with the black community. And, second, because the BBC in its attempt to promote the comedy as both 'all-black' but also as

'a sitcom about a family that just happens to be black', revealed obvious anxieties around how to represent and position the series for various 'mainstream' audiences. The familiar pattern of the ensuing criticism indicates how, to be really effective, claims for better recognition must confront the important condition of agency. This requires not just thinking in terms of numbers – how many participants in reality programmes or characters in drama – but also being aware of the perspectives and *positioning* of both viewers and producers.

Ethnic minority audiences: the 'unreachables'?

In 2002 Caroline Thompson, then BBC Director of Public Policy, stated that ethnic minority audiences were:

> not connecting with public service broadcasting and all it can offer with its mix of entertainment, education and information. The BBC and other public service broadcasters need to connect with this audience. Just how we make that connection is developing all the time. (Thompson 2002)

But five years later, the BBC deputy Director-General, Mark Byford declared that, for broadcasters, some people will always be 'unreachable'. He stated, 'If we chase every group with the aim of converting them as an audience, then we could run the risk of losing the core audience we already hold. There will always be some unreachables' (*Guardian*, 24 January 2007).

The idea that there are some groups who cannot be reached by public service broadcasters is a significant admission to be made on behalf of the BBC, given that its broadcasting legacy is underpinned by universalist goals. It is not absolutely clear that Byford was referring to ethnic minority groups as 'unreachable'. But what is undeniable is that the old broadcasting order with its requirement to serve the public in ways that are both unified and yet distinct is undergoing radical transformation and ethnic minority audiences play a significant role here (Karim 2003). Audience research, viewing figures and reports published by public broadcasters and their regulator, Ofcom, continue to suggest that terrestrial television is a turn-off for black and Asian audiences, with Asians showing a particularly strong inclination to 'go elsewhere' by tuning into digital and cable television options. In the Ofcom Report on ethnic minority groups and communication services, there is a suggestion that black and Asian viewers do not feel they are getting the representation they want from terrestrial public service television (Ofcom 2007b). One possible reason for migrating audiences – besides the fact that those who can/want to pay for digital services have more choice – is that black and Asian viewers feel that PSB is no longer responsive to their views and choices. As the UK switches over to digital, the question of what plurality means in a digital world is likely to dominate future public service reviews. The argument that the public service aspect of terrestrial television is what gives it a distinctive edge over the rest of television is a pervasive one.

The Ofcom Report concludes that when it comes to the perceived value of digital television, access to channels with specialist focus was ranked highest by BME groups, with 77 per cent of the ethnic minority population seeing it as an important factor compared with 56 per cent of the rest of the population. This statistic alone indicates that public service broadcasters need to offer more specifically targeted content, include so-called 'ethnic programmes', to satisfactorily represent and appeal to all members of a diverse viewing public. However, a move back to the kind of 'specialist focus' that ethnic minority groups are currently tuning into elsewhere, works against current trends in two main ways. First, it is contrary to the current political momentum arguing against specialist ethnic programming. Second, it runs up against the economic fact that small and medium independent producers who are the ones most likely to deliver specialist programming for the public service broadcast media are seeing their funding diminish in a ratings-led, competitive climate in which 'super-independent' producers dominate. Besides, UK public service broadcasters have been seriously influenced by the US approach of 'capturing' and 'penetrating' markets. US models suggest that it is the white middle-class experience that becomes the representative centre when competing for global audiences. Anything 'too niche' (meaning often, 'too ethnic') is perceived to limit the chances of appealing to everyone (Havens 2002). What is understood as 'liberal' freedom in this scenario is not essentially about ensuring pluralistic access to resources or 'practising multiculturalism', but primarily about market liberalism, the economic freedom for individuals to do as well as they can, while leaving the broader issues about collectivities to market forces – to be addressed only if they meet the needs of a profitable cultural marketplace.

Meanwhile, the flip side of this open global market is that broadcasters outside the UK are targeting black and Asian audiences. New competition from global media channels is now putting economic pressure on UK public service broadcasters to secure the loyalties of black and Asian British audiences. In June 2007, US cable network Black Entertainment Network, owned by Viacom, announced the introduction of a 24-hour general service entertainment in the UK. Its plan is to air both big American imports and locally commissioned programmes in order to 'super-serve the black British, Caribbean and African communities' (Michael Armstrong, *Guardian*, 20 June 2007). Similarly Doordarshan, India's state broadcaster, began to air in April 2007 with the claim that it would bring 'the essence of India to Great Britain'. Echoing the BBC's first Director-General, John Reith, it promised to provide 'high quality programmes which entertain, educate and inform'. At the same time, figures suggest that the global commercial channels, such as Rupert Murdoch's digital Star TV, are the preferred providers for many British-Asian viewers.

Faced with this kind of competition the dominant industry concerns have been based around terrestrial public service broadcasters losing a growing economically significant demographic. However, the way these concerns are sometimes expressed is through the notion of 'self-segregation', whereby the blame is opportunistically pinned on 'Muslim' (significantly, rather than the

more general epithet 'Asian') audiences. For example, in an article on the BBC News website about ethnic minority audiences and digital viewing habits it was suggested that such trends run the danger of Muslims 'not becoming attuned to British ideas'.[3] The subtext – not least through the use of the term 'ghetto' is that certain religious minority audiences are segregating themselves, typifying emergent moral panics around the national loyalty of British-Muslims.

It is clear that if ethnic minority audiences do not get the representation they want from terrestrial public service broadcasters, they are likely to seek the global alternatives of Al Jazeera, Star and Sony television. One justification for this choice is offered by Creeber with the suggestion that 'cable and satellite better reflects the complex cultural and national diversities of contemporary Britain and Europe' (2004: 33). There is, however, considerable doubt that the transnational marketplace alone can adequately address all the citizen and consumer interests that represent Europe's divergent cultural diversity. There is also the question of regulation which is underpinned by a more general concern that, as the media and communication environment diversify, the citizen interest in communication could decline (Livingstone *et al.* 2007). So while for some UK diasporic communities the development of commercial satellite, cable and digital television may actually serve their needs better than a form of PSB developed in relation to the concept of 'bringing the nation together', at the same time there are also problems to do with leaving the cultural needs of ethnic minority communities purely in the hands of commercial broadcasters.

Concluding remarks

My central argument has been that PSB has made available to ethnic minorities a range of opportunities for representation. However, the increasing emphasis on 'integration', motivated by political and economic factors, has had the effect of marginalizing BME communities. But now the challenge from global media organizations is pushing Britain's mainstream terrestrial broadcasters to resolve the tension around how to accommodate both commonality and difference in the name of 'public service'. In many ways, the social and citizen's rights arguments here may already have lost out to the more forceful economic case.

This situation presents a major challenge for a politics of recognition confronted with a variety of social rights. Many attempts by identity-based groups to acquire communication rights in the public sphere have come up against the widespread view from within broadcasting that it is impossible for these rights to be available to all sections of society precisely because of changed economic, social and political circumstances.

Yet the founding principles of PSB were never based on market share but on providing programmes that large sections of the public often didn't actually want to watch. Given that audience size is now the foremost concern for even non-commercial broadcasters, the question of what viewers are likely to

watch dominates how programmes are commissioned, scheduled and marketed. This approach automatically tends to work against what minority or specialist audiences may want or what broadcasters feel they should give them. Hence the question arises: how can the politics of difference be recognized and accommodated within a media culture which aspires to 'sameness'? Attempting to answer this question I suggested that reality programming offers an important resource here, because it demonstrates how market pressures to produce standardized kinds of popular programming do not always have to involve the marginalization of minority representations or the closure of diversity. Reality formats can be analysed in terms of both new modes of populism and attempts to include minority representation. But, as I argued, the reality genre also opens up a set of contradictions, raising further questions about how 'reality culture' mediates discourses of race and signs of racial difference in relation to culturally assimilationist agendas.

The ambivalence of the UK broadcast media's approach to black and Asian representation on-screen indicates acute uncertainty around traditional multicultural principles and practices and a lack of reflection about how they could be superseded in the interests of audiences. Television remains deeply imbricated in the struggle between these two principles of multiculturalism and equal citizenship. How British television represents ethnic minorities gets to the heart of the complicated ways in which we are currently 'living with difference' in Stuart Hall's terms. And as Hall reminds us in his discussion of black arts, race and diaspora, 'Questions of democracy, questions of equality, questions of difference, all have to be resolved' (2007: 151).

The relationship between cultural diversity and PSB is currently in a moment of unsettled negotiation. Challenging 'institutional racism' or 'hideous whiteness' or indeed approaching any kind of cultural equality or diversity of representation still remains a highly politicized, contested and complex issue. PSB in the UK is a key site in the whole process. It is not only where the major debates on representation get focused; crucially, it also highlights the current failure to address adequately the challenges involved.

Notes

1 Dramas such as *White Teeth* (Channel 4, 2002), *Life is All Ha Ha Hee Hee* (BBC, 2005) and *Britz* (Channel 4, 2007), comedy formats such as *The Kumars at No. 42* (BBC, 2001–6), and youth-oriented drama series such as *Sugar Rush* (Channel 4, 2005–6) and *Skins* (Channel 4, 2007) have all been notable examples. We have seen flashes of excellence in fictions such as *Second Generation* (Channel 4, 2003), *Bradford Riots* (Channel 4, 2006), *The Sea Captain's Tale* (BBC1, 2004; part of the *Canterbury Tales* series) and *Shoot the Messenger* (BBC2, 2006).

2 *The Crouches*, BBC press release, 27 August 2003 (www.bbc.co.uk/pressoffice/ pressreleases/stories/2003/08_august/27/crouches.shtml; accessed 13 August 2007).

3 'A Muslim "Digital Ghetto"'?, 16 August 2006 (http://news.bbc.co.uk/1/hi/uk/ 4798813.stm).

Voicing the Community: Participation and Change in Black and Minority Ethnic Local UK Radio

Caroline Mitchell

In a postcolonial landscape, much of the discussion around broadcasting and ethnic minorities has been about their portrayal and (mis)representation by mainstream media. Both public service and commercial broadcasters have proposed various strategies for producing relevant content for particular audiences. They have also aimed to ensure that ethnic minorities are adequately represented in the media workforce (Husband and Chouhan, 1985; Cottle, 1998). However, until very recently in the UK there has been an absence of programme content produced by people who can speak from the direct experience of particular ethnic backgrounds, cultures and religions.

This chapter discusses how marginalized communities may find a voice through community radio. As a broadcaster myself, I have always had a powerful desire to enable people without a representative voice to broadcast and produce. For instance, when I was a new entrant in the radio industry I was very soon aware how few women there were in any of the key positions in radio. Hence I became determined to see how women might get more involved in the industry. This led to my setting up a short-term community station for women called Fem FM based in Bristol, England and I have been writing, researching, training and programme-making in this area ever since. More recently, I have been working on a European training project concerning community radio with migrants, refugees and asylum seekers,

Drawing on my own background in the industry, this chapter charts the history of community radio in the UK and the development of particular types of stations run by and for different ethnic communities. It argues that

community radio offers a context for the empowerment of individuals and groups from black and Asian communities and thus can provide a social, cultural, and sometimes political, platform for diverse and divergent voices. The chapter goes on to consider how community radio programmes are shaped by structures, conventions and economic constraints. Finally it explores how this form of local, participatory and grassroots broadcasting enables minorities to establish conditions from which to speak for and to themselves in their own terms. In this way, I suggest, communities may no longer assume the status that Spivak describes as 'subaltern' where minorities can only be 'the spoken-for' (Spivak 1988). Through a discussion of these issues, the article seeks to demonstrate that community radio offers a potentially open space where people can define and redefine themselves, moving beyond the fixed identities that mainstream broadcasting may impose or reinforce.

Campaigning for community radio

Community radio (CR) only became fully regulated in Britain following the government's 2004 Community Radio Order which established CR as a distinct sector alongside BBC and commercial radio. Under the Order the UK broadcasting regulator, Ofcom, became the licensing body in 2005. By the time Ofcom issued its first report on the new sector four years later, there were 130 stations throughout the UK, available to a possible eight million listeners, and 50 more in the pipeline (Ofcom 2009).

CR stations are not-for-profit organizations usually serving specific geographical communities, both urban and rural, or communities of interest. They aim to be democratically owned and controlled with volunteers participating in both the running of the station and programme making (Lewis and Booth 1989). In other countries with multi-ethnic populations, for example Australia, Sweden and Germany, community radio sectors have been established for at least twenty-five years. It is indicative of the struggle that community radio campaigners, including those representing black and minority ethnic (BME) groups, have had to undertake that it has taken so long to develop their equivalents in Britain. Yet the UK government was one of the first to sign up to the Universal Declaration of Human Rights whose Article 19 states:

> Everyone has the right to freedom of opinion and expression; this right includes the freedom to hold opinions without interference and to seek, receive and impart information and ideas through any media and regardless of frontiers. (United Nations, 1948)

Nevertheless, both Labour and Conservative post-war governments have delayed legislating for community radio often because, as I will indicate, they have been concerned about what non-professional broadcasters will 'do' with the airwaves.

The campaign to develop minority ethnic CR in Britain grew out dissatisfaction with a lack of representation on mainstream local radio programmes,

both from the BBC and commercial companies. The BBC's approach to 'catering for' minority groups has generally been to provide poorly funded, off-peak slots for programmes made by volunteer or seconded producers. Criticising the BBC on these grounds Tsagarousianou has stated that the Corporation 'did not deem it necessary to adopt an empathetic standpoint and to address members of the ethnic communities as citizens with particular communications needs, interests and rights' (Tsagarousianou 2002: 216).

In response, the BBC would no doubt argue that it has an ongoing policy which fulfils its Royal Charter obligation to represent Britain's nations, regions and communities through diversity in programme content and in its workforce. But in this connection, recent radio industry employment surveys provide a useful reality check. By the start of the twenty-first century, only 1.8 per cent of workers in BBC and commercial mainstream radio were black or Asian (Skillset 2004). Most media workers are currently based in London, the North West and South East of England, where the industry employs a low proportion of ethnic minority staff (Skillset 2007). Commentators are critical of how the BBC staff and management have been dominated by a white male culture. Describing how the BBC operates Shamash suggests that 'It has a certain way of working and networking, which determines who gets on. The BBC is an organization where you have to market yourself aggressively and where you need confidence' (Shamash 2000).

As early as 1978, the BBC made an internal recommendation for a London-wide station for black and Asian communities. But it didn't follow through: 'The BBC lost a chance to sidestep in an innovative way the problem of the hugeness of its coverage area' (Lewis and Booth 1989: 98). Instead, the BBC's policy was to allocate to its Radio London station an hour-long magazine programme, *Black Londoners*, on weekday evenings and to present *Reggae Rockers*, a Sunday afternoon show aimed at African Caribbeans plus an hour-long programme in English for Asian communities.

To get a more complex picture of minority broadcasting in the late 1970s–early 1980s period I refer to Mohammed Anwar's 1983 survey of British ethnic minority broadcasting carried out for the Commission for Racial Equality (CRE). This report drew heavily on CRE's ethos of the time about promoting good race relations and reflected its views that, not only should ethnic minorities be fairly represented but also BME audiences required education and information programmes that would enable better integration into British culture and society. From this perspective, Anwar's report criticized the actual situation showing that the majority of relevant programmes were under-resourced, of short duration and broadcast at non-peak times.

Furthermore, there was not only a problem with the BBC. At this time, before the deregulation of radio in 1990, the Independent Broadcasting Authority (IBA) had a statutory requirement for commercial radio stations to provide programming that reflected the make-up of their target audience. However, all such programmes were in off-peak time and the majority lasted between 30 and 60 minutes a week. Nevertheless, they had high listening figures among their target audience which showed that they were needed and

appreciated. The CRE Report noted that in all mainstream radio programming, including the news, there were very few presenters of black or Asian origin – although there was a small amount of BBC programming in Urdu, Hindi, Bengali and Gujarati in local stations around the country which was highly regarded by older generations. Hence one of the report's major recommendations was that there should be space on *all* local stations for daily BME programming (Anwar 1983:70). But this did not happen. There remained a yawning gap in broadcasting provision with ever more pressure to set up different kinds of station that could provide not just an hour a day but have their whole output aimed at specific ethnic communities.

In the same year as the CRE published Anwar's report, the Black Women's Radio Group took part in a survey of London's local radio looking at general coverage of and programmes for ethnic minorities (Mitchell 2000). They found that there was a dearth of coverage of items of BME interest in daytime radio; that there were not enough black reporters and there was a 'lack of respect for different cultures' by presenters which could have amounted to a 'bias' against them (Local Radio Workshop 1983: 130). The Black Women's Radio Group was particularly critical of the way that white presenters handled phone-in guests from minority groups, often siding with views from official sources, such as police representatives, rather than exploring issues from the perspective of black callers. They concluded that there needed to be more broadcast input from community-based groups themselves about their direct concerns. However, the Local Radio Workshop which had commissioned this report and itself made programmes for mainstream local radio was dismissive of attempts to establish community licences, seeing them as a distraction from their own campaign to make the existing BBC and commercial stations accountable and representative of local and minority issues. In addition, the Workshop was strongly opposed to another development of the time: the emergence of unlicensed or 'pirate' broadcasting which it saw as predominantly a tool for promoting the further commercialization of radio (*ibid.*: 8).

From piracy to licensed commercialism

Radio piracy has always been a significant force in Britain for representing otherwise unheard ethnic minority voices. The unlicensed stations of the late seventies and early eighties helped pave the way for the official licences later awarded to stations aimed at listeners with specialist music interests including soul and reggae. Most pirates were based in London, broadcasting music of black origin which at the time had no outlets on BBC or commercial stations (Crisell 1997). These unlicensed stations evinced little interest in the community radio movement (Barbrook 1985). Many did, however, develop a strong community ethos and thus helped to provide role models for those future community stations which were interested in providing more than just a niche music service.

Dread Broadcasting Corporation (DBC) was set up in 1981 in west London and is credited as the first black music station in London. It aimed to be the

first legal one and was the most outspoken about the lack of licences for BME radio. But as a 'pirate' it was also constantly vulnerable to raids from police and regulatory services, particularly, the Department of Trade and Industry. DBC was a music station aimed at the first generation of Caribbeans who had come to Britain in the 1950s and 1960s. Reggae was very popular with this group but the only airplay it was getting at the time was through the Radio London *Reggae Rockers* show. So DBC set out to promote reggae, becoming famous also for its slogans – 'tune in if yu rankin' – and its jingles that made punning references to the BBC. Also known as DBC Rebel Radio, the station was funded through vigorous merchandising of records and clothing featuring a distinctive logo of a Rastafarian 'dread head' in headphones smoking a joint. The station saw itself as primarily 'about' black British music and culture and featured as DJs the rapper and singer-songwriter, Neneh Cherry and Rankin Miss P, the sister of DJ Lepke, DBC's founder, who later migrated to mainstream BBC Radio 1. But the station also took on an increasingly political campaigning edge. One of its several white staff, Mike 'The Bike' Williams, responsible for much of the technical backup for the station, described how the change came about:

> The station had always remained apolitical but we finally realised that we really were being monitored when Botha [the then president of apartheid South Africa] came to London in 1984 at the request of Margaret Thatcher. We were all obviously bitterly opposed to this and we read out a letter from *The Guardian* on air that reflected our views...Barrington Levy's *Under mi Sensa* was on the turntable as Plod [the local police] came over the rooftops and shut us down. (Hakes 2004: 1)

It was later in 1984, soon after this event that the station stopped broadcasting permanently. But by then DBC had acquired legendary local status, both for its promotion of previously rarely aired music and for its campaigning.

People's Community Radio Link (PCRL), which started out as Radio Star in Birmingham in 1982, had a more direct relationship to anti-racism from its inception. Coming in the aftermath of widespread rioting across inner-city Britain in the summer of 1981 that was sparked by heavy police intervention, Radio Star/PCRL offered a channel for the airing of grievances, particularly for black British youth. The station played a similar role during the second summer of riots in the Handsworth district of Birmingham in 1985. It became a 24-hour station broadcasting a range of music of black origin including reggae, funk, soul, calypso and dance oldies, with consciousness-raising anti-racist politics woven into the music programming. Both producers and audience were largely British-born and immigrant Caribbeans, attracted in the first instance by the station's music playlist. But unlike many music pirates, PCRL also offered news bulletins, health information and phone-ins on political subjects, such as discussions on the rise of far-right nationalist groups and the role of campaigning organizations such as the Anti-Nazi League, in challenging them. In these ways the station was involved in raising political and social

awareness within its own local area. And besides its broadcasting role, PCRL was also heavily engaged in inner-city fundraising and youth training schemes.

This idea of stations having a role in wider social projects continued to be relevant when the licensed community radio sector was set up. However, in the 1980s stations which broadcast speech programmes that could in any way be deemed by the authorities to be promoting BME interests appeared to come under increased surveillance. Both DBC and PCRL were frequently raided by the authorities and had thousands of pounds worth of transmitters and equipment confiscated. In the case of PCRL, producers were prosecuted for illegal broadcasting and interference with emergency services' radio frequencies and one was banned from holding a radio licence. Despite making applications, neither station gained a licence once community radio was legalized.

In 1985 the Conservative government announced a two-year experiment in community radio, and then cancelled it saying that full legislation was required before licences could be offered. A year later the government abolished the Greater London Council (GLC) which had run a Community Radio Development Unit. This Unit had funded and supported campaigns for community groups such as London Asian Radio and the Afro-Caribbean Radio Group. When the GLC's abolition forced the Unit's closure, an already slight financial and political infrastructure for community radio in London was further weakened.

So when the Independent Broadcasting Authority announced a new set of 'incremental' licences providing for community stations on a commercial model few of the remaining 'pirates' felt they were in a position to refuse to apply. 'Incremental' meant that the licences were an addition to existing local commercial radio but crucially there was to be no distinction made between these new stations and the existing ones: they would all be competing for advertising revenue in the same local marketplace. There would an amnesty for the pirates: providing they came off air by end of January 1989, they would be allowed to apply for one of the incremental licences on offer. The majority of pirates promoting black music and culture complied with this ruling, feeling they had no option. They then found themselves inevitably drawn towards a competitive, commercial model for providing music and information services.

In 1990, 23 incremental station licences were awarded to a variety of small-scale stations which included Black, Asian, Turkish and Greek stations in London, Birmingham and Bristol and one station, Spectrum Radio, in London which allocated airtime to a variety of different language groups including Spanish, Italian and Chinese. But they were set up to 'enhance diversity rather than to promote participation' (Everitt 2003: 16). These additional stations would have to fight for mass audiences in a rapidly deregulated sector: there was no protection from competition with commercial operators or financial support for community radio development and programming.

Already by 1991, when the new Radio Authority took over responsibility for the licensing of commercial radio from the IBA, it was clear that the incremental stations were struggling financially and most were being bought out by

commercial radio groups. A few of the others that survived discovered that survival came at the cost of their community role. A case in point is the former Bristol pirate station, For the People (FTP) Radio. After it transferred to legal broadcasting the station found that the lack of statutory protection for the community participation side of its output meant that programmes that did offer access to 'ordinary' voices from previously marginalized communities were soon axed to make way for programmes that commanded more commercially viable audiences. At the time I was producing a participatory programme called *Vox Pop* for FTP: it was axed under commercial pressure and within a year the sound and content of FTP changed from having a wide range of voices and musical genres on air to broadcasting a tightly run music playlist. The station producers were increasingly influenced by commercial managers from the mainstream commercial radio industry who were drafted in to keep the station afloat. Eventually they bought out the station and reformed it as the commercial music station Galaxy. The effect at the time was to silence the legal broadcast outlet that had been run by individuals from the BME communities in Bristol. It was very clear to me then that, as primarily entertainment-led radio was being further expanded and deregulated, very little value was placed by either government or the broadcasting authorities on the need for a radio sector controlled by and made for grassroots interests and concerns from the BME community.

In the end, none of the original pirates survived the 'incremental' licence system to remain as properly representative community stations. Instead, a new commercial BME media sector was emerging and stations such as Sunrise Radio, aimed at South Asian communities and the wide-ranging Spectrum Radio were receiving revenue from advertisers who welcomed the new opportunity to reach specific ethnic audiences through radio. Thus, describing itself as 'the UK's only multi-ethnic radio station', Spectrum Radio offered 'precision targeting' for 'major brands to get their messages directly to London's key ethnic communities'. As Tsagarousianou suggests, this situation demonstrates 'how the idiom of community...can be used as a vehicle for the success of commercial logic in the ethnic community sector' (2002: 220). While ethnicity had been granted some value in the commercial radio world and some audiences in inner cities were now able to hear a slightly more diverse range of languages, music and news, there still remained major sectors which had no access to stations that adequately represented them or their interests. Hence, the continued concern to keep up the campaigning pressure for a different type of community radio.

Moving to 'third-sector' local broadcasting

Throughout the 1980s and 1990s the Community Radio Association (subsequently, the Community Media Association) was campaigning for a separate and distinct third sector of radio. The new Radio Authority introduced another form of licensing, the Restricted Service Licences (RSLs), whereby short-term stations could be established for up to four weeks a year. These

offered opportunities to try out new formats and cover special events, allowing groups time to develop their broadcasting and management expertise as well as relate to new audiences. Notably, RSLs were used by Muslim organizations during the month of Ramadan to broadcast programmes in English and other relevant languages about religious practices and women's issues (produced by and for women) and music shows for young people. In 2001, the first year of the scheme's operation, the biggest reason for RSL applications was religious (Bodi 2002). By 2005 there were 36 RSL stations and in each RSL area there was competition for frequencies. As Rigoni argues, the new 'Ramadan' stations served to bring 'new opportunities of citizenry' to minority groups (2005: 563).

Meanwhile, lobbying continued with renewed effort following the election of the Labour government in 1997. In 2002, the Radio Authority set up the Access Radio Pilot Scheme, describing it as a 'pioneering experiment of not-for-profit radio'. This experiment finally recognized a third sector of radio, different from both mainstream BBC and commercial radio. Out of the 15 stations awarded licences, seven were totally run by and for specific minority ethnic groups. These included New Style Radio an African-Caribbean station in Birmingham, Desi Radio, a station for the Punjabi community in Southall, London and Awaz FM aimed at Asian communities in Glasgow.

The government agreed to extend the period of the pilot and after it was independently evaluated as a success, the 2004 Community Radio Order legislated for the continued existence of this new sector (Everitt 2003). Following the abolition of the Radio Authority in January 2004 it was now to be regulated by the Office of Communications (Ofcom). Under the Order, community radio was described as a separate sector that was non-profit-oriented and could receive public funding and limited amounts of advertising. Central to this new notion of British community radio was the statutory requirement that stations must demonstrate how their on-air programming and related off-air activities, such as training and community development, would benefit their key audiences through what the Order described as 'social gain'. Applicants had to define in advance how they intended to deliver 'social gain', for instance, by showing how the station would attempt to reach an under-served audience, facilitate discussion and the expression of opinion, provide training for volunteers and enable 'the better understanding of the particular community and the strengthening of links within it' (Ofcom 2004: 1). Understanding its audience and close involvement with its local communities had always been the hallmark of BME community radio in both its licensed and unlicensed forms and could now be developed under the requirements and regulations of Ofcom. By 2007, about 30 per cent of the new Ofcom-licensed stations were wholly owned or run by a specific ethnic minority, religious or cultural group.

Three main models for this type of community radio have emerged. First, stations catering for one particular ethnic group. For example, Voice of Africa Radio, based in the London borough of Newham. This describes itself as a 'pan-African' station for all people of African origin, broadcasts 24/7 and offers advertising for local businesses. A second community model offers

individual programmes made by various representative local groups – some in mother tongue languages. An example here is Bradford Community Broadcasting (BCB) which was originally part of the Access Radio scheme and has broadcast since 2002. It now offers programmes in 12 different languages including Arabic, Punjabi, Kurdish and Polish. It also carries several music programmes based on genres traditionally associated with black and Asian people. Broadcast in English, these shows have achieved a wider, more diverse appeal for their music. Several of BCB's daily programmes have presenters from minority ethnic groups and there is also a team of community news reporters based in specific areas of Bradford. The station is funded from a wide variety of sources including the Home Office's Connecting Communities project, the local Council and the lottery – as well as receiving EU money.

The third model relates to projects that promote a particular religion and its related cultural and social activities. Dawn FM, a Sunni Muslim station based in Nottingham, is a typical example. This is run by the Karimia Institute, a local Muslim community organization. The Institute originally operated a 'Ramadan' station with a restricted-service licence. It was then involved in the pilot access scheme as one part of Radio Fiza. The other part was run by the Nottingham Asian Women's Project which went on to broadcast as Faza FM. Now with a permanent licence to broadcast, the Karimia Institute runs Radio Dawn as the flagship project for its community activities which include running a nursery, a Qur'anic school and Arabic classes. It broadcasts in at least six languages: English, Urdu, Arabic, Bengali, Somalia and Pashtun, carries news and comment on both local and national events, is part of the local Christian–Muslim Forum and broadcasts lectures from leading Muslim scholars.

'Giving a voice to the voiceless' – some issues

The three models I have exemplified are indicative of both the wide programme remit of community radio and the participatory aspirations of ethnic minority audiences. Mainstream representations of ethnicity have too often tended to assume that BME audiences are unwilling to participate in any aspect of broadcasting other than as 'just' listeners (the BBC model) or as 'just' consumers (the commercial model). Based on these mistaken assumptions, local broadcasting has too often provided stereotyped and homogenized programme content for its BME audiences.

I would therefore argue that the significance of the post-2004 community stations is that they hold out the possibility of what Tsagarousianou calls 'ethnic community (self) definition' (2002: 226). Community radio can broaden media representation with creatively useful definitions of communities. Self-definition may be through having control over the station as a whole by holding the licence or it might mean having control over particular programme content. Take my earlier example of Bradford Community Broadcasting. Under its Community Reporter Scheme, reporters are based in nine different areas of the city and have first-hand experience of particular

local ethnic groups. They have been trained by the station to contribute to daily news programmes and features. There is thus the potential to build up a relationship with people and events in a news patch that is very different from mainstream radio reporting. Traber defines such local communicators as 'native reporters' and suggests:

> [Their]...value lies not in their role as message-creators for a passive audience, but as members of a community whose work enables the whole community to come together, to 'analyse one's historical situation, which transforms consciousness, and leads to the will to change a situation' (Traber 1985: 3; also cited in Atton 2004: 35)

Traber's reference here to 'the will to change' relates closely to the polemical notion of 'giving a voice to the voiceless'. These are central tenets for all community radio campaigners, whether academics or practitioners (Girard 1992; Lewis 2006). In practice this could mean anything from broadcasting information in a mother tongue language so that a particular group is enabled to participate more fully in local life to using the radio to campaign for better conditions for factory workers. There are also many examples of how radio stations have empowered individuals. This is what a station manager from ALL FM, a community station in Manchester, had to say in 2007, introducing a statement from one of the production volunteers:

> Before she joined ALL FM ...she felt as an immigrant she had no voice. Now through community radio, she says she feels valued and it has opened doors: 'Although we don't get paid as radio volunteers, by doing it we gain a lot. Community radio has taught me a broad range of skills – now it's up to me what I do with them'.

Community radio has the potential to develop people within and beyond radio – as case studies on the website, www.comedia.com indicate. However, it is also the case that morale and confidence can be affected by conflicts within stations, particularly differences relating to perceptions of what audiences 'want' (Mitchell 1998).

In her study of women in local radio, Qureshi examined how young Scottish-Pakistani Muslim women tried to carve out a broadcast space that was both acceptable to them and also to the management team of their temporary community station. The women produced a magazine-style programme for young women with popular Asian music and features on subjects such as, 'women's safety; women back to work; and health, diet and "beauty"' (Qureshi 2000: 183). Qureshi found that there was management pressure on the producers concerning what it was deemed 'acceptable' for young women to talk about: for instance discussion of post-natal depression registered as a potentially taboo broadcasting topic.

The young producers initially resisted the pressure and questioned the traditional discourses that were working to position them. Management then gave

them the choice: change the programme time to one where fewer people listened or keep the popular evening slot and avoid serious discussion of apparently contentious subjects. Feeling unsupported by the station the women discontinued their broadcasts. The station was at the time lobbying for a full-time licence and therefore sensitive to the possibility of 'alienating' listeners and sponsors. Qureshi interprets what happened as an attempt by the producers to 'negotiate their own definition of gendered identity' (*ibid.*: 182). Although in this case the women continued to campaign together in the community, their 'voice' was effectively silenced on radio as a consequence of the conflicting demands and needs of regulators, audiences, station managers and community producers.

New technologies have made production more accessible and portable and adult and media educators have worked with community partners to design courses and ways of reaching particular groups so that they can have access to the airwaves (see also Mitchell and Baxter 2006). Nevertheless, the process of finding a voice through community radio also brings with it quite concrete and practical problems. For a start, it requires considerable personal commitment to learning the skills of radio production: how to record interviews, how to edit sound, how to get the best from the community's resources of stories, memories, information. Production can be a lengthy business and bring people into sharp conflict around questions of professionalism and quality and different perceptions of audience's views.

Finally, the notion of 'giving a voice to the voiceless' needs to be used with care to avoid the assumption that before the advent of local media BME communities simply lacked *any* recognized voice/s.

In 2006 the Department of Culture, Media and Sport (DCMS) commissioned a report to evaluate the future of community radio. In one section it praises the Punjabi Southall station, Desi Radio, in the following terms: the station 'has a strong presence in its community and is seen as an important communicator *for the largely silent* [my emphasis] Punjabi community that it serves' (Goatley 2006: 22). As it happens, Punjabi is the second most spoken language after English in the UK. So it was obviously already widely heard but, until stations like Desi Radio came on air, it lacked the public legitimacy and representation that its numbers of speakers were clearly entitled to expect. So community radio made 'speaking for ourselves' possible, *not*, as the DMCS Report insultingly implies, as if for the first time, but at a new level of civic participation.

Radio can indeed have a dramatic impact on previously 'dispossessed' languages as the example of Ireland demonstrates. Combating the corrosive effects of English imperialism's past attempts to ban the Irish language, the state broadcaster of the Republic of Ireland, and more recently its community media, now broadcast in Irish as a matter of routine. In Northern Ireland, which is still linked to the UK, BBC Radio Ulster broadcasts just one half-hour Irish language programme per day. However, one of the newly licensed stations, Raidió Fáilte, based in the capital city of Belfast broadcasts entirely in the Irish language. Although aimed primarily at the Irish-speaking minority,

it also offers Irish classes and aims to challenge sectarianism by representing both the Protestant and Catholic traditions. It thus offers an example of how the linguistic impact of having a voice may also reverberate politically in post-colonial situations.

Concluding remarks

My concern in this chapter has not been simply to consider whether or not the marginalized can speak or broadcast. It has been to demonstrate how third-sector radio offers opportunities, clears spaces, creates conditions, for local communities to speak for and to themselves. Confronting Spivak's crucial question, 'Can the subaltern speak?' (1988), community radio provides a medium through which people belonging to a wide range of ethnic, religious, cultural and linguistic minorities can define and communicate their identity and culture in a self-determined and self-controlled way. The need is then for people to *find* their voice rather than adapt to the one that is 'given' them. This process helps ensure that a respect for both hybridity and heterogeneity is retained.

Through this new sector of broadcasting more people from minority ethnic communities are enabled to produce narratives about their lives, interests and concerns – both through programme making and through the related practices of community development and training. Voices can be articulated through the individual enthusiasms of volunteer presenters and producers – and also, importantly, through the collectivities they represent: community groups, workers' associations and unions, youth projects, writers' groups, women's groups or places of worship. In this chapter I have documented a long period of campaigning by BME activists to set up self-directed and representative stations, licensed and unlicensed. Through the recent establishment of a legal sector of community stations with democratic structures and training, people may now have more control over what they do with radio: express opinion, display creativity and actively participate in all forms of production.

If a multicultural society based on the full recognition of difference and diversity is to develop, then I would suggest one final advantage of the new third-sector radio. A station is not required to regard its audiences as commercially pre-defined 'targets'. It therefore has no need to assume that those audiences are immediately and obviously 'knowable' and a more complex discursive relationship can be constructed between a station and the communities it serves. In the case of BME broadcasting, there is thus active potential for articulating identities within and between BME communities and for those self-definitions to be confidently relayed to majority Britain.

Chapter 6

From Mosque to YouTube: UK Muslims Go Online

Gary R. Bunt

This chapter explores ways in which the internet articulates Muslim experience and expression in the UK. It discusses how the internet has established a forum that offers information, discussion and reflection for different Muslim communities. It surveys the internet landscape to determine its key participants and consider the diverse ways Muslims present themselves online. The internet has become a critical adjunct to how many Muslims in the UK both perceive and represent themselves within communities and networks. In this chapter I want to explore the broad cyber spectrum: from the networking webpages and blogs of individual Muslims to the macro-level of how Muslim networks and organizations present themselves on websites or through social and political networking.

In earlier work I introduced the concept of *cyber Islamic environments* to describe online activities that can be understood as having an Islamic/Muslim ethos. Such activities could range from seeking fatwas via online religious authorities to social networking via chatrooms and blogs (Bunt 2000b, 2009). For technologically literate Muslims online and offline elements may blur together and not every activity they initiate online will necessarily have an Islamic ethos or even an Islamic edge. Indeed, surfing specific cyber Islamic environments might form but a small component of an individual's wider internet habits.

What is under examination here are complex sequences of digital interactions which raise detailed concerns about how the shapes of Muslim cyberspace in Britain are determined. With each example and case study that I have chosen I will be considering whether it is relevant or feasible to highlight specifically *British* cyber Muslim identities. While some online activities present explicit indicators associated with national or regional identities, these can

also feed into a diverse multiplicity of online and offline identities. In addition, anonymity online obviously creates another level of difficulty, as much for lurkers in cyber Islamic environments as for those researching them.

First, to give a brief idea of the range and availability of internet provision. For instance, some Muslims embrace cyberspace to circulate their religious messages, or as a means of keeping their peers within the authority and information loops of their various localities and communities. They may never want to visit the more internationally oriented sites and go on to relate to such leaders of the global Islamic internet marketplace as *Islam Online* and *IslamiCity*. Meanwhile, traditional Muslim print media such as *Q-News* and *Muslim News* and a variety of Muslim social welfare organizations, educational platforms and charities have all recognized the importance of maintaining a web presence. In addition, the growth of the 'green pound' has encouraged Muslim financial and business sectors to engage fully with the digital age.

The information marketplace is an intense, dynamic and competitive one. Islamic content must always contend with many other forms of online activity, especially among net-literate Muslim youth. Muslim organizations and web content providers in the UK therefore attempt to ensure that their content is responsive to innovation in order to compete with the formats of chat and entertainment that dominate most contemporary youth agendas.

Both Islamic organizations and individual Muslims have long recognized that the internet can influence how their communities are perceived. Hence the study of online content has a direct bearing on the understanding of how Islam is represented and interpreted in the UK. Internet representation takes many forms: news, commentaries on current affairs and political and religious campaigns are key. In addition, Islamic educational foundations and special-interest platforms invest considerable time and resources on their own digital programmes of study. Outside these more traditional paradigms there is also a high degree of interactivity and networking which is not connected to specific organizations or platforms but is driven by the formation of alternative online affiliations

How have these evolving digital lifestyles and technologies impacted on cyber Islamic environments? One approach is to look at the way designers seek to capture the attention of web-literate generations already familiar with gaming technology and phone texting. Internet content accessed and generated on mobile phones facilitates user flexibility and confidentiality and thus makes new demands on Islamic content providers to create new formats. There is also competition from more high-tech and glossier sites originating outside the UK such as those associated with Islamic so-called 'preachers', Yusuf al-Qaradawi, Amr Khaled, Hamza Yusuf and Mustafa Hosni. Content appears and disappears regularly and can be reproduced offline. It circulates with a viral intensity and rapidity that raises new questions about what I call 'the dynamics of understanding' in examining how Muslims represent themselves to themselves and to non-Muslims.

As the internet is increasingly integrated into the ways Muslims in the UK

receive and impart information about Islam, one of these questions concerns the very persistence of 'the digital divide'. This creates inequalities of communication and understanding, particularly for those socially and economically deprived communities without internet access or the requisite media literacy. Another set of questions relates to the delegitimation of authority. When sermons can appear online, bloggers post from their phones and there is access to information way beyond traditional knowledge boundaries then conventional Muslim authority networks are presented with significant challenges.

The traditional Islamic concept of a single global community, or *ummah*, has long been drawn upon by Muslim internet advocates as a rationale for their activities (Roy 2004; Mandaville 2001). Yet what we also need to grasp is that, paradoxically, the internet can serve to exacerbate division rather than promote cohesion. For instance, online sermons may emphasize sectarian differences based on certain interpretations of Islamic sources. These accord the status of 'unbeliever' to other Muslims and hence consign them to divine punishment. The proponents of such views may not be in the mainstream of Muslim authority in the UK, but internet media can amplify their influence. The pro-jihadi output of Omar Bakri Muhammad and al-Muhajiroun, Abu Hamza al-Masri and the Supporters of Shariah illustrates just how the internet can intensify and inflame conflict between and within different dynamics of Muslim understanding.

There are no simple paradigms operating here – especially in the areas associated with religious authority, and the edicts and opinions (fatwas) generated by Muslim scholars. Those seeking answers to specific issues requiring a solution based on interpretation of Islamic sources use the internet to go beyond traditional authority models and influences, in some cases breaking long-standing paradigms associated with cultural and religious affiliations. For instance, they may raise questions about personal law, marriage, divorce and relationships. There is also a developing trend towards 'shopping around' or Googling for an opinion that fits individual personal circumstances and requirements, using internet databases as well as petitioning for a specific personal answer to a question. In all such ways the internet can act as a catalyst for change in relation to social values, religious ideals and political understanding.

These examples demonstrate how internet usage has encouraged a new fluidity in the understanding of the nature of Islam and what being a Muslim may mean. I want now to consider in more depth some of the implications for Muslims of diverse online identities before going on to examine specific examples of social and political networking and the controversies surrounding jihadi and other campaigning websites.

UK Muslim identities online

Muslim communities have existed in Britain since the nineteenth century. They were first based around port communities like Cardiff, London,

Liverpool and South Shields. The majority of Muslims in the UK can trace their roots to the 'pioneer' generations of Muslims from the former British Commonwealth who came to the UK in the 1950s and 1960s. (Geaves 1999)

These pioneers were usually young single males intending to work in the UK and then return to their places of origin. New networks of obligation, the development of businesses and families and shifting personal circumstances influenced many to remain in the UK. The movement of refugees and economic migrants in later decades further determined the complex diversity of Muslim identities in the UK. One indicator of the presence of Muslims was the 2001 British Census: in response to its question on religious affiliation, 1.6 million people described themselves as Muslim.

Within this diverse population group located throughout the UK the multi-faceted identities of Muslim groups and individuals become magnified by cyberspace and in some cases actually mutate. This is because the internet inevitably represents Islam as linked to *specific* Muslim contexts offering different political and religious approaches to identity. A range of concepts associated with the nature of individual religiosity can be attached to the Muslim label. Further, for many so-called British Muslims, the label 'British', or even the label 'Muslim' itself, may not be a priority – indeed, some may think that the two labels are mutually incompatible (Ansari 2004; Lewis 2007 and Nielsen 2004). On the other hand, the term 'British Muslim' may be an acceptable self-identity which can coalesce with specific regional and cultural identities, such as 'Bradford Pakistani Muslim' or 'London Somali Muslim' or can be integrated into frameworks associated with 'European Muslims', 'Muslim minorities', and/or 'western Muslims'. There is even a website dedicated to those who choose to represent themselves as 'ex-Muslims'.

I suggested earlier how sectarian differences around some identities might be exacerbated in cyberspace. But there are also contrary examples. The British-Muslim identities of Barelwi and Deobandi, for instance, are two distinct, and often mutually hostile, forms of Sunni Islam, both having roots in the Indian sub-continent. Through the social networking site Facebook an attempt was made to end the animosity between them by setting up reconciliatory pages for discussion. Also through Facebook, another online group attempted to reduce the conflict and tension between Sunni and Shi'a Muslims, which had dramatically worsened since the 2003 invasion of Iraq.

Even in this brief overview, it is clear that no single paradigm can be attached to the label 'British Muslim' and that online identities associated with specific regional, ethnic, cultural, linguistic and/or religious groups are not always clear. Further contributors to social networking sites or discussion lists are frequently anonymous, and participants may be reluctant to provide personal details. This may be for reasons of personal security, especially when avatars have distinctly different online activities from their real life owners. Avatars may also be required for any male–female dialogue and for discussions around sex and sexuality (Bunt 2009). On the other hand, some

Muslim-oriented websites associated with dating, friendship and matrimonial agencies can be quite specific about personal identity – providing photographic detail and revealing data such as names, locations, religious adherence levels, and even perceived social class.

Social networking sites like MySpace, Bebo, MuslimSpace and Facebook can offer new possibilities for younger Muslims by providing spaces where offline social and cultural barriers are lifted. The elders, including parents, guardians and religious leaders, may not use these sites, or even be able to access the internet, and are therefore unable to control or monitor activities in the way that they would in the offline world. Elders may not be able to communicate in English, and be familiar with the new terminology and slang of the net.

While it would be wrong to suggest that net usage is generally not intergenerational, family elders may be unaware of the online avatars adopted by family members or know about the secure areas of the World Wide Web. Thus traditional lines of authority can become distorted. An extreme example here is the case of Hammaad Munshi, jailed for two years in 2008 under the Terrorism Act 2006 for creating or possessing internet materials for the purposes of terrorism. He is the grandson of a senior Islamic scholar from Dewsbury, Sheikh Yakub Munshi. Sheikh Munshi commented at the time:

> All of us feel there are lessons to be learnt, not only for us but also for the whole Muslim community in this country. This case demonstrates how a young, impressionable teenager can be groomed so easily through the internet to associate with those whose views run contrary to true Muslim beliefs and values. (BBC News, 'Computer terror teenage jailed', 19 September 2008)

But jihadi dialogues and activities are not typical of British cyber Islamic environments. My main contention remains that the internet offers UK Muslims in the UK, whatever their own cultural and religious orientation, an extension of social mobility. It creates the digital spaces that take both users and providers outside their traditional, geographical and cultural settings and posits alternative identities to engage with.

While non-Muslim public opinion focuses on the possible impact of the jihadi websites, the actual Islamic market leaders are the websites I referred to earlier: *Islam Online* and *Islamicity*. These have international audiences and promote traditional Muslim knowledge frameworks and particular ideas of the sacred (Bunt 2000a: 354). Other key sites are those belonging to Islamic political parties and organizations which create wide globalizing platforms and campaigns. These may often have a specific regional–cultural focus, such as the sites that encourage UK Muslims to retain and reinforce their links with their ancestral homelands. In summary, as miriam cooke and Bruce Lawrence observe:

> Precisely because Islam is not homogeneous, it is only through the prism of Muslim networks – whether they be academic or aesthetic, historical or

commercial – that one can gain a perspective on how diverse groups of Muslims contest and rearticulate what it means to be Muslim. (cooke and Lawrence 2005: 2)

I have been examining how the internet works as one such 'prism', developing online individual identities in all their heterogeneity. I will now go on to consider the internet's impact on a broader scale, examining more closely at Muslim on- and offline communities.

Online communities and infrastructures

I want to look at the impact of digital technology on pre-existing Muslim community infrastructures and how e-connectivity has made them less fragmented, more 'wired' to the world. In the UK the focus of the Muslim community is typically the mosque. This functions, not just as a place of worship, but as a significant cultural and community centre too. I will present a brief survey, offering examples of how the larger UK mosques use their websites to provide a window on their everyday activities.

The website of the main Birmingham mosque, for example, carries local information, a list of prayer times and a library of propagation documentation. While the London Central Mosque also includes in its net listings details of its nursery, the Nikkah (marriage contract) ceremony and health education and the East London Mosque in Whitechapel uses its website to give its own take on current affairs. Greenwich Islamic Centre's website offers an ambitious mix of video clips of children singing religious songs, streamed prayers from Mecca, local community information, Qur'an downloads and details of plans for its mosque development. During Ramadan 2008, it provided an account of activities during its own *taraweeh*, or community prayers. Finally, there is the example of the website of Leeds Grand Mosque. This details prayer times, lists members of committees and offers children's quizzes and information on mosque services such as funerals, sermons, marriage ceremonies and prayers. Leeds, like many of the big city mosques, also disseminates its regular Friday sermons in English-language versions so that they can be accessed by Muslims whose first language is English but also with the aim of appealing to non-Muslims and hence contributing to a demystification of Islam.

In the early days of the World Wide Web more quietist Muslim groups were reluctant to use the internet. They preferred to work through small cells of supporters and deprecated the evangelical diffusion of online Islam being advocated by other groups. But an increasingly pervasive awareness of the need to explain Muslim activities to others, if only to counter criticism and hostility, overcame this resistance.

Such was the trajectory of the Tablighi Jamaat movement in the UK. This traditionally quietist and non-political Deobandi community was founded in the Indian sub-continent in the 1920s. It now has a global presence, but continues to emphasize the propagation of Islam as its central focus (Bianquis

et al. 2008). In 2007, a branch of Tablighi Jamaat made the internet its central tool for a public relations campaign on a proposal to build a 'mega-mosque' in Newham, east London (Fox-Howard 1997). Their website attracted wide mainstream attention by providing clear explanations of the movement, links to videoclips on YouTube, photographs of the proposed site, planning details, and a message of support from London's then mayor Ken Livingstone. A linked Facebook page sought to encourage surfers to join its network, and sign a petition in support of the new mosque. This example reflects a global pattern of cyber Islamic response: religious authorities recognize their power is being usurped or challenged by online platforms and interlopers and realize that the situation necessitates an urgent engagement with the very digital media they might previously have distrusted.

UK Muslims and networking sites

The growth of social networking sites has encouraged Muslims to represent their identities online alongside their other interests. Facebook, for instance, contains numerous networks for UK Muslims. The network, British Muslims & Bloody Proud of It! has presented itself as, 'a group for British Muslims, who are quite content being just that'. Muslims United Against Terrorism (MUAT), with over 1,000 members, set itself up as a 'group is for all people who are against terrorism and for Islam, since terrorism has nothing to do with Islam'. One contributor asked, 'How come there are only 1000 people against terrorism? Where are all the other muslims in facebook? This is pathetic!'. There could be many answers to such questions. For instance, the lack of a Muslim presence is not necessarily indicative of apathy; the Facebook group may have been interpreted as overly apologetic. It might not have received enough publicity to encourage participation; it may have had links to organizations or individuals which visitors, and potential members, did not 'approve' of.

A feature of many Muslim Facebook networks is the discussion forum, sometimes with a distinctive political edge. In early 2008 the Young Muslims UK (YMUK) Facebook had 565 members. It offered networking workshops and links to external sites. YMUK can trace its roots to the Jama'at-e-Islami, a Pakistan Muslim political party, which itself was influenced by 'reformist' movements such as the Muslim Brotherhood. However, YMUK has also forged a distinct contemporary UK identity with the internet playing a critical networking role for local branch members and promoting communal youth activities such as the annual *Living Islam* event archived on YouTube (Living Islam, 17 March 2008).

The most prominent national Muslim organization in the UK is the Muslim Council of Britain (MCB) (see Figure 4), which has a highly developed online presence. Since its inception in 1997, the MCB has sought a role for itself as intermediary between UK Muslims and governmental agencies. This has caused suspicion and resentment from those Muslims who see the MCB as, in Peter Mandaville's description, 'too conservative in its views and beholden to

an older generation of Deobandi and Salafi-influenced leaders' (2007: 295). In this context, the term 'Salafi' is used in the sense of referring to movements or individuals associated with the 'renewal' or 'reform' of Islam. For several years, the MCB's website has sought to convey an impression of unity within British Muslim communities, with itself as the hub. But although it recently provided a listing of over approximately 200 associated Muslim organizations on its website, it also excludes groups outside the mainstream of Sunni orthodoxy, such as the Ahmadiyya, viewed as a 'schismatic' sect whose inclusion could alienate more mainstream members.

The MCB site projects a specific 'British Muslim' identity. For example, in 2003, it highlighted a photograph of a young girl in hijab, superimposed on the British Union flag. As part of its general explanation of Islam the site presents a detailed history of Muslims in the UK. It also promotes a number of public relations campaigns, including Islam is Peace, with the slogan, 'Proud to be a British Muslim' and a series of slickly produced videos. The MCB's condemnation of the presumed Islamicist attacks on Glasgow Airport in 2007 elicited positive responses from visitors to the site's guestbook.

The second most influential UK Muslim organization, also established in 1997, is the Muslim Association of Britain (MAB). This came to prominence in 2003 with its vocal opposition to war in Iraq. The MAB established alliances with many other opponents of the war, from a range of religious, cultural and political backgrounds. It has been 'accused' of having affiliations with the Muslim Brotherhood but, as Mandaville points out, there are many interpretations of the history and ethos of the Brotherhood, by no means all negative or implying threat (*ibid.*: 295). While lacking both the scale of MCB and its resources, the MAB has been able to mobilize actively through the

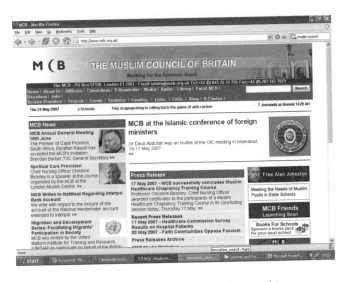

Figure 4 Muslim Council of Britain (www.mcb.org.uk)

internet, and its multimedia strategy offers audio Islamic material online, together with a series of e-books, some relating directly to campaigns around Iraq.

Other groupings provide a voice for those who feel unrepresented by either the MAB or MCB. The British Muslim Forum (BMF) was established in 2005, with a website as its central focus that promised content in Arabic, English and Urdu, although only the latter two languages were represented. Its 298 members group of mosques and organizations was originally based in the Midlands and the north of England. But in May 2007, it announced a UK-wide inaugural event on behalf of a new Mosques and Imams National Advisory Board (MINAB), in conjunction with MAB, MCB and the (Shi'a) Al-Khoei Foundation. This included the publication of a Good Practice Guide for British Imams and Mosques (British Muslim Forum, 30 May 2008). As part of a site redesign in 2008, the site's logo notably integrated the British Union flag with the Islamic symbol of the crescent moon (www.bmf.eu.com).

The establishment of the Sufi Muslim Council (SMC) (see Figure 5) in 2006 offered a different perspective: it focused on the esoteric dimensions of Islamic interpretation and ritualistic practice. The SMC was launched in Westminster, with MPs, politicians and leaders from other religious beliefs in attendance. In a detailed mission statement, *About Us*, the SMC's website explained its specific form of Sufism, while also condemning forms of extremism and promoting tolerance and civic duty. But the SMC has received critical comment on- and offline about its relationship with the government, its funding and its ideological orientation which has been described as 'neo-conservative.'

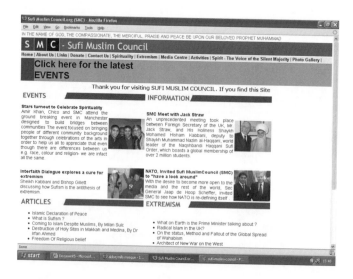

Figure 5 Sufi Muslim Council (www.sufimuslimcouncil.org)

A major focus of online discussions between Muslims concerns the Islamic caliphate and questions of religious leadership and authority. The 'caliphate' concept has elements of ambiguity that reflect different historical, religious and political interpretations. 'Caliph', from Arabic: *khalifah*, refers to the 'successor' or 'deputy' of the Prophet Muhammad. Historically, the caliphate has been a means whereby Muslim leaders legitimated themselves and their activities in different cultural and religious contexts (Esposito 1998; Berkey 2003). In current times Muslim activists have used the internet to promote the caliphate as a key adjunct of their quest for a form of global Islam. This quest *may* challenge and confront modern notions of a sovereign nation state and *may* also incorporate a commitment to violence for achieving political ends. But, as their differently nuanced webpages make clear, although the caliphate has clearly been a reference point for any number of so-called 'pro-caliphate' organizations, including al-Qaeda and Hamas, they cannot all be read off as if they do share the same confrontational objectives and violent strategies.

In all the cases I have discussed, the ever-expanding cyber presence of UK Muslim organizations is directly linked to their offline, real-world, political and religious affiliations. The internet thus serves as an immediate link between these organizations and such constituencies as mainstream politicians and national media – as well as members of actual Muslim communities. Besides serving as a public relations exercise, some sites act as an entry point for interpretations of Islam, whether at the introductory level or by offering advanced Qur'anic exegesis. There may also be an evangelical function here: using the internet as a means of acquiring and encouraging converts, either to Islam, and/or to a particular world-view associated with the religion. However, a failure on the part of some of these sites to present themselves effectively to the most web-literate sectors of their constituencies, in particular the under-30 generations, suggests that some revision of format and content is required. The limited appeal of such sites may have led some of the young people seeking knowledge about Islam getting diverted onto the more attractive, web-responsive sites that present themselves in dynamic activist terms – in particular those advocating jihad. It is these 'jihadi' sites that I will consider next.

UK jihadi voices

During the 1980s and 1990s, exiled Islamic activists established offices in the UK. The political and religious manifestos of these groups encouraged a new appellation of the capital city: it was ironically dubbed 'Londonistan' (Wiktorowicz 2005) by those who read the manifestos as unproblematically advocating that London become a central hub for militaristic jihad. The concept of 'jihad' derives from the Arabic term meaning effort or struggle on behalf of God and Islam but which the mainstream media often render simplistically as 'holy war'. Undoubtedly some groups were set up to promote a globalizing message with an overtly violent aim and, after their previous reliance on fax communication and print media, took early advantage of the

new information superhighway to do so. More recently, online chatrooms have emerged as important forums for debating the religious authority for different types of jihadi action, whether militaristic or not. It is clear from evidence presented in recent British court cases that some young Muslims were radicalized by exposure to extremist chatroom sites and jihadi message boards declaring responsibility for such events as the '7/7 bombings' that took place in London on 7 July 2005.

Prosecution of jihadi activists in the UK courts has reinforced awareness of the impact of the net on online jihadi discourse. The case of Babar Ahmad in 2007 was a complex and long-running example of the prosecution of an individual, in relation to the production and publication of internet materials. Ahmad was accused of running websites to raise cash and recruit fighters for both the Taliban and Chechen organizations. Although he faced no charges in the UK, Ahmad was alleged to be associated with a website called Azzam Publications in London (Bunt 2003: 67), and the US government attempted to have him extradited. He was still appealing extradition in 2008 while a website campaigned for his release and a 'Free Babar Ahmad' rap video was posted on YouTube.

A second case of online postings leading to prosecution was the work of Irhabi007 or 'Terrorist 007'. It included materials produced by al-Qaeda's media production unit, al-Sahab ('The Cloud'). The September 2005 posting claimed responsibility for the 7/7 bombings, juxtaposing film of one bomber with filmed statements from al-Qaeda's Ayman al-Zawahiri. Following a series of arrests in 2005, Londoner Younis Tsouli was convicted of being Irhabi007 in 2007. Under the 2006 Terrorism Act, he received ten years for inciting terrorism, subsequently increased to 17 years.

Critical to the case, and crucial to some of the subsequent acquittals, was the issue of whether mere possession of jihadi material was sufficient to necessitate prosecution. Politicians and legislators were required to reflect on how they were redrawing the parameters of freedom of speech in the post 9/11 context. In a separate case, in February 2008 five men had convictions quashed by the Court of Appeal for possession of jihad-oriented materials, including sermons derived from internet sources. The original convictions had been based on s. 57 of the 2000 Terrorism Act, which stated in its opening clause that:

> A person commits an offence if he possesses an article in circumstances which give rise to a reasonable suspicion that his possession is for a purpose connected with the commission, preparation or instigation of an act of terrorism. (Office of Public Sector Information 2000)

One of the defendant's solicitors, Saghir Hussein, commented:

> This is a landmark judgment in a test case over the innocent possession of materials, including books and speech. It was very difficult in the current climate for any jury to decide on anything apart from conviction. However,

a more detached and informed court has recognized the draconian nature of Sections 57/58. This will have implications for other cases, such as those alleging the glorification of terrorism. (Times Online, 13 February 2008)

The appeal successfully argued that this ruling allowed people to explore aspects of their religion, without fear of prosecution. The judgment held implications for earlier convictions and similar prosecutions. It was also significant for the many jihad-oriented groups and individuals that use the internet for fundraising, affiliating with other like-minded groups and promoting specific political–religious understandings of Islam.

Jihadi-oriented individuals have drawn on the internet to legitimize their activities while also using it as a tool for their research and logistics work. Jihadi activity online attracts much sensationalist media attention within a general law-and-order paradigm. But it should also be viewed in the wider context of the tapestry of Islamic discourse, which is often mundane, community-oriented and grounded well below the political and media radar. Furthermore, there is not a simple polarity between jihadi and other interests discussed online: the situation is a more fluid, fragmented and uncoordinated one. This point is evident in the following case study: an examination of the protests surrounding the series of cartoons published in Denmark in 2005. This, my final example, demonstrates that, while there may be a shared understanding of the target of protest, there will be many different online perspectives about how it is articulated.

The Danish cartoon protests

In September 2005 the Danish newspaper *Jyllands-Posten* published a series of Islam-themed cartoons. The 12 cartoons featured in a double-page spread illustrating an article on 'freedom of expression' and including caricatures of the Prophet Muhammad (*Jyllands-Posten*, 30 September 2005). These were immediately perceived by Muslim communities worldwide as an insult to the Prophet. An international campaign was initiated, supported by a website, for an international boycott of Danish goods to be launched, backed by a website. A demonstration in London on 3 February 2006 in support of the protest created much controversy when the media focused on homemade placards with the slogans, 'Behead those who insult Islam', 'Democracy go to hell' and 'Europe your 9/11 will come'.

The internet played a transformative role in the cartoon controversy by turning the issue into a global cause that reinforced Islamic messages with specific political and economic dimensions as discussion was encouraged by e-mail listings, blogs and web forums. Al-Ghurabaa (the Saved Sect), despite its relatively small membership, was highly proactive in organizing the London demonstration and promoted it online, stating that the cartoons:

> carry the death penalty in Islam for the perpetrators, since the Prophet said, 'Whoever insults a Prophet kill him' ...The Islamic verdict on individual or

individuals who insult any Prophet needs to be passed by an Islamic Court and implemented by the Islamic State, rather than individuals carrying out the verdict themselves. (al-Ghurabaa, 'Danish Demo', 6 February 2006)

The al-Ghurabaa website used the cartoon controversy to criticize Muslim communities and leadership, including that of the MCB and MAB, while linking the issue to its take on the global Islamic movement.

A further demonstration occurred the following weekend in London, organized by more 'moderate' groups, including the MAB, and aimed to present a different, more 'responsible' image of Muslim protest. Drawing on its long experience of using the internet for previous demonstrations, the MAB went online to call for calm. But it did cause some controversy itself by comparing the impact of the cartoons with the characterization of Jews over history and indicating the consequences of such stereotyping.

Bloggers also posted reactions to both demonstrations. Indigo Jo Blogs provided a typical eyewitness account of the first February demonstration, uploaded shortly after the event. The account presents itself to mainstream media as a more 'representative' Muslim view: 'I got to the embassy around 2:15pm, to find a collection of what one might call "the usual suspects" outside the embassy: men in kefiyyehs, brandishing black and white flags, with hostile expressions on their faces and yelling stupid slogans' (Indigo Jo, 'Extremists crash the party again (updated)', 3 February 2006). The blog notes a polarization of opinion within Muslim communities about the efficacy of militancy and the risk of increasing anti-Muslim feeling.

Such blogs offered Muslims an opportunity to comment as part of a long-standing, broader, dialogue on cultural, social and religious issues. They utilized a range of languages and linguistic styles – from the colloquial to a measured formality – and integrated different media forms, particularly photographs. The confident use of the internet as a forum for Muslim protest indicates its new significance as a channel for communal expression and mobilization. The cartoon controversy not only demonstrates a new level of internet campaigning proficiency, it also serves to highlight the wide spectrum of Muslim perspectives that are articulated and legitimated through the internet.

Concluding remarks

I have been arguing how, for wired, computer-literate Muslim individuals and Islam-oriented groups, online actions intersect with many aspects of everyday life. But I have also shown that interactivity takes users *beyond* their local communities and family influences, invigorating different connections to religious–cultural knowledge and introducing new interpretations of what being a Muslim means in ways that transcend the stereotypes of homogeneity.

While it's the jihad-oriented individuals and groups whose online forums receive most mainstream media attention, I have sought to demonstrate how shades of opinion associated with Qur'anic interpretation, political views and identities are actually far more nuanced in Muslim cyberspace. Meanwhile,

mosques and other Muslim organizations are recognizing the need to integrate net strategies to contend with alternative perspectives that challenge traditional models of authority.

The examples and case studies I have adduced in this chapter all serve to highlight how the internet has been embraced by UK Muslims as a means to engage within their communities and relate to others at both local and global levels. I have aimed to show how beliefs and identities have been defined and reworked in cyberspace and to explore the implications of internet usage for Muslim life in contemporary Britain.

Chapter 7

What a Burkha! Reflections on the UK Media Coverage of the Sharia Law Controversy

Rosalind Brunt

On 7 February 2008, the Archbishop of Canterbury, Dr Rowan Williams, spiritual head of the Church of England and of the worldwide Anglican Communion gave an evening lecture to an audience of about 1,000, composed primarily of lawyers and academics in the Great Hall of the Royal Courts of Justice. The title of the lecture was 'Civil and religious law in England: a religious perspective'. Despite its being on a topic of no obvious immediate relevance nor pressing general interest, this lecture dominated the UK news agenda before it was even delivered and then for the following week. This chapter asks how that came about. It considers the various forms the ensuing controversy took within two distinct 'public spheres' and addresses some of the postcolonial implications of the news story.

The Archbishop's lecture

First, to offer a brief exegesis. The Archbishop's lecture assumed both considerable knowledge and concentration on the part of its listeners. It contained little redundancy or repetition and was densely and rigorously argued – probably easier to read than to hear. It raised a wide-ranging set of questions about citizenship, community cohesion and adherence to religious traditions and values. It explored the legal and spiritual implications of individuals having multiple identities and hence being accountable not only to the state but also to the norms of culture and religion. The issue the Archbishop then posed was whether a universalist secular law was mature and confident enough to

accommodate other forms of law or belief system. He further suggested that post-Enlightenment western law should not be seen as superseding other traditional legal practices but as 'undergirding' them and thereby serving to guarantee their continued validity.

The Archbishop's main example here was sharia law and various interpretations of it by Muslim scholars and jurists, but he was also at pains to draw similarities with the two other Abrahamic faiths of Christianity and Judaism. His other illustrative examples refer to the positive potential of faith schools in Britain; Canadian law's respect for Native American jurisdiction; professional opt-out schemes such as medical 'conscience' clauses over performing abortions; and the Roman Catholic Church's opposition, which he had supported, to their adoption agencies accepting gay couples.

Although some of these examples would suggest otherwise to secularists, the stance and attitude of the whole lecture is one of liberal tolerance. While demonstrating his own allegiance to a particular faith tradition and not dodging his responsibility to uphold it, the Archbishop speaks the language of cultural pluralism and diversity. The lecture is open-minded and open-ended, with a much-qualified sentence structure; the tone is self-deprecating:

> My aim is only, as I have said, to tease out some of the broader issues around the rights of religious groups within a secular state, with a few thoughts about what might be entailed in crafting a just and constructive relationship between Islamic law and the statutory law of the United Kingdom. (Williams 2008a: 2)

In relation to the major example of sharia law in a British context the Archbishop anticipates a number of objections and problems and argues them through. The key issues he identifies are: the danger of 'vexatious appeals to religious scruple'; the difficulty sometimes of distinguishing between a religious belief and a superstition or prejudice; the complexities surrounding interpretations of 'forced marriage' and 'particularly serious consequences for the role and liberties of women'. Finally, the concern that 'supplementary' forms of jurisdiction may serve to undermine the great post-Enlightenment achievement of a secular state law applicable to all.

The Archbishop's response to these anticipated objections is cast in a language familiar to contemporary cultural studies, the politics of identity and postmodernism. The lecture is against generalized homogeneity – hence, secular law needs loosening from a 'monopolistic framework'. It favours a society based on 'interactive pluralism' and composed of 'diverse and overlapping affinities'. It opposes binarism and wishes to deconstruct 'crude oppositions and mythologies, whether of the nature of sharia or the nature of the Enlightenment'. In conclusion it advocates a model of 'transformative accommodation' whereby both civil and religious law may be changed by a mutually beneficial encounter to the advantage of social cohesion and creativity.

Rowan Williams acknowledges the complexity and difficulty of attempting

such an accommodation. He also does not shy away from issues of fundamentalism, referring several times to those he calls 'primitivists'. However, demonstrating a depth of international scholarship in law, philosophy, anthropology and comparative theology, he concentrates on quoting from those Qur'anic scholars and Islamic jurists who are similarly minded to challenge stereotypical and limited notions of sharia and seek to represent it as a judicial system capable of many cultural interpretations and codifications. Hence the very first problem the lecture tackles is the potential for misunderstanding sharia that exists in the Britain:

> Among the manifold anxieties that haunt the discussion of the place of Muslims in British society, one of the strongest, reinforced from time to time by the sensational reporting of opinion polls, is that Muslim communities in this country seek the freedom to live under *sharia* law. And what most people think they know of *sharia* is that it is repressive towards women and wedded to archaic and brutal physical punishments; just a few days ago, it was reported that a 'forced marriage' involving a young woman with learning difficulties had been 'sanctioned under *sharia* law' – the kind of story that, in its assumption that we all 'really' know what is involved in the practice of *sharia*, powerfully reinforces the image of – at best – a premodern system in which human rights have no role. The problem is freely admitted by Muslim scholars. 'In the West', writes Tariq Ramadan in his groundbreaking *Western Muslims and the Future of Islam*, 'the idea of *sharia* calls up all the darkest images of Islam...It has reached the extent that many Muslim intellectuals do not dare even to refer to the concept for fear of frightening people or arousing suspicion of all their work by the mere mention of the word' (p. 31). Even when some of the more dramatic fears are set aside, there remains a great deal of uncertainty about what degree of accommodation the law of the land can and should give to minority communities with their own strongly entrenched legal and moral codes. (*ibid.*: 1)

Besides being a distinguished theologian, Rowan Williams is also a respected poet, translator and literary critic (Shortt 2008). Six months before he gave the lecture he had completed a major study of Dostoevsky (Williams 2008b). In this work he demonstrates his long-standing admiration of the Russian theorist, Mikhail Bakhtin whose own analysis of Dostoevsky introduced the notions of the 'dialogic' and the 'polyphonic' into contemporary critical thought (Bahktin [1929] 1984). Both the theme and the style of Williams's lecture assume a dialogic position. Provisional and tentative, the lecture stresses that there are many voices to be listened to; that its subject matter is multifaceted and that the contribution the Archbishop is making is only the start of a discussion between peers. From that viewpoint, the lecture did indeed generate a fruitful 'conversation' on its own terrain of critical, undogmatic reflection.

Dialogue and debate

In this spirit and on these terms many entered into a collegiate dialogue with the Archbishop. For instance, Tina Beattie, Reader in Christian Studies at Roehampton University describes the lecture as 'an attempt to open up a conversation between the arguments and insights of certain strands of post-modernist philosophy and theory and the legal professionals who administer the law'. Her comments were posted on the website of *openDemocracy*, the online journal which bears the banner, 'free thinking for the world'. The journal aims to provide 'in-depth news analysis and commentary from a pro-Democracy, pro-Human rights perspective'. It defines its website as:

> A place to reflect – a place to be heard. Through our forum you can challenge our authors, question our visitors, express your views and read those of others. Help shape the world in conversation with other informed and opinionated citizens everywhere.

Throughout February 2008 *openDemocracy* provided a discussion forum for Muslim, Christian and atheist writers whether supporting, rigorously challenging the Archbishop's views or indeed questioning why he had voiced them in the first place. Drawing on deep reserves of cultural capital, the debate incorporated examples from the history of the Ottoman Empire, sharia law as practised in modern Greece, an anthropology of modern Indonesia and the etymology of 'sharia'. From whichever standpoint, and however critical, it always interpellated the Archbishop as a fellow intellectual whose ideas were *ipso facto* to be respected. Furthermore, the debate fitted a context already provided by many previous *openDemocracy* articles on, say, sharia and modernity, Islam and multiculturalism. Thus high levels of pre-existing knowledge, interest, and an understanding of the terms of the debate could be assumed between the key article writers and their reader-respondents.

In an article supporting Rowan Williams, Tariq Modood, Director of Bristol University's Centre for the Study of Ethnicity and Citizenship and a contributor to the earlier debates, describes 'an ethic of dialogic citizenship' that could also justify the role of *openDemocracy* itself. Modood goes on to talk of citizenship as a dynamic work-in-progress based on 'multilogues': 'The multilogues allow for views to qualify each other, overlap, synthesize, modify one's own views in the light of having to co-exist with others, hybridize, allow new adjustments to be made, conversations to take place' (2008). This openness to dialogue, or indeed multilogue, is not just typical of a self-sustaining internet community's responses to the lecture. It is also to be found in the 'older' media of press and broadcasting. The language may be less postmodern in these mainstream channels, but the commitment to liberal tolerance and pluralism is manifest. This is demonstrated in the 'quality' newspapers. Despite major disagreements with the lecture, they still discussed it on its own terrain of debate.

On the two days following the lecture the editorials of both the *Guardian*

and *Independent* daily newspapers came out strongly against the Archbishop's views on the grounds of impracticability, bad law and threats to community cohesion. However, their news reporting quoted a wide diversity of sources with statements from government, religious and civic authorities. The papers also carried background information boxes or 'Frequently asked questions about Sharia'; explanatory features, opinion columns and a wide range of readers' letters. The overwhelming sentiment from all these sources opposed the Archbishop and affirmed an 'equality before the law' position, upholding universalist and secular principles. At the same time, there remained a sense that, even in criticizing it, the lecture required careful and reflective debate.

The few newspaper columnists sympathetic to Williams's viewpoint based their support for him on issues such as the current UK application of sharia in financial affairs and in arbitration on civil matters such as marriage disputes. There was some recognition that Williams had been drawing on the work of reforming Muslim academics and that if the current procedures could be regularized in some way sharia might actually benefit women's position in Muslim communities. Thus Deborah Orr in the next day's *Independent* pushed Williams's argument further to suggest sharia courts could offer a 'benign' intervention:

> Muslim feminists explain until they are blue in their unveiled faces that at root Islam does not discriminate against women, and that such practices as female circumcision, forced marriage, 'honour killing' or full veiling are cultural practices that mistakenly, or in the case of full veiling, overzealously, have come to be associated with Islam. I have to confess that it lifts my heart to imagine a legally and religiously recognized board of Muslim people widely supported and committed to taking a lead in plotting a modern yet Islamic attitude to the rights of women in Britain and around the world. It could be rather wonderful, and is quite a different proposition from the one we have been led to believe that Williams made. (*The Independent*, 9 February 2008)

Two days later, however, Johann Hari, *The Independent*'s other big-name columnist, was quoting Muslim feminists to make his case *against* the extension of sharia. This was part of a wider argument he was posing in favour of liberalism but against a 'multiculturalism' that he perceived to be implicitly racist and potentially divisive: 'As the European Iranian feminist Azar Majedi puts it, "By creating different laws and judicial systems for each ethnic group we are not fighting racism. In fact we are institutionalising it"' (*The Independent*, 11 February 2008).

Hari went on to refer to a documentary put out on Channel 4 television a week previously, *Divorce Sharia Style*, about the working of a British sharia court which he said had shown women seeking divorce being advised to stay with dangerous and abusive men: 'These are the courts that Rowan Williams would give the stamp of British law...As the Muslim feminist Irshad Manji

puts it: "When it comes to contemporary *sharia*, choice is the theory; intimi-dation is the reality"' (*The Independent*, 11 February 2008).

Providing articles that are both pro and con is part of the contracts these 'quality' papers' make with their readers. The assumption behind them is that (mainly white, non-Muslim) readers are prepared to learn about previously unfamiliar areas and willing to approach them in an open, fair-minded way. The *Guardian* has a long-standing reputation for progressiveness forged from the reforming liberal strand of nineteenth-century Manchester industrialism; and one of *The Independent*'s most successful early slogans was, 'It is. We are. Are you?'. Their mode of audience address takes it for granted that readers' opinions are best formed out of serious and independent assessments of views and evidence.

As for mainstream broadcasting, the BBC used its public service remit to include several discussions of the lecture and its implications on its two flag-ship current affairs programmes, the nightly 45-minute television magazine, *Newsnight* (BBC 2) and the three-hour breakfast show, *Today* (Radio 4). There was also extensive coverage on the BBC's two regular weekly discussion programmes: Radio 4's *Any Questions?* and television's *Question Time* (BBC 1). Both use a panel of discussants and adopt the format of a studio audience asking questions and then often being invited to comment on the replies given. The chair also makes a point of inviting the 'home' audience to send further email or text comments and the radio programme has a follow-up half-hour Saturday programme, *Any Answers*, continuing the previous evening's debate mainly by live phone-in and some emails. Most unusually, the 9 February edition of *Any Answers* was entirely devoted to comments on the Archbishop's lecture, with the chair commenting that the programme had never received so many emails.

The *Question Time* programme, transmitted on the same evening as the Archbishop's lecture was delivered, included on the panel Andy Burnham, the new Secretary of State for Culture Media and Sport, and the Director of the human rights organization, Liberty, Shami Chakrabarti. Both stressed the 'complexity' of the issue and praised the Archbishop as a 'thoughtful' person while reiterating the principle of one secular law. On radio's *Any Questions?* the following night the issue featured as the first question. It was posed by a Muslim audience member thus: 'Does the panel think there is a place for reli-gious law in our legal system?'. The three MP panellists thought not and that any sharia arbitration had to be clearly recognized as voluntary, non-pressur-izing and not pre-empting recourse to secular law; the fourth panellist, Inayat Bunglawala, Assistant Secretary-General of the Muslim Council of Britain, defended the Archbishop's views and made comparison with Orthodox Jewish arbitration in the Beth Din courts – which the other panellists then debated with knowledgeable references to Judaism.

Media and the 'public sphere'

These examples of 'new' and 'old' media formats recall Jürgen Habermas's

original formulation of the 'public sphere' in his book, *The Structural Transformation of the Public Sphere* (1989). Habermas famously provides the notion with an actual historical context, locating the public sphere within early bourgeois liberal philosophies of equality, democracy and freedom of speech and seeing its typical expression in the salons, coffeehouses and journals of eighteenth-century western Europe. Whereafter, he sees a marked decline, most notably in the 'structural transformations' produced by the industrial developments of the nineteenth and twentieth centuries which established the modern mass media. However, modern theorists of media have picked up on some of the same features Habermas highlights in his characterization of the bourgeois public sphere to apply to contemporary media formats and the current interactions of 'mass' press and broadcast media with newer, digital forums. Extrapolating from the original model, they conceptualize a modern public sphere that recreates some of the earlier 'bourgeois' aspects Habermas notes: the creation of spaces for democratic discussion between equals; and the exercise of critical reasoning powers within an ethos of the liberal tolerance of pluralism (Dahlgren 1995; Calhoun 1999; Goode, 2005).

This notion of a democratic modern public sphere has sometimes been idealized and sentimentalized, particularly in relation to the digital media. But as a sociological 'ideal-type' – a heuristic device where particular trends are deliberately highlighted for comparative research purposes, it has been productive in drawing attention to the formation of public opinion in contemporary societies. Hence, I think it is useful to see the cluster of responses to the Archbishop's lecture that I have outlined in the light of a twenty-first century liberal–democratic public sphere. Within this sphere, knowledgeable and well-informed people give consent to the social value of arguing through an issue which may not affect them at all on an individual level but which they perceive is important to debate in terms of a larger public good. The critical–rational discourse operating in this public sphere draws on the assumption that audiences are addressed as citizens interested in the development of democratic trends in their society and hence prepared to address matters beyond their immediate 'lifeworld' (Habermas [1962] 1989).

The mode of address in the press, broadcast and internet forums that I have exemplified in both 'new' and 'old' forms of media takes for granted a *bienpensant* citizenry whose well-considered views about political and ethical questions are assumed to influence national and international collectivities. Through measured, fair-minded and reflexive debate, they are perceived to contribute to the construction of an enlightened public opinion which is understood as an essential concomitant of democratic development.

However, it was not this type of public sphere that generated the main controversy around the Archbishop's lecture. There were other media forums whose responses to the lecture were so noisy, so angry, so grabby and unreflexive that they effectively drowned out any liberal–democratic discourse. These belonged to another, parallel, public sphere that I have characterized as *demotic–populist*: graphically clear-cut and direct to the point of dogmatism in its allegiance to a public conceived as already familiar with what's-what and

prepared to take no highfalutin nonsense from any cultural power elites. In the demotic–populist sphere, debate and dialogue about sharia became immediately translated into a row/fury/furore/uproar/outburst that dominated news headlines for six days until overtaken by the Paul McCartney–Heather Mills divorce hearing. Even then, the 'row' story continued well into a second week on the feature pages of the press, on individual papers' websites and phone-in audience forums for both press and broadcast media.

In the process, the Archbishop's lecture generated 'a perfect media storm'. As an intense and 'overdetermined' media event, the storm's very multiplicity of causes and effects served to highlight a number of issues about news values and public opinion formation. I want to go on and indicate some of these with particular reference to the mainstream press, their various types of reader talk-back forums and the functioning of a demotic–populist rhetoric, particularly in *The Sun* newspaper. But first I want to ask, how come a theological lecture on an interesting, but not apparently significant topic – and certainly not on any current news agenda at the time, came as if out of the blue into the perfect storm of media controversy.

Generating a media storm

In the first place, this was a lecture the Archbishop's office, Lambeth Palace, was very keen to promote in terms of interfaith dialogue and community cohesion. Implicitly it was also a follow-up to the Archbishop's unequivocal repudiation of statements made by the Bishop of Rochester the previous month. Bishop Michael Nazir-Ali, an evangelical populist and the most senior Asian cleric in England, had called for the government to proclaim the Christian values underlying Britishness and asserted that Islamic extremism had turned 'already separate communities into "no-go areas"' by attempting to impose "an Islamic character"' on them. The Archbishop had responded by regretting the language used by the bishop and referring, instead, to possible no-go areas for Muslims.

Before the lecture, Lambeth Palace press office had secured a detailed interview with the BBC's religious affairs correspondent, Christopher Landau, which was run on the lunchtime Radio 4 half-hour news magazine slot, *The World At One* (WATO) at the exceptional length of nine minutes. The timing was justified later by the BBC because of the editorial need to exercise caution on a potentially sensitive subject and also to allow the Archbishop adequate time to clarify his views ahead of the lecture. But, added Landau, when he appeared a week later on the listeners' comment programme, *Feedback* looking back at the coverage, 'we also knew we'd got a good story' (Radio 4, *The World At One*, 15 February 2008).

The *World at One* presenter, Martha Kearney's introduction to the interview is worth quoting in full because it demonstrates the BBC's judiciousness and care in providing context but also shows how the story is predefined as controversial before the lecture's even been given and also labelled as a significant 'exclusive' for the BBC:

Martha Kearney: The lecture may have been intended as a scholarly contribution to the relationship between English law and Islam but the Archbishop of Canterbury's statement that Sharia law *'seems unavoidable'* in parts of Britain *is highly controversial*. Rowan Williams, speaking tonight to lawyers in the Temple area of London, *will argue* that Muslims should be able to choose whether issues like marital disputes or financial matters should be dealt with in Sharia-compliant proceedings or the existing legal system. He argues this relies on Sharia being better understood. Britain has to face up to the fact that some of its citizens don't feel they relate to the British legal system alone; *he says they shouldn't feel they have to choose between 'the stark alternatives of cultural loyalty or state loyalty'.* Rowan Williams' *remarks are bound to provoke a reaction*. The European Court of Human Rights found that Sharia was incompatible with the fundamental principles of democracy, particularly with regard to its criminal law, its rules on the legal status of women and the way it intervened in all spheres of private and public life in accordance with religious precepts. His lecture comes just a month after an Anglican bishop warned that there were no-go areas in parts of Britain.
The Archbishop of Canterbury this morning gave *an exclusive interview to our reporter*, Christopher Landau. He asked him whether the adoption of Sharia law really was necessary for community cohesion.
Archbishop: *It seems unavoidable* and indeed as a matter of fact certain provisions of Sharia are already recognized in our society and under our law. So it's not as if we're bringing in an alien and rival system. (My italics; Radio 4, *The World At One*, 7 February 2008)

Kearney's introduction to the interview conforms strictly to the public service conventions of *balance* and *impartiality*. Its cautious and qualified contextual explanation paves the way for the subsequent rational–liberal discourses around the lecture. But it also serves to initiate the media storm that happens in the demotic–populist sphere. Precisely because the BBC cannot editorialize and take a 'BBC position' on current events it often resorts to justifying the priorities of its news agenda by predicting possible responses or consequences happening in the future. This strategy of *informed speculation*, particularly when it operates before an event has actually occurred, may well act as a self-fulfilling prophecy, generating further interest and drawing more speculation to the story (Hall *et al.* 2007). In this case, the strategy fits not only with the public service obligations of neutrality but more pressingly and urgently with the political economy imperatives of multichannel commercial competition which the BBC, increasingly, cannot 'afford' to ignore. An 'exclusive' package of informed speculation puts the BBC in pole position in the 24-hour news marketplace as the unique originator of a 'breaking' news story which it has already defined as 'highly controversial' and 'bound to provoke a reaction'. By mid-afternoon, the BBC news website leads with a picture of the Archbishop and the headline, 'Sharia law in UK is "unavoidable"' and it is this angle that dominates all newspaper headlines the following day.

But even before the programme had finished airing, listeners' emails were already pouring into its *WATO Comments* slot. The immediate response was overwhelmingly hostile and concentrated on the shock and amazement the Archbishop's interview had elicited. These initial extracts are typical:

> Did I hear it right? That we should change our current legal system to suit the needs of those immigrants who just don't like it? This must be a joke surely?
>
> I could hardly believe my ears, the Archbishop of Canterbury condoning – implicitly supporting – a separate legal system for religious people who don't like the one we all live under…My first email to *WATO* and my first ever call for a resignation but this is shocking…
>
> Please tell me I've slept through the rest of February and all of March and this is 1st April! The leader of the Church of England advocating the adoption of sharia law in the UK? I've never had any time for this tediously pompous windbag but until now did not realize he was completely barking mad…
>
> The man has totally lost the plot. Sharia law has no place in this country. (Radio 4, *The World At One*, 7 February, 2008)

Friday's newspapers all pick up on the 'stark alternatives' remark from the lecture that Kearney first highlighted and also the 'seems unavoidable' phrase she extracted from both the lecture and the interview. But translated to the press, the 'seems' disappears, as it did on the BBC website, and the phrase starts to feature, particularly in the tabloids, as a much more dogmatic assertion, an insistence, an injunction, even, on the Archbishop's part. The Archbishop's 'demand' for sharia then serves to justify savage personal abuse and calls for his resignation from the press that echo and amplify the initial listener reaction. Similarly, despite the Archbishop's attempts throughout most of the lecture to transcend binarism and appeal to liberal and postmodern discourses, what the populist press discourse presents is indeed a 'stark' choice: it's *either* the whole of Britain accept the 'demand' and the alien threats it conjures up *or* all decent-minded Britons must forthwith reject it.

Demotic–populist responses

As the next day's press completes the transformation of the lecture into a controversy of sharp oppositions and intense emotions, the *Daily Express* front page headline reads: '"MUSLIM LAWS MUST COME TO BRITAIN": Fury at call for sharia courts by Archbishop of Canterbury' (Daily Express, 8 February 2008). *Fury*, as with *outrage* or *uproar* in other papers, features as a graphic, but unspecified abstraction. Although some sources of the 'fury' are subsequently quoted in the ensuing article, the impact of the headline both sharpens a sense of conflict while ensuring only one person is named as responsible for it. This is typical tabloid dramatization that critical linguistics calls *nominalization*

(Fowler 1991). In this case, nominalization empties out the relevant contexts of time and space; it doesn't ask who might actually be furious, or why, but evokes a generalized anger as the only obvious response to the Archbishop's 'call'.

The headline article is accompanied by a picture which relates to a completely different news event and which is captioned, 'Hook will be extradited to face justice in US. See page six'. The photograph, showing a turbaned head, bearded face and artificial metal hand, is of Abu Hamza al-Masri, the former imam of Finsbury Park mosque, north London, jailed in 2006 for inciting murder and race hate in Britain. Having the 'fury' story alongside the best-known Islamist folk devil, usually labelled in the tabloid press as 'Hook, the preacher of hate', the implication is clear: Britain can expect more of his ilk if the Archbishop gets his way. As the first sentence of the *Express* headline story puts it: 'The Archbishop of Canterbury was accused of surrendering to Muslim extremists last night by calling for Islamist law to rule in parts of Britain'.

The only qualifier here is 'parts of Britain', but the rest of the story uses *passive agent deleted* constructions – for instance, who is the accuser here? – which critical linguistics describes as having the effect of mystifying actions and motives and diminishing any journalistic responsibility for what is being reported (Trew 1979). The inside pages of the *Express* continue the simplified juxtaposition of extreme angles. The main feature story offers the rhetorical question: 'How can Archbishop say Sharia law is "unavoidable"?' and illustrates it with a picture of a beheading in Saudi Arabia captioned, '137 beheadings in just one year' and a question to the readership for a phone-in poll: 'Should Sharia law be banned in Britain?'.

The readers' web forums and phone-in polls that accompany all the sharia law stories are framed, both by the initial BBC coverage and by their papers' particular ethos and angles on the controversy. For instance, the *Daily Mail* highlights for reader comment a feature headlined, 'The Church should have the guts to sack the Archbishop and pick a man who TRULY treasures British values!' (10 February 2008), written by their star columnist, Melanie Phillips. Such a man she suggests, signalling at once both her apparently non-racist and pro-British credentials, would be the 'embattled' Michael Nazir-Ali 'who has received death threats for telling the truth about Islamic "no-go areas" and who *is* [i.e. unlike Rowan Williams] trying to defend the religion and culture of this country'.

This article draws 75 email responses, only two in favour of the Archbishop's position and the majority adopting some aspect of Phillips's and the *Mail*'s familiar *trahison des clercs* theme. The main viewpoint expressed is that because of their suspect, weak 'permissiveness', the 'liberal and religious elites' have become, not only the apologists and stalking horses for Islam, but are 'letting in' people who will ultimately destroy 'our' way of life. There are many calls to sack Williams for 'treason' or to deport him to a country where sharia law applies. A sense of an alien, if unspecific, threat permeates most of the correspondence as this email indicates: 'One can only assume that there is some "movement" in this country, rather like the communists in the 1960s,

that wants to destroy everything that Britain stands for. And Williams is part of it…Well said, Melanie' (*Mail* blog, 10 February 2008).

The morning after the lecture, the *Guardian Unlimited Comment is Free* blog contains 127 emails, almost all opposed to the Archbishop. These are often jokey, and with a strong thread of anti-clerical atheism, dismissing all religions as make-believe or dangerously meddlesome and evoking current interest in the recently published book, *The God Delusion* (Dawkins 2007), as here: 'There is only one god – Richard Dawkins. Let's all implement Dawkins' Law and ex-communicate all these old (bearded) goats'.

This last comment is a reference to how the *Guardian* blog has framed its initial request for reader comments: 'Visionary archbishop or silly old goat?' (8 February 2009). The *Guardian* like most of the contemporary 'quality' press, enjoys and indulges populist rhetoric, but always as if in quotation marks – a distancing and sceptical stance that enables it to preserve its liberal credentials and reputation for high-mindedness. So it sets up its blog with a page quoting from the overnight reaction of other papers to the lecture and the goat reference is a quotation it takes from *The Sun*'s characterization of the Archbishop. The blog thereby permits an occasion for populist ridicule that is not of the *Guardian*'s own making. But the *Guardian*'s choice of phrase is also a recognition of *The Sun*'s ability to both construct and crystallize a national mood. And it is the contribution *The Sun* makes to the perfect storm of media comment around the lecture that I think demonstrates most clearly the deep strain of anti-intellectualism in the populist rhetoric opposing the Archbishop's views and shows how it can also serve as an alibi for racist, and particularly Islamophobic, attitudes.

The Sun says…

The quotation the *Guardian* refers to is taken from the first, unusually long, editorial in the regular comment column, '*The Sun* says'. It is headlined: '<u>Dangerous *rant*</u>' and starts:

> <u>It's easy to dismiss Archbishop of Canterbury Rowan Williams as a silly old goat.</u>
> In fact, he's a dangerous *threat* to our nation. He says the adoption in Britain of parts of Islamic sharia law is '*unavoidable*'. If he believes that he is unfit for his job.
> Williams says the idea of 'one law for all' is 'a bit of a danger'.
> With that one sentence he destroys his authority and credibility as leader of the Church of England…
> [Concluding section] Why is *our* Archbishop *promoting* a law under which women are stoned to death and shoplifters barbarically dismembered?
> As Williams was cosying up to Islam yesterday, one of his bishops – Michael Nazir-Ali…was being protected by police.
> He has received death threats from Muslims for warning of Islamic no-go areas in Britain.

What has Williams to say in support of the Bishop? Nothing.
<u>The Archbishop of Canterbury is in the wrong church</u>. (My italics; *The Sun*, 8 February 2008)

This editorial is part of a double-page spread framed by three descending headlines:

FURY AT CHURCH OF ENGLAND CHIEF'S *DEMAND*
Archbishop says UK must accept Islamic Sharia law. He claims it's 'unavoidable'. His *outburst* is a...
Victory for terrorism

The feature, which amplifies the themes of the editorial, is accompanied by three pictures labelled 'carnage' (the aftermath of the London 7/7 bombings); 'flogging' and 'cruel cut' (hand amputation) grouped together as '*BRUTALITY* THAT SICKENED WEST'. Two small *comment* pieces, by-lined by Sun columnist Anila Baig and Labour MP Khalid Mahmood indicate that there is no support for the Archbishop from common-sense Muslim opinion and the spread is completed with a *You the Jury* invitation to readers to enter a yes/no phone poll: 'Should the Archbishop be sacked for his comments on Sharia law'?

Again, the mystifying nominalization and passivization, some of which I've indicated in italics, as a questioning, open-ended lecture is transformed into a dangerous ranting demand that supports terrorism. In the fine detail of the feature story it is cautiously noted that Rowan Williams had stressed his opposition to the 'extreme elements of Islamic law – including stoning and whipping' and that the Qu'ran tells Muslims in a non-Muslim country to follow the state's laws. But the dominating visual images and headlines draw attention to the overwhelmingly opposite impression.

The Sun typifies the populist press response to the Archbishop in its front page lead, juxtaposing it to the 'hate-filled cleric' Hamza extradition story that the *Express* used and adopting the same 'fury' motif, bordering the main news item with the headings: 'CHURCH LEADER SPARKS FURY'; and '<u>Archbishop wants Muslim law in UK</u>'. These frame the central bold statement: '**WHAT A BURKHA**'.

The Sun's punning headlines are famous for the way they can summarize a situation by creating a new synthesis out of familiar repertoires. 'What a Burkha' exemplifies in one phrase the demotic–populist response to the Archbishop. It takes a popular saying for gross ineptitude which is derived from Cockney rhyming slang for a woman's genitals and links it to the one item of Muslim dress that immediately, following previous recent controversies highlighted in the tabloid press, suggests extremism and oppression.

The epithet is amplified by two symmetrical photographs illustrating the story; woman in burkha giving obscene V-sign, captioned 'Fury'; Archbishop looking away from her, captioned 'Rage'. As with many of these emotive abstractions and agent-deleted passives, the effect is again that readers are discouraged from actively considering questions of who/what/why. The

images, captions and headlines together form a generalized blur of reactive feeling: something, whatever it is, is very wrong here – and likely to get worse, all thanks to the 'raging' Archbishop. So the V-signing-woman-in-a-burkha could be a sign of the 'fury' to come to Britain if he has his way. But fury and rage are also what we, the readers are invited to feel about the very juxtaposition of images, shocking in the extremity of its opposing terms: an Archbishop (who should be pillar of Englishness and Establishment values) *demanding* Islamic law (primarily represented as the barbaric punishments of public stoning, amputation and beheading plus suicide bombing).

These oppositions render the Archbishop both ridiculous and dangerous at the same time – a familiar contradictory trope of moral panics (Pearce 1973). He is first presented as the epitome of the unworldly cleric with visual head-and-shoulder images highlighting this impression. The Archbishop's 'look' could be read theologically according to the many religious traditions he admires: the prophetic; the monastic and the Russian Orthodox 'holy fool'. But in populist discourse he becomes a figure to mock: the beardy-weirdy who is admittedly clever, but rather 'too' clever to be in touch with ordinary people. The attitude taken towards him by the mass press was long ago identified by Richard Hoggart as 'the aggressive plain man' stance, whereby a strong strain of anti-intellectualism is sanctioned in apparently egalitarian spirit, while actually encouraging the demotic strain Hoggart characterizes, adapting de Tocqueville, as 'unbending the springs of action' (1959).

The generally hostile media coverage on the first day after the lecture emboldened *The Sun* to develop the 'dangerous' aspect of the Archbishop's persona. The following day it turned its call for Williams's sacking into a populist campaign announced on its front page as 'BASH THE BISHOP' with another double-spread inside, entitled 'ARCH ENEMY' accompanied by the results of the phone poll: '96% of readers say he must go', and a cut-out card for readers to send to *The Sun* stating 'I wish to make a complaint of misconduct …[because, inter alia the Archbishop] has given heart to Muslim terrorists' (*The Sun*, 9 February 2008).

What became abbreviated as the *Bash the Bish Campaign* demonstrates how easily the demotic–populist sphere can endorse what Bourdieu has characterized as 'symbolic violence' (1991). His theory relates to many of the linguistic features I have already identified. But a key aspect of symbolic violence for Bourdieu is that it *misrecognizes* real relations of power and thereby mystifies them. Hence, *The Sun*, the UK newspaper with the largest daily circulation of over three million and an estimated readership of between 7.8 and 10 million, habitually misrecognizes its own power by representing itself in the demotic vernacular as just like you-the-ordinary-reader and speaking up for ordinary decent Britons against powerful elites. The paper's vivid displays of symbolic violence against the Archbishop imply that his power as both intellectual and spiritual leader is somehow greater than the global resources of News International, its multimedia platforms and the intergovernmental networking that together constitute the actual political and economic bases of *The Sun*'s symbolic power.

Concluding remarks

The Sun's violence was, however, *only* symbolic. No one got hurt. The Archbishop stayed in his post, receiving a prolonged ovation when he opened the Anglican governing body, General Synod, the following week. 'Bash the bish' petered out with a story relegated to page 13, headlined: 'BISH BOSH, WHAT A LOAD OF TOSH! <u>Rowan refuses to apologise for Sharia outburst</u>' (*The Sun*, 12 February 2008). So did this controversy have any lasting implications from a postcolonial perspective?

Two final comments. The 'tosh' mentioned by *The Sun* refers to the only public statement Rowan Williams made about the controversy. Addressing the Synod, he said 'I must, of course, take responsibility for any unclarity'. In the original radio interview, the second question Christopher Landau put to him was: 'But I suppose Sharia does have this very clear image in people's minds – whether it's stoning or what might happen to a woman who's been raped. These are big hurdles to overcome if you're trying to rehabilitate Sharia'.

The Archbishop replied, with what the BBC transcribed as a single sentence, full of caveats and qualifications:

> There's a lot of internal debate within the Islamic community about the nature of Sharia and its extent; nobody in their right mind I think would want to see in this country a kind of humanity that's sometimes been associated with the practice of the law in some Islamic states – the extreme punishments, the attitudes to women as well and I think one of the points again that's come up very interestingly in recent discussion between Muslim and other legal theorists is the way in which the original context of Islamic law, quite often provisions relating to women, are more enlightened than others of their day; but you have to translate that into a setting where actually that whole area…has moved on. (Radio 4, 7 February, 2008)

The audience emails that asked rhetorically whether they had heard aright were of course mistaken. But it was not surprising that listeners 'heard' only *sharia* and *Archbishop* and then expressed what those two terms and their shocking juxtaposition immediately connoted for them. In his lecture, the Archbishop referred to the repressive aspects of sharia as 'what most people think they know' of it – as if they were somehow mistakenly imagining it. By passing up the opportunity, in both interview and lecture, to make an unequivocal, outright criticism of all sharia law practices and punishments which are clear violations of human rights and by not directly addressing examples of actually existing practices of sharia in various Middle Eastern and African countries which would indeed be what 'most people' in the UK had heard of, the Archbishop unwittingly created a vacuum into which demotic–populist discourses of a dramatically reactive and emotive kind could be poured.

Hence the paradox of the consequences: a lecture and interview intended to promote community cohesion results in apparently advocating a return to barbarism and encouraging acts of terrorism. Ludicrous and quite nebulous as these claims are when examined within the public sphere of critical–rational debate, they can be accommodated all too readily within the existing repertoires of heightened anxiety and moral panic that demotic populism constructs around 'the threat of Islam'.

The Archbishop's statement to Synod concluded, 'I believe quite strongly that it is not inappropriate for a pastor of the Church of England to discuss the perceived concerns of other religious communities and try to bring them into better public focus'. Obviously not the public focus he'd originally intended. But Rowan Williams's point indicates another agenda here: the social and spiritual role of the Church of England itself. As the only state-established Church, yet with active church membership in seemingly inexorable decline, the Anglican Church has for some time been carving out a position whereby it derives new strength by speaking on behalf of all mainstream religions in the UK.

But in assuming the right to speak on behalf of other faiths and their cultural and legal traditions, the Archbishop initiated a process without an adequately prepared-for context. Just as there are many interpretations of sharia, so UK Muslim communities and individuals have different views about what, if any, aspects of sharia it might be useful to give legal recognition to. As to these views being formulated into any kind of campaign, demand or even public request in 2008, sharia law was not on the agenda of any representative Muslim or Islamic group at the time. So in both interview and lecture, the Archbishop took on, apparently unasked and without any grassroots consultation, the role of delegate for sharia.

The ensuing controversy demonstrated what Bourdieu describes as *the oracle effect* whereby 'someone speaks in the name of something which he brings into existence by his very discourse'. The situation is compounded, he suggests, when the oracular is spoken through a delegate who may not have been properly 'delegated' to speak in the first place. Delegation by self-appointment can then turn into what Bourdieu calls *usurpatory ventriloquism* (1991: 211). By usurping the role of community representatives and religious leaders in the name of interfaith and multicultural dialogue, the Archbishop ended up inadvertently encouraging Islamophobia. Because he became himself the object of scorn and ridicule and a 'danger' to society, it was obviously 'all right' to attack a white, middle-aged authority figure well-protected within a palace. Hence, quite rampant racism could be 'legitimately' expressed and sanctioned through hostility to him. On email sites and in the tabloid press in particular, the controversy allowed the familiar tropes of fear and threat to resurface. The story could be 'safely' represented as yet another example of the extent of Islamic subversion: look, 'they' have now even suborned the Church of England to 'their' cause! And then the us-and-them polarities of populist rhetoric could follow the usual lines of: if they don't like our laws/the way we live, then why don't they go

back to their own sharia-loving countries? Thus, the unintended postcolonial 'effect' of the controversy on the real world is to add yet another example of threatened Islamic takeover to the lengthening list of fears and racist anxiety.

Engaging Theory and Making Films: Radical Black Cinema in Britain

Chi-Yun Shin

This chapter will discuss two important decades of black film-making and their very diverse approach to questions of race, identity and cultural belonging. For example an important feature of the new generation of black film-makers who have emerged during the 1980s is their thorough grasp of cultural notions of identity, developed by the theoretical writings of black British cultural and postcolonial critics such as Stuart Hall, Paul Gilroy, Kobena Mercer and Homi Bhabha. In particular, the members of two leading black workshops, which will be discussed in this chapter – Black Audio and Sankofa Film and Video Collective – drew extensively on critical writings, which constituted a significant difference from the earlier generation of black film-makers who did not share the same preoccupation about film cultural theory with the white independent filmmakers of the 1970s. As the first generation to take their academic and technical training at British universities and arts schools, the new generation of black film-makers were well versed in contemporary theories, which provided a framework to their creative work.[1] Their work manifested their understandings of the complex relationship between black-produced imagery and dominant representation with a distinctive aesthetic dimension. Indeed, some of the films are themselves theoretical essays in their own right, not just illustrations of theory.[2]

On the other hand the beginning of the 1990s presents a very different picture about black film-making in Britain, with the end of the workshop era, as the revenue funding that had provided the protected environment for black workshops to produce experimental and oppositional films had virtually ceased. The demise of the workshop sector came from the knock-on effects of the successive Conservative government's deregulatory, market-driven policy and overriding hostility towards the public sector, which led public institutions

including Channel 4 and the BFI to reassess their commitment to the independent film sector. Therefore, although institutions continued to finance certain black films, public finance for black film production dramatically dwindled in the 1990s, despite the fact that there was a steady rise in the number of independent black film production companies. The second part of this chapter will discuss how the production of black British films entered something of a slump during the 1990s with only a handful of films theatrically released – notably *Young Soul Rebels* (Isaac Julien, 1991), *Who Needs a Heart?* (John Akomfrah, 1992), *Welcome II the Terrordome* (Ngozi Onwurah, 1995), *Frantz Fanon: Black Skin, White Masks* (Isaac Julien, 1997) and *Babymother* (Julian Henriques, 1998).[3] The definition 'generic angst', part of the title of this chapter is used here as a way of referring to the attempts of black film-makers who had been making experimental films to cross over to the more mainstream genre films in their need to expand the audience base.

Politics of form in black workshop films

Spearheaded by films such as Sankofa's *Territories* (dir. Isaac Julien, 1984), *Passion of Remembrance* (dir. Isaac Julien and Maureen Blackwood) and Black Audio's *Handsworth Songs* (dir. John Akomfrah, 1986), the 'new wave' of black British films actively involved what Stuart Hall describes as the politics of representation. That is, as Hall puts it, an understanding of 'how things are represented and the "machineries" and regimes of representation in a culture do play a *constitutive*, and not merely a reflexive, after-the-event, role' (1997: 274–5). As an oppositional practice, therefore, these films take a counter-strategy, which locates itself within the complexities and ambivalences of representation and tries to contest it from within, hence there is more concern with the forms of racial representation than with introducing a new content. Formal experimentation that characterizes many of the black workshop films is thus not incidental but integral to these works. Indeed, new black films from the workshop sector are fundamentally concerned with the production of new languages that reflect the complexity of black experience in Britain.

This emphasis and insistence on searching for new language generated a set of critical debates on black aesthetics in relation to issues of race and ethnicity in film and television. The 1988 'Black Film, British Cinema' Conference at London's Institute for Contemporary Arts was instrumental in underlining some of the responses to these 'new wave' of black British films. In his influential essay 'Recoding Narrative of Race and Nation' (that was published after the conference), Kobena Mercer observed that black narrative fiction films such as Menelik Shabazz's *Burning an Illusion* (1982) and Horace Ove's *Playing Away* (1986) 're-tell stories of black British identity...within a code or a language which positions that identity as a "problem"', whereas a new wave of black films (i.e. experimental films) 'marks a turning point not because it transcends this problematic, but self-consciously enunciates an explicit attempt to break out of the constraints of the master code' (1988: 10–11).

Similarly, 'campaign' documentaries in a realist tradition such as *Blood Ah Go Run* (Kuumba Productions, 1982) and *The People's Account* (dir. Milton Bryan, 1986) were seen to 'adhere to the same aesthetic principles as the media discourses whose power and ideological effects they seek to resist', although 'the "reality-effect"…is an important rhetorical element by which the "authority" of dominant media discourses is disrupted by black counter-discourse' (*ibid*.: 9).[4]

Writing in 1988, Jim Pines also argues that the new wave of black film-making, exemplified in works such as *Passion of Remembrance* and *Handsworth Songs* 'signalled the break with old-style "race relations" and multiculturalism' that privileges 'black–white relations in the classic "race problem" sense' (Pines, in Cham and Andrade-Watkins 1988: 27).[5] In particular, by challenging the British 'race relations' documentary tradition, the new films 'are marked off from other kinds of independent work, because institutionalized "race relations" has a marginalizing effect structurally and tends to reinforce rather than ameliorate the "otherness" of the subject' (*ibid*.: 29) Similarly, narrative films such as *Burning an Illusion* and *Playing Away* were seen to homogenize and totalize the black experience in Britain, although they are important precursors of the new black films.[6] As such, many commentators hailed the emergence of new black films as the most innovative and exciting aspect in the history of black film-making in Britain.[7]

However, alongside there was also the argument that the experimental approach was inappropriate for the black film-makers' responsibility to produce 'positive images' of the community as the answer to racist misrepresentation. The most prominent reservation was about their elitism. Their avant-garde techniques were felt by many to be too intellectual and inaccessible. For instance, Judith Williamson in her talk given at the 'Black Film, British Cinema' conference, criticizes the 'good/bad dichotomy which … says realist, narrative, mainstream cinema = bad; non-narrative, difficult, even boring, oppositional cinema = good' (Williamson 1988: 108). Indeed, as Williamson points out, 'the black British work that's been taken up most widely in the world of theory, been most written about and also picked up at festivals, on tours, and so on, is the work that fits most obviously into that category of avant-garde' (*ibid*.: 108).

To some extent, it is fair to say that experimental black films have become synonymous with black film-making practice in Britain during the 1980s. These experimental films practices were a unique intellectual contribution to black British cultural studies and interests in the politics of race representation. In fact, high-profile black intellectuals not only have been included in the 'thank you' list at the end credits, but also participated in the production of workshop films. Stuart Hall, for instance, provided a voice-over to Sankofa's *Looking for Langston* (dir. Isaac Julien, 1989); Paul Gilroy and Homi Bhabha were prominently featured in Black Audio's *Twilight City* (dir. Reece Auguiste, 1989). As such, the relationship between the film-makers and the cultural theorists is self-reflexive and inextricably bound to the specific postcolonial circumstances of black people in Britain in the 1980s, when the question of

national identity and belonging was high on the political agenda. In this respect, the black experimental films can also be characterized as what Raymond Williams has called a cultural formation; that is, relatively coherent associations of artists and intellectuals centred around shared social and aesthetic ideologies (1981).

Furthermore the new wave of black films had more to do with celebrating the new possibilities in representing black experience in postcolonial Britain rather than with undermining or dismissing certain types of film practice. More importantly, the development of experimental film-making practice from black workshops has been one of the most fertile areas of growth within the black film sector during the 1980s. As Mercer has argued, 'the emergence of a new "experimental" approach has widened the parameters of black film practice, bringing new quality of diversity to black film-making' (Mercer, in Cham and Andrade-Watkins 1988: 50).

Aesthetics of diaspora: the strategies of 'hybridity'

Although their individual circumstances vary widely, many of new black films of the 1980s share a number of discernible aesthetic qualities and strategies. One of the major strategies they collectively deploy is the montage or collage documentary practice, in which archive materials, found footage, TV news reports, newspaper clips, interviews, allegorical tableaux, still photographs and even fictional dramas are put together. With varying degrees, this collage mode of film-making has been employed in films such as *Territories*, *Passion of Remembrance*, *Handsworth Songs*, *Twilight City*, *Looking for Langston*, Ceddo Film Collective's *Time and Judgement* (dir. Menelik Shabazz, 1988) and Ngozi Onwurah's *Coffee Coloured Children* (1988). These films, as Dick Hebdige puts it, 'use everything at their disposal ... in order to assert the fact of difference, to articulate new relations to the body, subjectivity, politics, to make fresh connections between another set of bodies, another set of histories' (Hebdige, in Baker *et al.*: 1996: 141). Coco Fusco also points out that besides the influences of the European avant-garde, the two collectives – Black Audio and Sankofa, 'are surrounded by and acutely aware of "popular" media forms', which includes musical performance, television aesthetics, the fast-pace editing and non-narrative structures found in advertising and music video (1995: 314).

The principle behind mixed form is also evident in the subject matter, which is not limited to the time and space inhabited by the black community in contemporary Britain. For instance, Ceddo's *Time and Judgement* travels back and forth from the war effort of colonial Ethiopia (then Abyssinia) in 1935 to the National Black People's Day of Action in London in 1981; from the massacre of apartheid South Africa against Angolans in 1982 to Bob Marley's 'exodus' performance; from the US invasion of the Caribbean island of Grenada in 1983 to Louis Farrakhan's speech; from the African famine to Broadwater Farm in Tottenham. Combining images of Marcus Garvey, Nelson Mandela and the Queen of Sheba, the film denotes how 'after four hundred

years of oppression', the African people 'rose up with the rod of Moses and passed judgement against Babylon'.

Similarly, Black Audio's second feature, *Testament* (dir. John Akomfrah, 1988) makes a historical connection with Africa in the make-up of black British identity by dealing with a Ghanaian exile. Abena's journey back to Ghana, from which she left after the coup in 1966, is entangled with postcolonial concerns. Another example of interrogating the past elsewhere is Isaac Julien's *Looking for Langston* that looks back at the black American poet Langston Hughes and the Harlem renaissance of the 1920s. Indeed, black British films draw from many different cultural traditions in a deliberate attempt to map out the hybrid past of black people in Britain. In this respect, Laura Marks includes many of the black workshop films in what she calls 'intercultural cinema', which 'operates at the intersections of two or more cultural regimes of knowledge' (2000: 24).

As such, this eclectic mode of film-making, on the one hand, points to the awareness, on the film-makers' part, of the notion of cultural 'hybridity' that is closely related to the diasporic experience of black people in Britain. As Paul Gilroy has pointed out:

> Black Britain defines itself crucially as part of a diaspora. Its unique cultures draw inspiration from those developed by black populations elsewhere. In particular, the culture and politics of black America and the Caribbean have become raw materials for creative processes which redefine what it means to be black, adapting it to distinctively British experiences and meanings. (1987: 254)

The synthetic quality of experimental black films, therefore, corresponds to the cultural hybridity of the black community in Britain. More significantly, as textual hybrids, these films challenge the separateness of cultures – that of Britishness and blackness, thus dismissing the idea of cultural distinction and implying there is no pure or homogeneous nationality. In this respect, Kobena Mercer argues that the critical debates which new black films provoked:

> highlights the way image-making has become an important arena of cultural contestation – contestation over what it means to be British today; contestation over what Britishness itself means as a national or cultural identity; and contestation over the values that underpin the Britishness of British cinema as a national film culture. (1988a: 5)

The strategies of syncretism and 'hybridity' derive from the need and desire to retell the histories of blackness and Britishness from a new vantage point. In this case, the use of archive material – by recalling, retrieving, recycling and juxtaposing it with the new material – becomes an active means to reduce the textual authority of archive material, which all too often has served as visual evidence of history. It is also done with an emphasis on evoking an alternative history that has been silenced and distorted in the official history. Black

Audio's *Handsworth Songs* is the most prominent example that reaches for historical depth, through moving back and forth between clips of Caribbean immigrants arriving in England in the 1950s and the 1985 disturbances in Birmingham and London.

While aesthetically different, Sankofa's *Passion of Remembrance* shares with *Handsworth Songs* its concern to interrogate the past. The video material in the film, which is reprocessed and re-presented in the form of montage, is in Martina Attille's words, 'intended to document periods of recent British history, moments of celebration as well as protest' (1988: 54).[8] At the same time, the images provide a reference point to question the authenticity of the images of past claims, in particular, the male-oriented black activism. In fact, the name of the workshop, 'Sankofa' is a mythical bird that symbolizes looking into the past to prepare for the future in the African Akan language, which reflects the group's awareness of importance in referring back to the past in order to assess the relevance for the present.

A related aim of this collage form of film-making practice is to perform, in Kobena Mercer's words, 'a critical function in providing a counter-discourse against those versions of reality produced by dominant voices and discourses in British film and media' (1988b: 52). Sankofa's *Territories*, for instance, is concerned with the way in which black cultures have been interpreted by the voyeuristic gaze of the white-oriented media. The film is in two parts, the first part dealing with the BBC's ethnographic account of the carnival, and the second part deconstructing the BBC's version. In the first part, over the images of the BBC documentary, we hear two commentators in the film repeat after one another:

> That in conventional documentaries of carnival, we are routinely taken into a past, shown a plantocracy. We are told the ambiguities of mock revolutions. We are told the mimicry and parody of plantocrats and their manners. What do these conventional stories add up to? The same old story. A string of stereotypes about black culture. Carnival is neutralised and framed, contained as a site of spectacle. (Sankofa, *Territories*)

In order to displace the conventional documentary, which sees carnival only as an event about the West Indies and its culture, the second part of the film employs the new cinematic discourse of montage, which starts with the image of the Union Jack on fire. As the flames burn through the middle of the flag, the images of black youth confronting the police are revealed. On these images, several different shots of street scenes are superimposed and dissolved onto each other. Then, there appears an image of two black gay men embracing over a still photograph of policemen. As such, the editing accentuates the transgression against the system, cross-cutting the two oppositional elements of youth and police, desire and law. As Manthia Diawara suggests, unlike the BBC documentary, the film makes it clear that 'the event is about Britain, about war between black youth and the police, and about the reclaiming of urban streets as expressive spaces for black culture' (1996: 299).

The montage form of film practice, in this respect, is deeply grounded in the suspicion of conventions of both classical narratives and realism, especially the ideological presumption that cinema *can* represent reality. A related feature to foreground the limits of visuality is the extensive use of spoken words. Indeed, many of the experimental films feature didactic voice-overs and explanatory dialogues are often poetic and speculative. It is partly to present what they cannot show, but the main emphasis is on the non-western tradition of oral histories as different means of representing cultural counter-memories. Another related feature is that the films stress the social character of body and the non-visual senses. In particular, when the film works with body images which are 'ready-made' (through montage), the filmmakers can distance themselves from the body filmed. Thus, the body in these films is not just of individuals but also of cultural memory that represents the experience of living between two or more cultural regimes of knowledge.

Ngozi Onwurah's first short film, *Coffee Coloured Children*, made while Onwurah was attending St Martin's School of Art, is a good example mixing autobiography – evoking the individual memory and experience – with a rigorous interrogation of dominant cinematic style. Thus, for example, the confused thoughts of a mixed-race childhood ('Domestos wouldn't clean my skin') – recalling the film-maker's own childhood, growing up in Newcastle-upon-Tyne as the only black family in sight – is followed by the now adult voice-over explanation over images of a young girl applying bathroom cleaning powder to her cheeks ('because my skin wasn't dirty') are juxtaposed with thoughts and images from the present day. This complex montage comprises home-movie footage with dramatic reconstructions and fantasies. But when we realize that home-movie shots are actually staged for the camera, the whole nature of memory and its definition are then thrown into relief.

As such, this new wave of black films take an experimental approach that is very conscious of the selection and choices made in the process of image-making: explicating the conventions and structures themselves is to reveal the hidden relations of power and knowledge inherent in popular and official discourse of race. It also creates a position that maintains a critical relationship to what is shown on the screen, allowing multiple entry points for the audience. In this respect, John Hill argues that the films 'may be seen to have links with a post-modern cultural practice of "resistance" that '"deconstruct" or "denaturalize" old meanings through the repositioning or "re-functioning" of artistic and cultural discourse' (1999: 221–2). In the intertextual and fragmentary montage forms, the pre-existing official images are disrupted, as the authority and transparency of realistic conventions of British ethnographic documentaries and media reports, which has been the principal form of dominant representations of race in Britain, are challenged and denied.

Black features of the 1990s

Significant changes in the material conditions of black films since the early 1990s have forced black film-makers to readjust to the increasingly commercial

climate. Already by the end of the 1980s the collective spirit of the workshop movement had been replaced to some extent by an attention to individual directors like John Akomfrah and Isaac Julien. Also raised were the questions as to their aesthetic preference (to anti-narrative) and their relation to audience in particular (not being ratings driven). Indeed, the experimental documentary form the black workshops employed has been a relatively unpopular one, which meant that the enthusiastic reception of the films of Sankofa and the Black Audio Film Collective of the 1980s has been limited within the metropolitan avant-garde intellectual community. With their emphasis on the issues of representation and the ideology around 'difference', these oppositional experimental political films were criticized for not being 'representative' enough. It was argued that they, in their various ways, did not reflect the 'reality' of the lives of most black people. In fact, these films were never intended to be popular or to develop a commercial basis, as these films often achieved visibility through promotion in leading international film festivals.

Taking a particular example of Black Audio's press release on *Testament* (1988), Paul Gilroy has raised the question whether 'the group had simply overlooked or forgotten the possibility that black British film culture might have a different agenda of priorities from that set by international film festival circuits'. According to Gilroy, the group made explicit that 'there is no base or context for the type of films they want to make within the black communities in this country' (1993: 113–14).[9] Identifying and criticizing such specifics of black film as determinedly experimental avant-garde forms, Gilroy calls for a 'populist modernism', which 're-articulates the positive core of aesthetic modernism into resolutely populist formats' that is 'aligned to vernacular forms and modes of expression' (*ibid.*: 103 and 110). John Hill, however, identifies one problem with Gilroy's criticism in that it ignores how the 'base and context' for all British film-making changed during this period and how, as a result, the film festival circuit increased in importance for the whole of British film culture (1999: 238).

From a similar perspective, Judith Williamson also identified that the workshop movement as a whole 'has never successfully grappled with the question of audiences' (1988: 111). Comparing the different reception of the accessible and popular *My Beautiful Laundrette* and the relatively difficult *The Passion of Remembrance*, Williamson claims that 'the whole oppositional movement has a lot to learn about cinematic pleasure', because 'if you're political you do want to reach people beyond your buddies' (*ibid.*: 111–12).

In many ways, such criticisms are based on an elaboration of what Stuart Hall describes as the 'politics of criticism', which entails the recognition that 'the films are not necessarily good because black people make them. They are not necessarily "right-on" by virtue of the fact that they deal with the black experience' (1996: 166). These questions regarding the audience for black films are also intricately related to the fact that while there has been an understanding of black film as a cultural product, there has been very little discussion of it as a commercial product within the context of the dominance of market economy. Another factor related to the commercial context is that ever

since the late 1980s a new wave of popular African-American films was beginning to establish a commercial basis for itself in the US as well as worldwide. Driven by hip-hop culture and rap-music icons and dealing with the urban black American street life, the African-American films such as *Do the Right Thing* (dir. Spike Lee, 1989) and *Boys N the Hood* (dir. John Singleton, 1991) made such a big impact in the market. Consequently, major US companies eagerly sought after certain black film-makers to exploit the market for black films, which led to the creation of a so-called 'New Jack' genre with a new ghetto aesthetic that portrays the grim realities of black urban life with the focus on 'black-on-black crime'.

The immediate effect of the commercial success of African-American features on black British films had been twofold. On the one hand, it demonstrated that there is an audience for black films, providing the possibility and aspiration for black British films to be commercially viable and successful. On the other hand, it filled the gap in the British market for black films. As Kobena Mercer points out, 'black British films didn't get an audience because if we're thinking of black film as a genre, they were overtaken by the Americans. They had bigger budgets and a deeper cultural tradition. They were drawing on blues, on jazz, and soundtrack, which is very important' (interview with author, 8 December 2001). Indeed, culturally and politically, black America has had a deep influence upon black Britain. As Paul Gilroy claims, 'culture does not develop along ethnically absolute lines but in complex, dynamic patterns of syncretism in which new definitions of what it means to be black emerge from raw materials provided by black populations elsewhere in the diaspora' (1987: 13). However, the commercial impact of black American films upon black British films turned out to be less positive, pushing black British films further into the margin of the market (Wambu and Arnold 1999: 15–18).

One of the black British film-makers' responses to such conditions – the changing funding structure of the industry, increased pressure on expanding the audience base, and the importation of African-American films – can be exemplified in the several black features that anxiously (and cautiously) attempted to move towards a more commercially oriented film, such as *Young Soul Rebels*, *Welcome II the Terrordome* and *Babymother*. The first of these however, can be viewed as an illustration of transition from avant-garde practice to more commercially oriented film-making.

Below I am going to discuss the political implications of choices and decisions made at the level of film-form.[10]

Mixing politics with pleasure: *Young Soul Rebels*

One of the first examples of a transition from experimental to a more populist stance made by black film-makers is Isaac Julien's 1991 feature film, *Young Soul Rebels*. Compared to Julien's earlier films – *Passion of Remembrance* (1986) or *Looking for Langston* (1989), *Young Soul Rebels* is a much more conventional film, adopting a largely linear and coherent narrative and

making use of the genre conventions (murder-mystery mixed with buddy movie), glossy cinematography and heavily soul-based soundtrack. Indeed, unlike Julien's previous films, the film is geared to more than film festival audiences. In Julien's words, by 'making a film that would be seen by a wider audience than we have had access to in the past', 'I'm into making some intervention in the marketplace because the cultural spaces have shrunk considerably. Thatcherism has killed off a number of them very successfully. So I think it's important to try to build an audience for your work' (1991b: 16). Produced by the BFI for £1.2 million (large scale compared to an average black British project), the audience the film targeted was 18–25-year-old cinemagoers. As Liz Reddish who was in charge of marketing the film described, the marketing strategy of the film was 'to get people as excited as possible, emphasising the music, fashion, street culture and entertainment aspects' (in Foster 1991: 18).

Set in London during the Queen's Silver Jubilee year of 1977, the film is also concerned to retrieve a particular moment of black history in Britain. For co-writer/director Isaac Julien and the film's producer Nadine Marsh-Edwards (who is also a co-founder of Sankofa), the real starting point for *Young Soul Rebels* was the desire to make a film about 1977 as 'the moment in black British culture when you witnessed black style becoming a social force – a kind of resistance through style' (Julien 1991b: 15). Therefore, the Jubilee year is thoroughly evoked in the film, not just through the rich soundtrack but also in the dance steps, clubs, clothes, cars, as well as cardboard cut-outs of the waving Queen.[11]

In his introduction to the published script Julien commented:

> That year was so important because on the one hand you had the incredible chauvinism of the Queen's Silver Jubilee and on the other there were very powerful counter-narratives that outlined new kinds of national possibilities. Now everybody knows about the one called 'punk', which was at its height in 1977 and which was a very obvious opposition. But there was another counter narrative, much disdained by the left; which was the growth of a black popular culture particularly in terms of disco music – soul music. (Julien and McCabe 1991: 1)

According to Julien, the reinvention of black British culture 'started around [soul] music, opening up a space for a whole number of transgressions – both sexual and racial: these were the first clubs with black and white, straight and gay mixed in the audiences' (*ibid.*: 2). It is this 'utopian space' that the film seeks to explore as well as reinstate the importance of soul music and the role that it played in relation to the politics of race and gender in this period, which had never been figured in the dominant media.

While Julien acknowledges the importance of 'reggae as part of the mythology of 1977', for him 'reggae really relates back to the Caribbean whereas soul takes one into the wider black diaspora'. In addition, 'reggae was more tied up with Black Nationalism and certain rigidities of sex and race – tough

masculine left politics. Soul, on the other hand, allowed for inter-racial rela-
tionships and challenged some of the structures of black masculinity. As Julien
argues, although soul is often regarded as 'apolitical', especially when set
against the more 'militant' sounds of punk and reggae, it nonetheless 'opened
up a less fixed and more fluid space' (*ibid*.: 2).

This utopianism is present in the friendship between Chris and Caz, as
Chris just accepts Caz's sexuality without really thinking very much about it
in terms of race and sex. This vision is also underpinned in the relationship
that develops between Caz and Billibud whose lovemaking is accompanied by
Sylvester's 'You Make Me Feel (Mighty Real)', instead of punk (X-Ray Spex's
'Identity') or reggae (Junior Murvin's 'Police and Thieves'). The utopian space
the film celebrates is also most evident in the last scene of the film when the
film's main characters – black and white, male and female, gay and straight,
dance to El Coco's 'Let's Get It Together'. Gilroy suggests that although 'senti-
mental', the ending is 'a genuine attempt to find a "symbol"' for, precisely, 'the
anti-racist, polysexual, democratic aspirations' that the film had been advocat-
ing (Gilroy *et al*.: 1991: 19).

As Stuart Hall points out, the film rereads the politics of the 1970s
'through several other registers: sexual politics, the gay movement, the musi-
cal subculture, and so on' (*ibid*.: 17). Therefore, on the one hand, the film is
concerned with the exploration of gay male desire. In Homi Bhabha's words,
'it is sexuality – largely homoerotic or homophobic – that is the site on which
questions of race, social location and community are staged. Pleasure, desire,
eroticism and fantasy make cultural identification and political commitment
ambivalent, complex affairs' (*ibid*.). This is suggested in the characterization
of Ken whose ambivalent sexuality, a mixture of fear of and desire towards
the black men, leads him to kill TJ. On the other hand, the film seeks to
explore the realities of racism. It starts with the killing of a black man by a
white man, deals with crude bigotry displayed by the police on black
suspects. There is also the menacing presence of skinheads on the streets and
of National Front graffiti on the walls. In particular, the film is concerned to
counter the resurgent white patriotism and the nationalist discourse that was
associated with the Jubilee. In this respect, Gilroy argues that the film 'makes
bold claims for 1977 and the social and political movements that emerged
amid punk, the Jubilee, Rock Against Racism and the popular anti-fascist
politics of the period' (*ibid*.).

Welcome II the Terrordome and *Babymother*: populist militancy and musical extravaganza

Ngozi Onwurah's debut feature, *Welcome II the Terrordome* (1994) is the first
independent feature directed by a British woman of African descent. Produced
by her company Non Aligned Production (formed with her brother Simon
who oversaw the production of the film as producer) in conjunction with
Channel 4 and Metro Tartan, the film is a dystopic political action thriller.
Writing about the four feature films, including *Welcome II the Terrordome*,

released in the summer of 1994, Nick Roddick describes Onwurah as one of the so-called 'multiplex generation' of young British directors who 'whole-heartedly embrace the popular, from a distinctly British perspective' (1994: 28). Indeed, *Terrordome* clearly intends to be popular with its extensive use of hip-hop soundtrack and genre underpinnings.[12] However, the film (that Roddick describes as 'an ambitious, angry allegory of race relations...a serious political argument') is least 'distinctly British' in its intercultural concern with more global questions of race and identity. Mostly set in the decaying and racially segregated city of the near future where the main economy is drug dealing, and where two rival gangs fight for business with white customers from outside the city. On the soundtrack we hear excerpts from speeches of Malcolm X:

> Until the American Negro lets the white man know that we are really really ready and willing to pay the price that is necessary for freedom, our people will always be walking around here second-class citizens, or what you call, 'twentieth century slaves'. The price of freedom is death.

The film attempts to explore the devastating psychological effects inherent in the history of slavery, connecting the events from the past and the future across the Atlantic, however in its endorsement of militarism, the film is a highly disturbing and disrupting call for action. In fact, its unflinching militancy has come under severe criticism. Most notoriously, Paul Gilroy in his *Sight & Sound* article, condemned the film as 'unimaginatively bad, artistically and conceptually inept, the script an embarrassment, the narrative incoherent, much of the acting risible'. According to Gilroy, 'through the film's oppor-tunistic, pseudo-political flirtations with racial absolutism and misogyny', 'the modest gains [of black British cultural activists] of the last 20 years will be placed in jeopardy' (1995: 18). Indeed, the film's stark black–white essential-ism is most problematic in that the characters are almost the personified myths of blackness and whiteness. With colour being the definitive divider of *Terrordome*, the film in fact offers no hope for interracial harmony and peace-ful coexistence, let alone successful interracial relationships.

Nick Roddick stated that the film sets 'action and atmosphere above moti-vation, camera movements before characterisation', creating world and rules of its own 'in much the same way as modern Hollywood action movies do' (1994: 28) but the film's disastrous performance at the box office, despite its enthusiastic hype to a well-targeted young black market through its attitude, content and music in particular, still remained very much an art-house movie for its target audience.

Babymother (1998), following in the wake of *Young Soul Rebels* and *Welcome II the Terrordome*, also represents an attempt to fashion a more commercially oriented black British film than had been the case in the 1980s. As the film's director points out, the film 'was not conceived as anything other than a mainstream movie' (Henriques, in Wambu and Arnold 1999: 27). It is Julian Henriques' first feature, a former art documentary filmmaker, most

notably for the BBC's *Arena* programme and it was produced through Formation Films (a company which Henriques runs with his wife and producer Parminder Vir), funded by Channel 4 and some money from the National Lottery through the Arts Council of England. Heavily (and slightly misleadingly) marketed as a 'reggae musical', *Babymother* is the first feature on the vibrant black scene of dancehall culture to receive a commercial (although limited) release in the UK. Shot on location in Harlesden, west London, using largely non-professional actors, the film is also seen by many as a natural progression and expansion of the preoccupation of his 1992 Channel 4 docu-drama *We the Ragamuffin*.

Babymother tells the story of Anita (Anjela Lauren Smith), a young black woman who raises her two children with the help of her mother Edith (Corinne Skinner Carter) on a housing estate in Harlesden. Her babyfather Byron (Wil Johnson) is a local reggae star, who casually invites her to perform in his show but is too obsessed with his stardom to follow up the offer. Angry and frustrated, Anita is determined to set up her own act with her best friends Sharon (Caroline Chikezie) and Yvette (Jocelyn Esien). The film's plot follows the efforts of Anita and her girlfriends as they cajole, manipulate, bully and flirt their way to their goal: a chance to rule the local dance hall with a successful recording.

This storyline, however, as Stuart Hall notes, 'is merely the thin scaffold for the elements that really give *Babymother* its vitality and raw energy, which have everything to do with the dancehall scene' (1998: 25). A defining and distinctive feature of the film is Anita and her group's transgressive desire to make it in the dance hall, an environment previously male dominated. As Hall puts it, 'the girls' taking of centre stage, putting their new-found independence (or, not to mince words, "pussy-power") into the music and their bodies fully on the line … represents the capture and overrunning of the last bastion of the male-dominated reggae scene' (*ibid*.). Leone Ross also describes the main strength of *Babymother* as 'the fact that it introduces an international viewing public to a very accurate visual representation of women like Anita and her friends – working class, Black British women in an unapologetic world of their own' (1998: 20). Designed to lend emotional depth to the portrait of Anita's life and social context to the story, these scenes feel as if they have been conceived and directed in a different register, owing more to well-made, social–realist British television drama than to the exuberant stylisations of the musical' (Hall 1998: 26). As such, this effort to make a serious film about black popular culture within a cinematic format of musical entertainment suggests the film's 'generic angst', which in turn holds its potential to be a commercially successful feature.

Concluding remarks

This chapter has tried to show how black experimental films of the 1980s explored 'black' identity in postcolonial Britain, breaking away from the established modes of social realism and an identity-crisis point of view that

had been the main characteristic of black British cinema in its early stage. Accounting for the strategy involved in the production of *Territories*, Isaac Julien has commented:

> Up to now there have only been linear narrative films and realist documentaries and in a sense they are the modes that have been considered as the natural and accepted types of films for black filmmakers to make. We have to try and break away from that, and try to create space for other kinds of intervention. (1985: 5)

In this respect, Fusco argues the new black films 'implicitly disrupt assumptions about what kind of films the workshops should make and about what constitutes a "proper" reflection of the underrepresented communities from which they speak' (1995: 312). Similarly, Dick Hebdige suggests the new generation of black film-makers are 'finding a distinctive voice and vision for black Britons – a vision and a voice which challenge the established fixings of both "black politics" and "black films"' (1996: 141).

The emergence and development of these new black films in the 1980s reflected the conjunction of several factors, which include the rise of a multicultural policy that led to changes in funding policy, and an intellectual climate characterized by the disintegration of 'master narratives'. Indeed, the films belong to a specific historical moment of a specific social formation, functioning as alternative space in a decade of increased cultural and political activism. In these films, the implicit challenge of footage/montage practice to aesthetic conventions of individual authorship, memory and vision was exploited as a problem of subjectivity, authority, and most importantly, history. The end of an era, then, as Manthia Diawara suggests, was indicated 'with the return of authorship, implicit in the fame associated with names such as Julien, Akomfrah' (1993: 159).

In a somewhat controversial discussion on black audiences and black aesthetics, John Akomfrah has claimed that 'on the whole nobody in the British industry was interested in a black cinema. The only time they started thinking about it was when they realised that a pornographic display of black life was worth some money'. Pointing out the audience's demand to duplicate a kind of certainty that African-American film embodies based on a simplistic comparison between black British and black American film popularity, Akomfrah also argues that 'the idea that by some miracle this fifth column called black British commercial film-making is going to break through is baloney. It's a massive exercise in wishful filming' (1993: 14). What Akomfrah is criticizing here is not the wish to make or see mainstream black British films, but the situation that does not allow different kinds of black film-making. Indeed, the major question asked today is, as Sarita Malik puts it, '"who is going to watch these films?" – a question with direct reference to audience size, ratings and box-office success and directly related to the vexed issue of distribution' (2002: 171). Wishful filming or not, despite their efforts to broaden the audience base, black British films of the 1990s have ultimately

failed to cross over from relatively selective, small-scale, art-house audiences to larger and commercial ones.

To the question why there aren't more black themed films made, Julian Henriques said that 'basically when you say black movie you just about doubled the stakes in the eyes of the backers' (Henriques, in Wambu and Arnold 1999: 26). This industry-wide deep-seated anxiety about black film is reflected not just in the small numbers of black films made and released, but also in the films themselves. As examined above, the genre films are unsure of what kind of films they aim to be – while using popular cinematic formats, the films in various ways attempt to explore contemporary critical discussions of the way blackness is represented and seen in British society. For instance, Isaac Julien's *Young Soul Rebels*, as Stuart Hall notes, is 'a film about black soul music, sexual politics and growing up black and male in London, a political thriller and a film noir rolled into one'. It is, as Hall puts it, 'as if [the black filmmakers] are seduced into trying to realise all the movies they have in their heads in one go, in case they never get another shot at it' (Gilroy *et al.* 1991: 19). All this suggests the difficult position from which black film-makers have to negotiate while trying to survive in the free market that has been increasingly reluctant to support black films.

Notes

1 Black Audio's members, John Akomfrah, Lina Gopaul, Reece Auguiste, and Avril Johnson attended Portsmouth Polytechnic. Sankofa's members were primarily from arts and communications theory backgrounds. Nadine Marsh-Edwards studied mass communication and sociology at Goldsmiths' College in London and Isaac Julien went to St Martin's Art School.
2 This is partly due to the fact that black films by definition are marginal to mainstream productions and their analysts, which led black film-making practices to become self-consciously informed about theory and articulations of media and society.
3 Lesser-known features of black film-makers are *Smack and Thistle* (Tunde Ikoli, 1990), a thriller-cum-love story, and *Ama* (Kwesi Owusu and Kwate Neen Owoo, 1991), a psychodrama that was hailed as a rare example of 'magic realism' mostly set in Ghana.
4 Ceddo's *The People's Account*, now more famous for being censored by the Independent Broadcasting Authority, is a film about the community's view of the 1985 riot in Broadwater Farm in Tottenham (London). The film focuses mainly on policing, comparing the police's treatment of black people in Britain to the treatment of blacks in apartheid South Africa. It accuses the police of 'terrorist raids against black communities', and describes black people as victims of police racism, and calls the events of Broadwater Farm a 'classic example of self-defence'. Ceddo film crews have been present among the crowd to film the police at various riots, and the original footage from the Ceddo archive has been used in other workshop films such as *Handsworth Songs*. See Mercer (1988: 58–9).
5 African-American scholar Manthia Diawara also claimed that 'by 1986 ... a new film language had been forged that marked a significant departure from race relation films that constructed black presence in Britain as a problem, from white

independent cinema that rendered race invisible, and from diaspora and Third Cinema films that lacked cinematic pleasure and took ambivalent subject positions' (1993: 151).

6 Jim Pines notes that *Burning an Illusion* in particular marked an important advance in terms of addressing questions of 'race' and black cultural politics in black narrative fiction. The film is not concerned with 'race relations' as such but focuses instead on how personal relationships particularly between men and women within a black community change with black consciousness and cultural politicisation. See Pines (1988: 32).

7 Such commentators include Paul Willemen and Coco Fusco. Willemen described black British cinema as constituting 'the most intellectually and cinematically innovative edge of British cultural politics' (1989: 28). Fusco claimed that Sankofa and Black Audio's 'insistence on shifting the terms of avant-garde film theory and practice to include an ongoing engagement with the politics of race sets them apart from long-standing traditions of documentary realism in British and Black film cultures' (1995: 306).

8 Attille also accounted that 'it was important to document the visibility of public protest/demonstration, particularly at a time when those forms of public protest are increasingly threatened by public order legislation' (*ibid.*).

9 The Black Audio Film Collective's press release chronicled the success of *Handsworth Songs* and described its successor *Testament* as follows: '*Testament*, Black Audio Film Collective's new film, has won the 1988 Grand Prize at the Rimini Cinema International Film Festival in Italy. The award follows *Testament*'s premiere at the Cannes International Film Festival (May) and its subsequent screenings at the Munich Film Festival (June), Montreal World Film Festival (August), Toronto Festival of Festivals (September) and its British premiere at the Birmingham International Film Festival (September)'.

10 An equally important phenomenon of the 1990s was the emergence of mainstream British films featuring interesting black characters, in feature films such as *Crying Game* (dir. Neil Jordan, 1992) and *Secrets and Lies* (dir. Mike Leigh, 1996). These films undoubtedly demonstrate the integration of black film professionals into the existing industry, but they cannot be considered as black films here as they do not provide the black perspective.

11 The cardboard queen (at the entrance of Metro Radio Station building) is a very suggestive use of queen and the crown, transforming while at the same time undermining what they stand for. Another example of this is the Union Jack. A white punk wears (or sticks) his Union Jack-designed underpants on his back in a party scene.

12 The title of the film is said to be taken from the music of the rap group Public Enemy.

Chapter 9

You've Been Framed: Stereotyping and Performativity in *Yasmin*

Peter Morey

The period since the terrorist attacks of September 11 2001 has seen a spate of film and television dramas about Muslims in the West, usually in the context of Islamic terrorism. This chapter argues that the position of the Muslim communities in Britain, as they appear in a range of contemporary public discourses and forms of representation, is circumscribed and framed by a normalizing agenda. I suggest that this agenda works to recognize the subjectivity of Muslims through a split register that operates as both performed identity and yet at a deeper level, also sees that subjectivity as based on an essential ontology characterized by difference.

There are numerous instances of this divided construction. For instance, it inhered in the rhetoric of the former Prime Minister Tony Blair's foreign policy speech delivered in March 2006. His call for Muslims to join 'us' in 'modernity' was embedded in the speech as a requirement for performed action: in part an applied re-formation of Muslim theological interpretation to bring communities into the fold of modernity. Seeking to defend his government's 'interventionist' foreign policy from its critics at home and abroad, Blair aimed to distance himself from the idea that Islam and its adherents were inherently antipathetic to western modernity. In an argument nevertheless replete with well-established binaries, the Prime Minister insisted:

> This is not a clash *between* civilisations. It is a clash *about* civilisation. It is the age-old battle between progress and reaction, between those who embrace and see opportunity in the modern world and those who reject its existence ... This is, ultimately, a battle about modernity. Some of it can only be won within Islam itself.[1]

Yet, despite the evident intention of Blair here to acknowledge Muslims as active agents and co-participants in modernity, just a few months after this speech, a security officer detailed to protect the Prime Minister was relieved of his duties since his 'Muslimness' – now perceived as an essence – constituted a possible security threat.[2]

This example give an indication of how official discourse in Britain on Muslims constantly vacillates between a notion of improvement and a latent conviction by some sections of the press and society of inherent regressive characteristics. In this respect, as Paul Gilroy has shown, it directly inherits colonialist tropes wherein the native is, at one and the same time, the object of the improving intervention of the colonizer *and* a hopelessly recidivist type whose very ontology negates this missionary project (2004a: 67–9). There is a clear continuity with colonialist thinking whereby modern social development is read in temporal terms, through an evolutionary sequence and a posited clash between 'advanced' and 'backward' civilizations. In *Time and the Other*, Johannes Fabian has called this thinking 'the denial of coevalness'. He explains the notion as 'a persistent and systematic tendency to place the refer-ent(s) of anthropology in a Time other than the present of the producer of anthropological discourse' (1983: 31). It alerts us to the need to rethink the means by which such structures of representation are created and circulated to take account of the double bind in which Muslims repeatedly find themselves framed and already 'read'. In particular, we need to address the processes and effects of stereotyping here.

In the field of postcolonial studies, the most immediately familiar paradigm for understanding the colonial stereotype is probably that constructed by Homi K. Bhabha in his essay, 'The Other Question: Stereotype, Discrimination and the Discourse of Colonialism' (1994: 66–84). Here Bhabha draws on Freud's notion of the fetish and Lacan's idea of the Imaginary to suggest the psychoanalytic coordinates of the colonial stereotype, which simultaneously articulates both fear of the Other and desire for the Other. His account is a useful and compelling explanation of stereotyping as a kind of blowhole for repressed impulses. This theory, which Bhabha originally applied to the colo-nial situation, also lends itself to an understanding of contemporary forms of racial 'denigration'. Bhabha's psychoanalytic focus here appears to locate the stereotype in discrete pathologies, implying that they are an ever-present feature of the individual psychological landscape which then finds its way into the public sphere – although he does not specify how. What Bhabha tends to overlook are the means by which stereotyped images are circulated, especially aspects of the dialogical process adopted in the projection and recognition of stereotypical images, and the ever-changing historical context in which the meaning of such images is constantly being made, broken and remade in different ways. However, there is a suggestive moment in Bhabha's essay when he considers how the stereotype, which he describes as based on the suppos-edly 'already known', must nevertheless be anxiously restated time and again: 'the *same old stories* of the Negro's animality, the Coolie's inscrutability or the stupidity of the Irish must be told (compulsively) again and afresh' (*ibid.*: 77).

This chapter is interested in tracing these 'restatements' of the stereotyping process as they are manifest in the visual media through performance, metonymy and framing.

Despite its essentialist function, the stereotype actually works as an inherently dialogic structure and as an example of discourse in action rather than located in the unchangeable psyche of individuals. The 'same old stories' are constantly born and reborn from the constructed consensus shared within given speech communities. Mikhail Bakhtin reminds us of how the word (or the text) exists in specific social contexts, registers and moments of utterance and reception (Allen 2000: 11). Language and texts bear the imprint of institutional, national and group interests. So there is no such thing as neutral language. It follows that both the negative stereotypes that have been reanimated recently, as well as those cries for 'positive representation' that have arisen from more progressive elements in the media and in the embattled stereotyped communities themselves, are also inherently dialogical. They call out to each other and answer each other antiphonally.

However, it should be understood that this relationship is dialogic and not simplistically dialectical. This is not a situation where bad stereotype clashes with good stereotype leading to some sort of facile synthesis offering an 'accurate, realistic representation' that will correct previous misrepresentations and satisfy all parties. As Elizabeth Poole has observed of news discourse, it is not the case that the 'true' representation lies somewhere between the two extremes, since this 'presupposes that that there is some neutral image that could replace the distorted'. Rather, current practices reduce 'the rich variety of [Muslim] life to a simplified framework informed by "Occidental cultural legacies" that are transmuted within contemporary political conditions' (2002: 252). In other words, the necessities of certain political discourses shape and give form to representation. Therefore, while recognizing the need to challenge the invidious nature of negative and prejudiced stereotyping, we also need to acknowledge stereotyping as necessary to meaning, to making sense of the world.

The idea that stereotyping has social utility and validity has been more readily acknowledged and explored by theorists of social identity. The model of media stereotyping I am proposing in this chapter owes something to the work of the social identity theorist, Henri Tajfel as outlined in his book, *Human Groups and Social Categories*. Stereotypes, he suggests there, have three overlapping functions. There is a 'social causal' function where the stereotyped group is seen as the cause of an event such as economic recession or acts of terrorism; a 'social justificatory' function – stereotypes are created to justify behaviour towards a given group as in the denigration of the Other in colonialism or slavery; and, third, a 'social differentiation' function, wherein differences between groups are accentuated in favour of one group over another. This last function is particularly observable at times when the distinction between groups appears under threat – as in the present multicultural western world (Leyens *et al.* 1994: 70–1).

In order to apply these theories to British film and television drama I note

that the stereotype tends to be articulated through an implicit distance posited between the viewer (the normalized subject) and the Muslim object of the gaze, whose 'difference' is always in view. This process of differentiation, heavily marked by racial value judgements, I call *ethnonormativity*. The ethnonormative space is the viewing space brought into being by the narrative tension between the contending groups depicted: for instance, host community versus alien 'wedge'. Its characteristics are defined according to whether the viewer is empowered to recognize ambiguities and ambivalences in relations between these groups, or whether he/she is merely expected to choose between predetermined ideological positions. This is the difference between the comparative banality of the 'good guy–bad guy' paradigm on display in a TV programme such as the US drama, *24*, about the 'real-time' adventures of a counter-terrorism unit, and more sophisticated modes where some degree of self-reflection about a national normalization project is evident. I am not concerned here with the issue of *how* productions are viewed and received either by their target demographic nor the communities they stereotype. Rather, I am interested in the processes of signification: the form, content and context of stereotype construction and the ethnonormative space the viewer is being invited to inhabit. Such signification takes place through recurring tropes and images which then effectively delineate the sanctioned discourse, or frame, through frequent repetition. As Elizabeth Poole has said, 'An event or action has to be indicative of some kind of essential "Muslimness", an idea of Islam, to be featured as such' (2002: 81). I am interested in how this process happens and hence, how certain discursive effects are produced by the processes of stereotyping.

On a formal televisual and cinematic level Muslims are most often conjured up through metonymy: Muslim women wear the hijab, men appear bearded, praying or both.[3] A Muslim in film and television drama is required to perform in certain recognizable ways: those deemed *significant* for the group by the conventions of the form in which they are being represented. In this respect, the 'indexing' process is similar to that outlined by Roland Barthes in his well-known essay 'Romans in Film', where the essential 'Romanness' of the characters in Joseph Mankiewicz's film, *Julius Caesar*, is guaranteed by the shared tonsorial indicator of the fringe. The beard of the Muslim patriarch, the hijab or burqa of the Muslim woman, or the act of prayer itself perform the function of signs which, in Barthes's terms, overshoot the target and make themselves visible *as* signs, remaining on the surface even as they seek to pass themselves off as depth (2000: 26–8). However, this arrangement of elements is not merely innocuous or incidental. Rather, in any given ethno-religiously marked drama involving Muslims, the stereotype works in three ways: first to *establish a location* in the manner of a cinematic establishing shot; second, to create a *milieu* – the Muslims under scrutiny will be placed in relation to a larger surrounding community figured, if only inadvertently as 'the norm'); third and most importantly, *to connote cultural values that are in some way discrepant with those of the norm*. This mode works so smoothly for film and television because Islam is a religion outwardly marked by cultural ritual and

performance: fasting, pilgrimage, dress, prayers, and so on. Religious commitment and, increasingly recently, ideological orientation in relation to a national norm can be visually represented through such exterior markers of identity.[4]

I want now to put some of these ideas to the test by considering the UK Channel 4 film, *Yasmin*, written by Simon Beaufoy and directed by Kenneth Glenaan in 2004. The film explores a young British Asian Muslim woman's experiences in a working class town in the north of England after 9/11. This central character, Yasmin, coexists uneasily with the demands of her traditionalist father and the community of which they are part, while also carrying on a clandestine relationship with John, a white male fellow worker. Her split identity is 'performed' for the viewer and signified in the way she is frequently depicted changing from the shalwar kameez and dupatta of her domestic life to the tight jeans and crop top she favours when working and socializing with the surrounding white community, and back again. Such performativity serves to collapse complex negotiations into a comparatively crude metonymic signifier of difference, and alerts us to the fact that the film as a whole operates through an *economy of alterity*, albeit sympathetically handled, wherein a representative Muslim community *in extremis* is visualized performing difference for the ethnographic gaze of the camera. Within such performances lurks once more the question of modernity: can these Muslim characters be pulled into the orbit of a modernity which is increasingly defined by draconian anti-terror laws and surveillance? Can they be dragged there through the operations of white peer pressure, fissiparous domestic struggles or the repressive apparatuses of the police and security services that raid Yasmin's community in search of terrorist accomplices after 9/11?

The plot of the film is simple, as befits its drama-documentary origins. The focus is on Yasmin's family and its immediate environment, and the effects of the 9/11 terrorist attacks and subsequent implementation of new anti-terror laws. Yasmin herself begins by straddling the cultural divide between the British–Pakistani community of which she is a part and the surrounding white English society. After 9/11, her fellow workers turn on her: someone draws a beard on a picture of her; a note reading 'Yas loves Osama' is pinned to her locker; and an unsympathetic personnel manager suggests she takes some 'time off', supposedly while things cool down following the 9/11 attacks. Worse follows when Yasmin's home is violently raided by an anti-terror police squad alerted by some telephone calls her husband has been innocently making to a cousin in Pakistan who may or may not have links to Kashmiri separatists. After this watershed event, the chasm between communities is exposed and Yasmin and her brother 'rediscover' their Muslim identity. He is radicalized by propagandists who distribute leaflets outside the mosque and hold recruitment meetings where photos of slaughtered Muslims from the world's war zones are shown. She experiences rejection and hostility from those she once thought of as friends, bridles at the injustice done to her husband, and also finds herself temporarily detained for supposedly withholding information about her husband from the police investigating officer.

In publicity interviews the film-makers were at pains to emphasize *Yasmin*'s credentials as a piece of realism that emerged from extensive research and workshops among the Muslim communities in the mill towns of Yorkshire and Lancashire, and that mixed together professional actors with performers drawn from the local population. Writer Simon Beaufoy pointed out that the experiences of the eponymous central character were based on a true story and that the plotline as a whole was built up from the stories shared by people in the communities (*Start the Week*, BBC Radio 4, 10 January 2005). The director, Kenneth Glenaan went further:

> We haven't made anything up in the script – the poetic licence is in amalgamating all those stories and squeezing them into an hour and a half and into one family. Hopefully we're being as representative ...as we possibly can be ... What we were trying to do is to give people a bit of dignity, really, without being too grand about it – giving people a voice ... I think what you get is a really interesting tone, deliberately blurring the lines between fiction and documentary.

As the comment about 'giving people a voice' might suggest here, in dealing with its object the documentary realist form is forced repeatedly by the film-maker to seek out ways to make knowable the operations of a community assumed by the filmmaker to be outside the ethnonormative framework of its national audience. I would argue that in order to do this the film falls back most often on conventions of representation which have their roots in the twin projects of colonialism and Orientalism, as defined by Said ([1978] 1991). These, in turn, have the effect of positioning the Muslim community as an outsider one and in conflict with the forces of statist modernity: in effect, re-enacting and reinforcing that problematic colonial binary most recently reanimated by Bush and Blair. *Yasmin*'s scrupulous concern to present a Muslim point of view becomes, in effect, a positivist illusion taking the form of naive realism. The outward performance of identity operates to 'confuse the sign with what is signified' in what Barthes describes as 'a duplicity that is peculiar to bourgeois art' (2000: 28). As Homi Bhabha puts it in the context of colonial stereotypes: 'colonial discourse produces the colonised as a social reality which is at once an "other" and yet entirely knowable and visible ... [To do so] it employs a system of representation, a regime of truth, structurally similar to realism' (1994: 70–1).

From this perspective, Muslims must appear on the screen with their 'Muslimness' marked out in some way. Their existence as subjects in any other sense is effectively voided. Yet, at the same time as the Muslim 'essence' is made visible, its difference from the normalized community around it is underlined. Muslims exist for us on the screen as mere traces. Christian Metz has described how the power of the cinema image lies precisely in its ability to simulate presence in the face of actual absence. As paraphrased by Antony Easthope:

Film presents objects, figures, landscapes, cities and the bric-a-brac of everyday life with a breathtaking actuality not possible from any other means of representation ... but only on condition that those very objects, figures etc. are placed somewhere else, 'made present' on the screen 'in the mode of absence'. (1999: 135)

When it comes to the representation of Muslims in contemporary film and television the tendency is for individuality and specificity to retreat behind the all-encompassing signs of 'Muslimness'. However, the attempt to comprehend the Other simultaneously marks its distance from 'us', indicating that lack in the imagining of the nation figured by those immigrant communities not deemed to be playing by 'our' rules. Such a system of ethnonormative othering appears in *Yasmin* in a number of guises.

In the opening scene, for instance, we are introduced to the central characters: Yasmin, her father and her headstrong and wayward brother, Nasir who also, we learn, deals drugs despite dutifully issuing the call to prayer from the local mosque. There is also her husband, Faisal, fresh from Pakistan and pejoratively referred to by other characters as 'Banana Boat'. Yasmin feels no affection for Faisal but has been persuaded by her father to marry him so that he gains residency rights in Britain. As the story moves on, it becomes clear that the requirements of the docu-drama form necessitate Yasmin's family carrying the burden of representation for a whole community and all three main characters, father, daughter and son, must operate as stereotypes. Yasmin's father is the hard-working, yet disappointed, first-generation immigrant from Pakistan who owns a television repair shop and holds the keys to the local mosque whose protective shutters he carefully cleanses of racist graffiti. Yasmin is the would-be dutiful daughter who takes the place of her dead mother by cooking and cleaning for her male relatives, while covertly enjoying the 'western' lifestyle and social opportunities her workmates provide. Nasir, meanwhile, embodies the dilemmas of both masculinity and consumer culture, with his penchant for designer trainers, bling jewellery and the sense of power afforded by the sexual conquest of white girls.

The visual motif of Yasmin surreptitiously changing clothes, a metonymic signifier of her split identity, is foregrounded right at the start and recurs throughout the first half of the film. At the same time, in the opening scene, the introduction of the main characters is interspersed with long shots of Yasmin's anonymous Muslim neighbours framed against the rundown streets and back-to-back houses of a Victorian town in northern England. Thus, they are 'situated' but also, at the same time depicted as 'out of place', as not belonging. This prepares us for the idea of a group under siege from a wider host community, but it also emphasizes the ethnographic role of the camera that can take us into the world of this Other community. The long-shot point of view is repeatedly used and intended as a marker of objectivity. However, when viewed in the context I am suggesting, it may remind us of Bourdieu's injunction about the dangers of 'objectivism' for the ethnographer who views those she studies from a vantage point inevitably marked by difference and projection:

Objectivism constitutes the social world as a spectacle presented to an observer who takes up a 'point of view' on the action, who stands back so as to observe it and, transferring into the object the principles of his relation to the object, conceives of it as a totality intended for cognition alone, in which all interactions are reduced to symbolic exchanges. (Fabian 1983: 141)

In *Yasmin* our relation to the object on view is that of outsider: this time through the culturally performative moment of the muezzin's call to prayer, set against the fields and dry stone walls of northern England and interrupted by a shot of satellite receivers appended to the walls of houses. And the symbolic exchange we are invited to participate in is an insight into an Other culture, in other words, we are offered essentially anthropological knowledge.

In the film, Yasmin is pulled this way and that by contending desires and obligations. Post-9/11, and after the police raid on her home, her decisions are presented as a choice between binary opposites: to accept one identity or the other, with never a suggestion that this may be an impossible outcome. Once more, her inner turmoil is metonymically signified through dress. She begins by wearing a simple, loose dupatta which occasionally slips back, exposing her hair. However, near the end she is shown clad in the much more tightly fitted black Al Amira-style veil, which covers the head and is fastened around the chin, revealing only the face. She is now on the way to the local mosque, having been awoken to her 'true' identity by a night in the police cells and a rediscovery of the Qu'ran.

Indeed, for both Yasmin and Nasir their increasing alienation from valorized versions of Britishness and journey towards a renewed Islamic identification must always be performed for the anthropological gaze of the camera. Their lives are transformed to the ironic accompaniment of juxtaposed excerpts from the contemporary speeches of George Bush and Tony Blair, about how the United States, unlike the terrorists, values every human life, and how British law is to be changed, not to deny 'basic liberties but to prevent their abuse'. Yet God, liberty and equality – so casually invoked by the political leaders seem to have withdrawn from this world, leaving it free for the police cars that slowly patrol the streets around Yasmin's home, the helicopters that buzz menacingly overhead, and the plain-clothes officers who try to persuade Nasir to inform on the agent provocateur who has appeared in the community and who distributes leaflets outside the mosque. In an awkward attempt to compensate for her now alien Muslimness, Yasmin tries to blend in with her friends from work by ordering a vodka at the bar they frequent. Yet faced with indifference and racist sniping, she overindulges and ends up drunkenly abusing a Muslim cleric who appears on the television. Her lover John unwittingly articulates the sense of difference that has intruded upon their relationship when he explains to Yasmin that no one has 'said sorry' for the Twin Towers attacks, after which she apologizes loudly to the whole bar before heading home to vomit up the bitter fruit of the night's excess. The pendulum of performativity, by which questions of identity are visualized in

this film, begins to swing the other way for Yasmin when, after the police raid, she dons her hijab and looks closely at herself in a mirror at home. A similar process is played out with Nasir. His natural rebelliousness is re-channelled after the raid in which a gun is put to his head, and he finds himself drawn to the message of the radical propagandist that requires of the 'good Muslim' some positive action to alleviate the sufferings of his brothers and sisters. In a gesture rather clumsily symbolic of the distance he is now to put between himself and his previous uncritical consumerism, he throws his mobile phone into the local canal and strides off into the black mouth of a railway tunnel, supposedly signifying his journey into the unknown.

The nature of Yasmin's marriage is at the heart of her gendered position as a Muslim Asian woman in the film, and gives scope for more performative signification and cultural stereotyping. Not only is she required to perform the multiple roles of daughter, wife and sympathetic older sister, she is also placed under an obligation to accept as a husband a man chosen for her by her parents but with whom she has nothing in common. The emotional vice is tightened when it is impressed upon Yasmin that it was her late mother's wish that she marry Faisal. She keeps her marriage secret from John and determines that as soon as Faisal has leave to remain in Britain she will divorce him. At one point she tells Faisal that while they may be married she will never be his wife. After this, while wondering the streets, Faisal discovers a goat and takes it back home, allowing it to graze in the backyard. On one level it becomes a companion for him, and thus, as he affirms, a surrogate wife. The goat has an ambiguous symbolic valence in the film, standing both for 'backwardness' – what is he doing, walking around with a goat on a lead in a twenty-first century British town? – and also for the affective connections Faisal has been unable to find in the strange country to which he has been sent, clearly also against his will and simply out of duty to the family.

We first see Faisal rising drowsily from the mattress on which he sleeps in Yasmin's spare room. Subsequently, he is shown cooking his meal outdoors on a makeshift stove set up in the yard. In deeds and words he is depicted as occupying a space outside that of the other characters. While their everyday lives bring them into contact with a surrounding white English community where they are increasingly viewed with suspicion and thinly veiled hostility, Faisal lurches through his new life, baffled at his wife's coldness, but with enough self-esteem to rebuff the attentions of the ageing white prostitute who patrols a local street corner. Crucially, he knows almost no English, and communicates with Yasmin in Punjabi. It is this lack of linguistic and cultural knowledge that adds to the nightmarish quality surrounding his arrest. The police raid Yasmin's home in search of Faisal, the originator of the suspicious calls to Pakistan, but he is out. Instead, the rest of the family are pinned to the floor and detained. He himself is only picked up when he comes home to find the house deserted and ransacked and then approaches the police to find out what has happened.

Faisal is locked up, first in the local police cells and thereafter at a detention centre where the high brick wall, topped by surveillance cameras symbolizes

both the insurmountable barrier to intercommunity understanding that has now arisen and the intrusive operation of technological statist modernity of the kind which appears to have swallowed him up. He is required to 'inform' on those with whom he has been communicating. When he fails to yield the information his interrogators demand, they hold Yasmin as well. In one of the most significant exchanges between Yasmin and her interrogator the absurdity but also the comedic character of the situation is brought home:

> Interrogator: Under the 2001 Terrorism Act I could charge you with withholding information. You know that, don't you?
> Yasmin: What information?
> Interrogator: You tell me.
> Yasmin: I don't have any information. You don't know what information you're looking for, and I don't have any information, so I can't tell you, and you're gonna charge me with withholding that information: the information I don't have. How do I get out of that?
> [Silence]

It can be argued that the information Faisal is supposed to hold is sought by the police precisely because it allows a consolidation of national ethnonormativity by distinguishing those acts and connections that mark participants as being Other, not 'one of us' in a new dispensation wherein both President Bush and al-Qaeda can claim that not to be 'with us' is to be 'against us'. Inasmuch as this Self–Other dyad is central both to colonialism and identity formation more generally, it could be said that Faisal is being asked by the film to take up the position of Native Informant, first accounted for in Kant's *Critique of Judgement* (1790) and more recently analysed from a postcolonial perspective by Gayatri C. Spivak. Spivak critiques Kant's casually dismissive invocation of the inhabitants of New Holland and Tierra del Fuego as 'unnecessary' and useless instances of humanity. Rather, she argues that it is through the expulsion of these natives 'from the name of Man' that western identity comes to be inscribed. The figure of the 'Native' used in this way remains a blank – despite giving shape to the self-perception of his colonial master. Spivak proposes a postcolonial reading strategy which will produce 'a counter-narrative that will make visible the foreclosure of the subject whose lack of access to the position of narrator is the condition of possibility' of Kant's philosophy and thus of western identity itself (1999: 9).

Crucially, according to Spivak, the success of this project is dependent on the silence of the actual Native. He is made into a kind of silent informant, mutely yielding to the colonizer all that is necessary for the latter's self-constitution, and is never, himself the speaking subject. I would argue that Faisal, in *Yasmin*, acts as a kind of Native Informant, albeit a radically destabilizing one, both at the level of plot through his detention and at the level of the film's grammar, which is equally dependent on his position beyond the English-speaking characters we are being invited to identify with. On the one hand, he is expected, literally, to become an informant, telling his interrogators what

they need to know about Kashmiri insurgents (and, thus, potential terrorists) the better to police the bounds of national belonging and normativity. Yet at the same time, since he does not speak English, he is kept outside the mêlée of contending voices seeking to redefine British identity and determine and delimit the position of Muslims within it. As such, he embodies the idea of a counter-narrative, albeit a non-linguistic one, to set against the hardening attitudes of both sides.

After his release and subsequent divorce from Yasmin, Faisal wanders off with his goat, out of the movie and out of the claustrophobic world of this small Muslim community now changed forever by its entanglement with the repressive state apparatuses of modernity. Indeed, I would argue that it is this character, inarticulate and, in the terms of anthropological modernity, 'primitive', who most effectively manages to resist identification within a postcolonial economy based on racial and cultural difference. Precisely because he is a stereotype of a stereotype, overdetermined in the drama as out of place, rural and backward, he cannot be accommodated either by the British Muslim community with its emerging political awareness or by the enforcement agencies of national normativity, such as the police and politicians. His awkward presence parodies the emerging orthodoxy which brands Muslims as recidivist types fatally at odds with western modernity. He operates as a literal innocent abroad, a kind of Holy Fool, able to throw into relief the divergent and hardening perspectives of the newly radicalized Muslim political consciousness – as represented by Nasir, who eventually goes off to a terrorist training camp in Pakistan – and the paranoid operations of the nation state. Despite the best efforts of the police *and* the apparatus of performative anthropological realism, Faisal manages to evade capture by the film's binaries, wandering out of the frame near the end, accompanied by his goat.

His ambiguous position and uncertain destination makes him an example of what Spivak, drawing on Derrida, calls a 'lever of intervention': a moment 'of textual transgression … or bafflement that discloses not only limits but also possibilities to a new politics of reading' (1999: 98). While the other characters seem stranded, left to come to terms with the new ordinance that sees them as a national security threat, a man and his goat move offstage and out of the frame – headed who knows where? – in a radical moment of indeterminacy, as if beyond the film's control.

There is one earlier moment in this film that could also work as a 'lever of intervention'. It involves an elderly white woman who wanders into shot to comfort one of Yasmin's neighbours who has been the object of racist abuse in a shopping mall. Although the racist attack was a fictional element of the film, the shocked bystander wandering into shot to commiserate and apologies for what she takes to be a real-life event marks another moment of textual rupture within and beyond the narrative plot. At once, this moment registers the existence of a sense of white culpability for the fact that some northern Muslim communities, like those which would produce in the following year the 7 July London bombers, are excluded from the wider, racially inscribed notion of Britishness and belonging. It also marks a site of individualist decency and

fairness of the kind that was erased by the authoritarianism of the Bush and Blair governments and their rhetoric of so-called 'Homeland Security'.

Finally, considering the double bind of required performativity and ontological essentialism, I wonder whether we might interpret some contemporary expressions of Muslim identity such as the upsurge in veiling, demands for sharia law and so on as a kind of hyper-performativity whereby Muslim communities and individuals interpolate themselves into the framing narrative of irreconcilable difference. The question would then become whether hyper-performativity and the strategic assimilation and sometimes deliberate transgression of stereotypes offer a way to explode fixed ontological discourse, or whether they ultimately result in complicity in one's marginalization. But *Yasmin* does not set out to answer such questions. Instead, we are left with the image of a man walking out of the claustrophobic narrative space of the film, and a woman stumbling into it from outside. Both images have the potential to transgress the frame wherein the ethnonormativity of public discourses and certain cultural forms work to ensure the separation of the viewing and viewed subjects, and to keep Muslims 'outside' the nation and firmly in the media ghetto.[5]

Notes

1 'Blair Sees Iraq as "Clash about Civilisation"', and 'Tony Blair's Speech to the Foreign Policy centre', *Guardian*, Tuesday, 21 March 2006.

2 'Mosque Defends Firearms Officer Stripped of His Post', and 'Sacked Muslim Officer Wants Police Protection', *Independent*, Wednesday, 8 November and Friday, 10 November 2006.

3 A recent addition to the phalanx of Muslim stereotypes has been what we may call the post-Huntington stereotype. Here the Muslims who pose a threat to the ethnonormalized community of the nation are, in outward appearance, 'westernized'. As such they are difficult to identify, thus constituting an even more menacing 'enemy within'. The term 'post-Huntington' I derive from a passage in *The Clash of Civilizations* where Huntington attempts to describe those ostensibly culturally hybrid subjects who may nonetheless be drawn to terrorism: 'Somewhere in the Middle East a half dozen young men could well be dressed in jeans, drinking coke, listening to rap and between their bows to Mecca, putting together a bomb to blow up an American airliner' (1998: 58).

4 As Elizabeth Poole has observed, 'The supposed shift from skin colour to cultural practices as the "ethnic signifier" has increased Muslims' visibility, given that being a Muslim often comprises an explicit projection of both' (2002: 48).

5 I am indebted to Amina Yaqin for the idea of Muslims occupying a 'media ghetto' (see Yaqin 2001: 10–11).

Discourses of Separation: News and Documentary Representations of Muslims in Britain

Myra Macdonald

This chapter examines the pervasiveness of discourses of 'separation' in media representations of British Muslims in the early years of the twenty-first century. In this period, an anxiety about the separateness of Muslims intensified and converged with increasing political scepticism about 'multiculturalism' (Holohan 2006; Modood 2007). Disturbances on the streets of northern English towns in the summer of 2001, together with the reverberations of 9/11 in the USA and the 7 July bombings in London in 2005, fuelled worries that 'social cohesion' was being jeopardized by a wilful self-segregation of Muslims from a consensus spun around mythical British values. References to 'separation' in this chapter thus connote anxieties around both *separateness* and also what is perceived to be deliberate *separatism*. In particular, the chapter considers how 'separation' has been constructed as a 'threat' to the majority population, which is implicitly assumed to be non-Muslim, while Muslims themselves are routinely portrayed as primarily, or even uniquely, responsible for both causing and rectifying the 'problem' of perceived threat.

I will explore three differing manifestations of this concern in media discourse. The first involves a fear of the penetration of 'terrorists' into the heart of British society and emphasizes the invisibility of the perpetrators alongside the menacing shadiness of their global networks. Then I consider two media images: the mosque and the veil, which, conversely, act as highly visible markers of segregated space, along both gender and ethnic dimensions. Throughout, I will indicate how discourses of separation operate not only in terms of actual locations and material spaces but also psychic, metaphorical and ideological ones.

With each of the three case studies I aim to show how media representations are underpinned by a renewed accent on an imagined 'clash of cultures' and by complacency about the benign qualities of 'Britishness'. In these images non-Muslim Britain is repeatedly fêted as tolerant, fair-minded and open to difference, lacking any of the vestiges of imperialism and racism that would require separation to be seen as a two-way process.

My analysis will be conducted through a variety of examples from the media, both from television documentaries and from newspaper coverage of public debates around the veil that reached a particular point of intensity in October 2006. I begin by considering the increasing media anxiety about the 'terrorist in our midst' and the ease with which television documentaries slipped into reinvoking the 'clash of civilizations' discourse that was originally associated with Samuel P. Huntington (1993a). This 'clash' was now accentuated by being sited *within* Britain, not somewhere outside.

'Clash of civilizations': in a place near you

When Samuel P. Huntington wrote about the 'clash of civilizations' (1993a, 1993b), he argued that cultural divisions would replace ideological or economic differences in driving international conflict. As globalization weakened umbilical attachments to nation states, identities stemming from the 'seven or eight major civilizations' of the world, he suggested, would rise in significance. Huntington's thesis was not simply about the longstanding 'fault line between Western and Islamic civilizations' (1993a: 31), but it is this aspect of his work that has dominated subsequent debate. His claim that, 'On both sides the interaction between Islam and the West is seen as a clash of civilizations' (*ibid.*: 32), became a neat aphorism, widely referenced in political and media discourse post-9/11.[1] His focus on *culture* as the basis of enmity dovetailed neatly into the growing doubts expressed by official spokespeople in Britain about multiculturalism's capacity to smooth relations between Muslim and non-Muslim populations.

The 'clash of civilizations' thesis encourages us to perceive cultures in monolithic and oppositional terms. Media discourses of Muslim 'separation' largely bypass the complexity and diversity of Islamic ideologies that exist in Britain and ignore the disputation and difference which are an inevitable aspect of a religion that has neither a hierarchy nor a central doctrinal committee. Instead, they focus on the central Islamic tenet of *ummah*, the world community of Muslims. However this is rendered as an abstract and homogenizing entity that lacks all specificity and variety and has acquired monolithic and threatening connotations. Only on the fringes of mainstream media do differences in belief systems within Islam get an airing.[2] Before 2001, from the perspective of a West emerging out of the shadow of the Cold War, the 'threat' posed by Islamic culture and values was visualized as developing in 'remote' places. However, 9/11 brought the supposed Islamic threat startlingly close to home for inhabitants of the USA, and with 7/7, the London bombings of July 2005, came the revelation that the 'menace' in Britain was now homegrown. The discursive ground had shifted.

Relocated in the previously imagined safe space of home, the alien construction of the terrorist acquires fresh potency. Fear of strangers, and their conceptualization as a 'problem' or 'threat' originates, as Sara Ahmed points out, in the duality of their distance–otherness and their nearness–infiltration into 'our' spaces: 'The "stranger" only becomes a figure through proximity' (2000: 13). From the paedophile at the gates of the school to the suicide bomber on the streets of London, 'strangers' emerge as objects of intense vilification when they transgress presumed borders to penetrate apparently safe places, transmuting from the 'enemy outside' to the 'enemy within'.

In the wake of evidence that terrorists and suicide bombers could be British born, television reporters began regularly scrutinizing familiar landscapes for visible clues that would explain their cultural formation. Even before 2005, Britain's export of homegrown terrorism to Tel Aviv in Israel in 2003 attracted the kind of attention that was to become more routinely familiar in the wake of the 7/7 bombings. In the programme, *Britain's First Suicide Bombers*, the reporter, Kevin Bouquet visits the original UK home of Omar Khan Sharif, the Tel Aviv bomber whose device failed to go off. His commentary notes:

> What is really striking about this street where Omar Khan Sharif used to live is how completely ordinary it is, situated in a very quiet respectable area of the city. There is absolutely nothing …to suggest why a young man who grew up in that house behind me should have walked into a bar in Tel Aviv last night and tried to blow himself up. (BBC2, 11 July 2006)

The evident absurdity and futility of expecting physical environs to yield explanations of 'terrorist' proclivities is masked by the slippage from material to metaphorical conceptions of place: peaceful and 'respectable' streets transmute unobtrusively from real places to indices of the values of decency and non-violence which the reporter implies are quintessential hallmarks of Britishness.

This contrast between benign places and alien acts establishes a paradigm of British places as self-contained 'enclaves' with no historical or contemporary connections to a wider world. As cultural geographers have observed, in an increasingly globalised world we need to imagine places not as 'areas with boundaries around' but as 'articulated moments in networks of social relations and understandings' (Massey 1994: 154). From this perspective, specific places are neither static nor bounded, but informed by the social, cultural and political conditions of their past and present connections to the world 'outside'. It is rare for *any* documentary about Muslims to relate their experiences of British life to wider patterns of migration, post-industrialization or the impact of social policy on interethnic relations. Connections between present configurations of British places and histories of colonialism and imperialism remain largely unspoken in these media discourses.

A brief exception to this pattern of unspoken histories appears in a section of Charles Wheeler's documentary, *Culture Clash* (Channel 4, 9 March 2002). The programme sets out to explore how young British Muslims are dealing

with their claimed positioning between two cultures. Despite the evident allusion to Huntington's alarmist predictions in the programme's title and statement of purpose, one sequence takes us on a historical journey through Oldham, once a vibrant mill town in northern England, reminding viewers that when inwards migration was encouraged to cover night-working in the textile mills, differing ethnicities worked and socialized together. In the eyes of Wheeler's Oldham interviewees, current segregation owes much to socio-economic decline and the accentuating separation of Muslims and non-Muslims through educational and housing policies. This is an exceptional moment of insight. It contrasts with television's more customary enthusiasm for travelogues of terror which detach their visualized journeyings from any of the historical and policy influences that inform the social contours of current British communities.

Within these travelogues, presenters tend to construct Muslim spaces as threatening the bounded safety of a respectable, non-Muslim Britain because they appear to be harbouring hidden networks formed through shady global alliances. Robert Baer, a former CIA agent turned television commentator, has made a series of documentaries for Channel 4 tracking the global phenomenon of suicide bombing. In the first programme of the second series, his focus was on western involvement. On a journey to Beeston in Leeds, associated with two of the 7/ 7 bombers, Baer invites a local Asian businessman to guide him through the area (*Cult of the Suicide Bomber*, Channel 4, 11 September 2006). In the documentary, shots of boarded-up houses act as standard indices of urban dereliction, in this 'scrappy, rundown district in Leeds'. There is no attempt to offer any further commentary on the historic and social 'networks of relations' (Massey 1994) that shaped this place.[3] Instead, our guides zoom in on the Iqra bookshop which reputedly produced and sold 'jihadist' propaganda videos and acted as a focal point for the bombers. A fleeting exchange about the political motivation of the alleged ringleader of the 7/7 bombings, Mohammad Sidique Khan, is quickly elided by an extensive exploration of the hidden places within the bookshop where sedition was planned under global influences. Baer's commentary conjures up a propaganda-filled virtual space of corruption, reproducible anywhere, and detached from material conditions:

> Where did the 7/7 bombers come from? They came from within. Poisoned by the hateful ideology emanating from the Iqra bookstore, angered by Britain's foreign policy, indoctrinated by Khan – each bomber was a ready volunteer for martyrdom ... the cult of the suicide bomber had downloaded itself into the minds of these young British Muslims from Beeston. But they could have come from anywhere. (*Cult of the Suicide Bomber*, Channel 4, 11 September 2006)

The reference to Britain's foreign policy is fleetingly made, and quickly bracketed within the dominant narrative of an abstracted indoctrination from outside. An obsession with the international links of the relatively powerless

eclipses more searching investigations into the equally concealed networking of the globally powerful.

If 'terrorists' are lurking in 'our' midst, then the representation of 'ordinary' British Muslims as occupying different spaces from the rest of 'us' becomes a repeated refrain in documentary and current affairs programmes. This is the case even with reporters like Charles Wheeler and Jon Snow who have honourable track records in covering foreign relations without wearing ethnocentric blinkers but nevertheless reproduce a discourse of 'culture clashes' and 'separateness' when they investigate British Muslims. In Wheeler's *Culture Clash* (Channel 4, 9 March 2002), the premise underlying the programme's title ripples throughout the commentary. Modes of address are emphatically to a non-Muslim British audience. Wheeler's early musing: 'I do still wonder what it is that makes British Muslims so apart – is it us, or is it them?' establishes the nature of the assumed audience, but at least leaves open the possibility of mutual responsibility for 'separateness'. This reflexivity is not sustained for long. Reporting on the festive scenes on the streets of Manchester during Eid, he comments: 'on the face of it, a good-natured scene, though with an undertone of defiance of authority. Tonight, they seem to be saying, we're being Muslims, flying *our* flag, in *our* space'. The 'undertone of defiance of authority', invisible in the apparently good-natured behaviour of celebrating Muslims in the accompanying film footage, emerges from potential conflict with a substantial police presence. Despite mild criticism of the scale of the police operation, Wheeler fails to follow through the implied answer to his own question, letting 'our' state policies off the hook, and attributing potentially malicious agency to the 'defiant' Muslim celebrators alone.

In the *Dispatches* programme, 'What Muslims Want', Jon Snow starts a 'journey through the country' to find out (Channel 4, 7 August 2006). Despite declaring openly explorative intentions, the programme is inflected by the decision to base this *Dispatches* programme around an NOP survey reporting the views of 1,000 British Muslims. The effect of this emphasis is that, instead of accentuating the specific differences of origin, lifestyle or Islamic belief that are prevalent in different parts of the country, Snow's multi-ethnic backdrop becomes a conceptual space of separation. The audience is introduced to a series of multicultural places which turn quickly, through Snow's authoritative commentary and the programme's visual emphases, into spaces of division. Even although Snow is filmed repeatedly against the multi-ethnic flow of London and other city streets, the camera's lingering preoccupation with veiled Muslim women and bearded Muslim men interacts with the commentary to suggest social fragmentation, not cohesion, across the country. The occupation of separate cultural spaces identified in the survey frames the programme's approach: what our survey shows is that in effect integration has come to an end. Young British Muslims are less liberal, more religious than their parents, with many determined not just to be different but to be separate from the rest of the nation.

Separateness is what makes his subjects fascinating interview material, but fails to contextualize or illuminate their attitudes. Snow's frank discussions

with his interviewees certainly serve to counteract the potential menace of 'the other', but also increase the curiosity value of 'difference' for his assumed audience of non-Muslim addressees. Turning to camera following engaged exchanges with a fully veiled Muslim woman or with male students identifying strongly with Islamic values, it is the 'strangeness' and uniqueness of the experience that attract his comments: 'Well, I've never interviewed anybody through a veil before'; or 'Strange, really… I wouldn't call them extremists, I'd call them separatists'. His conclusion that the wearer of a full face-covering niqab may be erecting a communicative barrier, 'but I wouldn't say she's oppressed', dissents from the ready tendency that I discuss later to link the veil to Muslim women's lack of freedom. But in Snow's introduction to this interview he asserts, 'Nothing symbolizes the difference more than the veil'. The 'difference' he posits is between 'British values and Muslim values'. This formulation, like Wheeler's earlier 'is it us or is it them?' serves to reproduce the very exclusion of Muslims from adherence to 'Britishness' that the programme lays at the door of British Muslims alone.

Any evidence within the programme of the participants' integration into 'British culture' is undermined by the dominant discourse of separateness. Footage of a young Muslim female student socializing with friends in a café sets her in a place of 'British' consumer values and student lifestyle. But when Snow interviews her, it is the revelation of her anti-gay beliefs that forms the climax of the encounter. Snow's reflective postscript, presented directly to camera, demonstrates the fascinated bemusement of the outsider:

> It's amazing really because Heena kind of sums up everything – so integrated and yet at the same time so separate. You have this sense of somebody who's completely at peace with the i-pod, the Internet, plugs into friends at university and all the rest of it but I mean can't *abide* the thought of gays: completely integrated on the one hand and really very separate on the other. (*Dispatches* 'What Muslims Want', Channel 4, 7 August 2006)

The emphasis on the final phrase is underscored visually by a dramatic zoom from medium to close-up shot. The selected clips from the interview emphasize difference, not integration. If Snow had sought to find out more about this interviewee's use of the i-pod and internet or asked other young Muslims about their relations to other 'spaces' of contemporary communication, the programme would have produced a more variegated and nuanced sense of British Muslim identity (Werbner 2004; Qureshi 2006).

The spaces of separation in Snow's documentary are psychic rather than material. Recurring images of the mosque and the veil in the media, on the other hand, serve as visible indices of separateness, both spatial and temporal. As my discussion in the following sections demonstrates, images of mosques and of veiled women play a crucial role in underscoring a discourse that implies self-segregation on the part of British Muslims. Operating as markers of masculine domination and even misogyny within Islam, both the mosque and the veil may reinforce connotations of a temporal divide, enabling the

media to draw particularly sharp distinctions between claims of modern western progressiveness and allegations of Muslim backwardness.

The mosque as threatening space

Images of men at prayer in the mosque, or shots of its external architecture, constitute one of the most frequently iterated visual tropes of Muslim separatism. When the media construct the mosque as a uniquely masculine and ethnically bounded space, they disregard the manifold differences of belief and ideology *within* Islam. Religious disagreements and tensions within the 'Muslim community' have led to a diversification of mosques in Britain, with 44 in Bradford alone (McLoughlin 2005: 1048–9, 1050–1), but none of this diversity is signified in the recurring mediated trope. Muslim ethnicity is again constructed as a singular entity, easily caricatured into identification with a singular space; a space that is, moreover, readily associated with secrecy, masculine domination and exclusivity. As the following discussion of particular television programmes indicates, this space is also shown as failing to maintain its own boundaries. Documentaries combine representations of the mosque's susceptibility to dangerous fundamentalist influences from outside with concerns that it is also increasingly leaching these into non-Muslim spaces.

The masculine marking of the space of the mosque is routinely repeated in media representation. Although in many British mosques women are granted rights to participate both in prayers and social activities, the absence of women from mosque imagery confirms this place's 'separatist' status in media discourse. Women feature not at all in generic iconography of the mosque, and only sporadically when mosques themselves become the focus of journalistic investigation. In a fly-on-the-wall documentary on Birmingham's Central Mosque (*The Mosque*, BBC2, 14 August 2001), the mosque is, unusually, represented as a place of social exchange, within Islamic rules, for both sexes. Beyond the masculine preserve of the main prayer hall, other areas figure as relational spaces where women negotiate requests for divorce, and a female marriage counsellor pleads successfully for access to observe the mosque's sharia court, hitherto an exclusively male space. In scenes reminiscent of Kim Longinotto and Ziba Mir-Hosseini's *Divorce Iranian Style* (1998), the commanding presence of this female adviser, together with her compassionate good sense and shrewd evaluation of the limits set by Islamic law, contest the normative victimhood of Muslim women's representation in the popular media.

Women Only Jihad (Channel 4, 30 October 2006) presents a view of equally assertive women, but now more conventionally located 'outside' the space of the mosque. This documentary tracks the campaign of a group of women from the Muslim Public Affairs Committee (MPAC) against their exclusion from the claimed 60 per cent of British mosques which refuse women rights to pray. The commentary emphasizes the social benefits for the wider community of enabling Islamic religious practices to be 'feminized'. It

charts the softening of Islam's immoderate face through women's admission to the reconstructed 'Finsbury Park' mosque, previously associated with the radical cleric, Abu Hamza, and the 'shoe-bomber' Richard Reid.[4] At the same time this programme underlines male Muslims' frequently sharp and uncompromising rebuttal of the women's persistent claims. These exceptional forays into women's perspectives on the mosque's communal role, examining their attempts to participate more fully in its rituals suggest a contrast between mosques that are 'benign' (feminized, non-fundamentalist), and those deemed 'malevolent' (non-feminized, fundamentalist).

This contrast is developed in other documentaries, including Charles Wheeler's *Culture Clash*. At the start of this programme, Wheeler makes a distinction between what he labels 'disturbing' images of Islam with shots of an angry Muslim demonstration, and 'benign' ones, with a familiar shot of men praying in a mosque. But even 'benign' and peaceful mosques can connote wilful exclusivity. 'White Fright', a *Panorama* programme (BBC1, 7 May 2007), reports on growing tensions in Blackburn, Lancashire, between Muslim and non-Muslim residents.[5] Neutral images of worshippers in a mosque accompany a brief account of the alleged 'retreat' of this northern town's 'Asian Muslim' population from working 'alongside whites' 'back into their own community and their own identity, especially their Muslim faith'. The socio-economic conditions encouraging segregation, such as closure of the textile mills, rampant local unemployment, differential housing costs and educational opportunities, are excluded from this account. The image of the mosque accentuates the commentary's imputation of negative agency onto Muslims alone for withdrawing within boundaries supposedly of their own making.

Despite the mosque's 'boundedness', 'benign' or 'moderate' mosques are repeatedly represented as under threat from the capacity of radical anti-western messages to penetrate their façades. *Panorama*'s 'A Question of Leadership' (BBC1, 21 August 2005) and *Dispatches*' 'Undercover Mosque' (Channel 4, 15 January 2007) conduct critical investigations into the gap between Islam's moderate guise in Britain and its radical underbelly. The contrast is thereby drawn between the official, public face of British mosques and a hidden willingness to give houseroom to extremist interpretations of Islam. In *Panorama*, John Ware's investigation centres on the suspect connections between official Muslim bodies, such as the Muslim Council of Britain (MCB) and the Muslim Association of Britain (MAB), and groups with strongly held anti-western views. Ware's commentary implies a distinction between 'benign' mosques, such as the Sufi mosque in Perry Barr, Birmingham, which preach moderation and integration, and 'suspect' mosques, such as the East London mosque which, Ware emphasizes, has been funded partly by Saudi money, or the Leeds Grand Mosque, attended by a 7/7 bomber, Germaine Lindsay. Hence a particularly duplicitous image is reinforced of Islamic organizations cultivating apparently moderate public images while their strings are being pulled by extremists hostile to British interests. Saudi Arabia, Ware informs the viewer, is 'the most austere Islamic state in the world

whose ideology is the polar opposite of secular Britain'. However, what gets omitted is any reference to the ties that actually bind the British economy and government to the Saudi regime and that prevent the kind of public criticism of Saudi oppression commonly directed towards other authoritarian Arab states.[6] The sharp contradiction between Ware's condemnation of the regime and the British state's willing collusion with it can thus pass unnoticed.

The sinister opposition between 'public' and 'private' faces of Islam is taken further in 'Undercover Mosque'.[7] Here, grainy images, unstable framing, blurry images and echoing sound all accentuate the threat to British values from hidden brands of Islam. Surreptitiously filmed footage and authoritative voice-over commentary construct the dominant discourse, despite the punctuation of periodic rebuttals from the organizations exposed by the reporter. In a formulation repeatedly paraphrased at strategic points in the programme, the opening comment sets the tone:

> A *Dispatches* investigation has uncovered a fundamentalist message spreading from the Saudi Arabian religious establishment through mosques run by major UK organizations which claim to be dedicated to moderation and to dialogue with other faiths. (*Dispatches* 'Undercover Mosque', Channel 4, 15 January 2007)

In both programmes, voices of 'moderate' Muslims contrast with hotheaded Saudi or Saudi-trained clerics. The latter are filmed preaching anti-Semitic, misogynistic and homophobic hatred against '*kuffaars*', or infidels, and campaigning for an Islamic state in Britain. British politicians who accept the face of moderation promulgated by mosques are represented as victims of Muslim duplicity. Meanwhile, any suggestions of politicians' own responsibility for the rise in fundamentalism, whether through foreign policy or their own demands for Muslim assimilation, is left unexplored. As Wendy Brown comments, mismatch between public and private conduct among minority groups who are subjected to discrimination is often stimulated by the demands of those in power for 'integration' (2006: 94–5). Outward behaviour is adapted to conform, and thereby gain political acceptance, while private rituals, obscured from scrutiny and public debate, become increasingly entrenched.

If the space of the mosque is seen as readily penetrated by fundamentalist ideologies, it is also represented as failing to contain the dissent this breeds. Dissent becomes rendered as malevolent forces that can leak into non-Muslim British spaces. As mosques come under political and media pressure to police themselves more determinedly, it is the space around their borders that emerges as dangerous ground. A *Real Story* enquiry into the possibility of Muslims organizing home-bred terrorist attacks in Britain (BBC1, 5 April 2004) uses repeated images of mosques to underline Muslim 'difference', but also suggests that the mosque is still a relatively secure place for benevolent religious practice. When the programme's reporter, Paul Kenyon, visits the Derby mosque attended by the failed Tel Aviv suicide bomber, Omar Khan

Sharif, he comments, against the backdrop of men at prayer: 'This is no hotbed of radical Muslim opinion. In fact it's a moderate mosque. Some of the more radical members of Al-Muhajiroun have been banned from expressing their views here'.

This initial signalling of a 'benign' mosque is followed immediately by images of excluded members lobbying outside its gates. Members of Al-Muhajiroun are later shown to be meeting inside Derby's football stadium, thereby indicating how their organization can even infiltrate a space more commonly depicted as a heartland of Englishness. An Al-Muhajiroun member interviewed by Kenyon explains that, following 'martyrdom' training in Pakistan, young men return to resume their normal activities in Britain, blend-ing into the community to become, in the words of an intelligence expert, 'the invisible enemy'. 'Out there', in the world of normative British interaction, the Muslim male appears yet more threatening than in his obeisances during Friday prayers.

As these examples suggest, occasionally positive associations of mosques with religious devotion are regularly undercut in the media by stress on their masculine exclusivity, their deceptively quiescent façades, or their leaky boundaries. The perceived insecurity of the mosque's borders increasingly preoccupies documentary investigations. By contrast, as the issue of 'the veil' reappeared on the front pages of newspapers in October 2006, it was the figure of the 'veiled woman' and her separateness that dominated press discourse as she came to represent the creation of an intractable barrier between herself and the rest of society.

To veil or not to veil

Media representations of the mosque confirm perceptions of Islam as a reli-gion dominated by aggressive masculinity. Consonant with this image, media discourse has frequently associated the veil with the repression of Muslim women. Although not originating in Islam, the veil, as a generic term referenc-ing a range of Muslim head- and face-covering practices, has assumed a powerful symbolic status that acts cogently to silence the diversity of Muslim women's identities and perspectives (Macdonald 2006). While this association with repression denies Muslim women any real agency, it was the women's apparently wilful *self*-segregation that caught the newspaper headlines in the autumn of 2006. Within an intensifying discourse of separateness, newspapers reinforced the veil's potency as a sign of Muslims' personal responsibility for the breakdown of social cohesion and integration. This connotation was also apparent in the television programmes discussed above: all either fore-grounded veiled women as symptoms of a divided culture, or included them as an occasional backdrop to accentuate anxieties about separation. By thus pre-empting any discussion of face-covering practices that would place them prop-erly within a post-9/11 cultural context, a notion of wilful Muslim detachment from 'British culture' came to predominate.

Extensive press reporting in October 2006 stressed the insult to the basic

proprieties of good communication inherent in the face-covering niqab adopted by some Muslim women. The two triggers for this concentrated attention were the MP Jack Straw's well-publicized comments about niqab-wearing women in his Blackburn surgery (5 October 2006), and the tribunal ruling against teaching assistant Aishah Azmi for refusing to unveil in the presence of male teachers (19 October 2006). In an article for his constituency's local paper, Straw, then Leader of the House of Commons, announced his intention to request Muslim women visiting his surgery to remove their niqabs. His assertion 'that wearing a full veil was bound to make better relations *between the two communities* more difficult [as it] was such a visible statement of separation and difference' (my italics, *Lancashire Telegraph*, 5 October 2006) appeared at a time of growing political concern about Muslim segregation. His remarks were immediately amplified, and often distorted, in national press coverage.

Straw made it clear that his request applied only to the niqab. This distinction eluded most of the national press: despite graphic depiction in several papers of a variety of veiling traditions, they resorted to the generic 'veil' and the actions of 'veiling' or 'unveiling' as the focus of their accounts. Whether blatantly or more subtly the press constructed their (implicitly non-Muslim) readers as the sane majority, concerned with integration, effective communication and communal harmony. Polls of readers were misleadingly cited as evidence that the overwhelming majority supported Straw's position.[8] For instance, figures of 90 per cent and upwards were quoted by the *Daily Express* and the *Daily Mirror* of 7 October 2006 as pro-Jack Straw, while *The Times* made reference to a BBC telephone poll recording 93 per cent support. Muslim women were depicted as 'wilfully insulating themselves against mainstream society' (*Daily Express* editorial, 6 October 2006), or constructing 'a barrier' between themselves and others (*Times* editorial, 7 October 2006). The *Guardian*, overtly even-handed in its approach, reinforced the desirability of integration: 'The niqab may bring benefits but for a wearer there may be costs too in terms of contributing to and advancing in society' (editorial, 7 October 2006).

These comments underline that it is individual Muslim women themselves who are taken as responsible for failing in their communicative duty – and not the other parties to any interaction. Women have always been symbolically identified as the potential negotiators and peacemakers in divided communities. Hence, the resolute obscuring of their faces can be represented as a particularly offensive abrogation of their nurturing and bridge-building duties. Reporting on the Aishah Azmi case amplified this construction of defiance. Ms Azmi had taken her suspension for refusing to unveil in the presence of male teachers to a tribunal; this ruled against her, while conceding damages for intimidation. In the eyes of most of the newspaper press Ms Azmi had caused deliberate affront to communicative good sense through her claimed obstinacy and tenacious insistence on her rights. Perversely, however, her active agency and self-determination were inverted in some newspapers to be read as indices of backward-looking male oppression, reinforcing normative connotations of

Muslim veiling in western representations. In the words of a *Daily Telegraph* editorial, she had been 'turned into a mouthpiece for male Islamists who genuinely wish women to endure a form of medieval subjugation' (21 October 2006). For the *Daily Express*, the demand to wear a veil 'only signifies that the wearer has subjugated herself to warped male domination' (21 October 2006). In defiance of the evidence of Aishah Azmi's assertiveness, these constructions reproduced a familiar association between 'the veil' and the oppression of women.

The inscription of Ms Azmi into a discourse of pre-modern patriarchal oppression required the downgrading of any indices of her integration into western culture. This was most evident in the newspapers' pictorial choices. The *Daily Express* reported that Ms Azmi walked down the street, 'arm-in-arm in front of photographers with two elderly white neighbours' (21 October 2006), but this integrationist image was rejected in favour of a photograph, extensively reproduced in other papers contrasting her 'COVER UP' with her Indian-born husband's adoption of western-style clothing. The connotations of concealment and duplicity in 'cover up' became set against the assimilationist signification of her husband, with a clear implied preference for his adoption of casually fashionable attire. An earlier image in the same paper of Aishah Azmi striding along wearing a denim jacket on top of her jilbab, with jeans and trainers visible underneath (*Daily Express*, 20 October 2006) drew no attention in its captioning to the combination of western-style consumerism and Muslim-dress style that might query her reputedly single-minded assault on 'British' values and customs. This is especially ironic in the light of the *Express*'s readiness the following day to stress that her husband 'wears western clothes *including jeans*' (my italics, 21 October 2006), on the page facing the 'COVER UP' photograph.

In their mainstream address to a non-Muslim British public, the newspapers repeatedly contrasted 'our' tolerance and 'our' common sense with Ms Azmi's irrationality, extremism and 'bad manners'. As the *Daily Express* editorial put it, 'Her obstinacy flew in the face of reason, moderation and the good manners we should all show when working in a country with different cultural traditions' (20 October 2006). Authoritative Muslim spokespeople, such as Shahid Malik (MP) and Dr Ghayasuddin Siddiqui (leader of the Muslim Parliament of Great Britain), were reported as criticizing Ms Azmi's actions, thereby reinforcing her media positioning on a fundamentalist fringe. On 21 October 2006, the *Daily Express* editorial reminded its readers that Britain is 'the most tolerant country in the world' but needs to defend the 'core components of our culture' against 'fundamentalists with no respect for Britain' while the *Daily Telegraph* commented that 'The veil stretches our tolerance to its limits'. Thus positive connotations of 'tolerance' are invoked, while the papers' presupposition that those whom we tolerate are inferior to 'us' is ignored.

Tolerance is a term that is generally assumed to have positive connotations. But, as Wendy Brown incisively comments, 'tolerance' readily presents itself as a benign substitute for 'justice', sidestepping the need to rectify imbalances in power, and conferring apparent virtue on those doing the tolerating (2006: 14,

16). *Our* way of doing things is consequently assumed to be the right one, while *we* congratulate ourselves about our magnanimity towards those who choose an alternative path which is coded as aberrant or misguided. This ethnocentrist tendency to applaud or 'sanitise' our own actions while casting those of 'the other' as inferior (Shohat and Stam 1994: 3) is manifest in much of the newspaper coverage of the Azmi case.

While, predictably, the more right-wing newspapers offer some criticism of New Labour's wavering policies on multiculturalism, their addressees, the non-Muslim residents of Britain are exonerated from any responsibility for the failure of integration. Ms Azmi's actions 'serve to harm relations between ourselves and moderate Muslims', claims the *Express* editorial (20 October 2006), without any compunction about excluding moderate Muslims from *our* midst. The *Daily Mail* criticizes New Labour's shifting policies, but concludes its editorial with the comment that 'the Muslim community...must do more – much more – to integrate into British society. For its part, the rest of the country should remember Britain's proud tradition of live-and-let-live tolerance' (21 October 2006). Noble traditions, by implication, enable non-Muslims to rest on their laurels; remedial action is required only from those whom they tolerate.

Even liberal newspapers can fall into this trap. Distinguishing the veiled woman from 'masked robbers or "hoodies"', *The Independent*'s editorial (7 October 2006) identifies the crux of the veil's problem as the depersonalizing of the wearer: 'She seems to resemble an anonymous object. The veil thus comes to symbolise the subordinate position of women in so many Muslim societies', adding smugly, 'The notion of women as second-class citizens is something we long ago rejected for ourselves'. This opposition between western commitment to gender equality and Muslim misogyny has been one of the most persuasive, if unjustifiable, arguments for attacking Muslim women's veiling (see, for example, Stabile and Kumar 2005; Macdonald 2006). The media readily exonerate Britain and the West from any traces of the oppressive attitude to women they so eagerly ascribe to the Muslim world.

Across the press, there is only very occasional recognition that 'separateness' may be a two-way street. While several newspapers cite Jemima Khan, a celebrity convert to Islam, as endorsing Straw's arguments, it is only a report in *The Independent* that prints her qualification:

> While the sight of a woman in a veil may be shocking to the average Westerner, there are many Muslim women in this country who will argue that the image of a skeletal 14-year-old on a catwalk is equally disturbing and exploitative. (7 October 2006)

Most newspapers evince no interest in exploring this comparison, given its invitation to query British cultural conventions. On the previous day, only the *Independent* editorial can admit that fear of 'the other' remains a key, but 'unreasonable' and 'unjust', feature of British society. With its front pages dominated by reports on the ethnic divides in Britain, based on 2001 Census

data, it concludes: 'If Britain's Muslims present a problem, it is that they constitute easily the most deprived communities in Britain – and this is reason for positive action, not fear'. Under a heading 'We are repeating the mistakes of the past', it argues, ironically counter to its editorial of the following day, that Britain is in danger of forgetting 'some of the less edifying chapters of the past' (*The Independent*, 6 October 2006). Other editorials suggest the need for improved interaction between Britain's non-Muslim and Muslim populations, but *The Independent* is alone in proposing the necessity of redressing an imbalance in power relations.

Most of the media fail to acknowledge that 'separateness' becomes a 'problem' only if there is a conflict of interest, and a 'threat' only if it poses a challenge to existing sources of power. As this chapter has documented, British Muslims have been granted extensive media attention in recent years; but the one-sidedness of television and press analysis of the sources of 'separateness' is overdue for review. By constructing the Muslim population as the agents solely responsible for separation, those 'at risk' become, almost by definition, the non-Muslim majority. However, reiterated evocations of 'the terrorists in our midst', and the supposedly separatist tendencies of British Muslim men and women, indexed through repeated images of mosques and veils, has all too real material consequences for many Muslims who have no truck with fundamentalist ideologies or terrorist actions. In a society where mosques and veils are not just media icons of segregation, but repeated targets of racist violence and abuse, when 'risk' is an issue, it is actually the minority populations who bear its burden.

Notes

1 In a survey of Muslim responses to news coverage of 9/11, no interviewees supported Huntington's 'clash of civilizations' thesis, although it was widely recognised that the media promoted this hypothesis, often out of ignorance about Islam (Ahmad 2006: 975).

2 For example, the late-night scheduling on Channel 4 of *Shariah TV* (2004–). A panel of Islamic scholars face testing questions about the interpretation of their religion, and lively theological disputes contradict the caricaturing of Islam as a singular ideology, dictated by ranting clerics.

3 A report in 2004 linked Beeston with 'some of the worst deprivation' in Leeds (Leeds City Council 2004: 3).

4 The Finsbury Park mosque in north London (since renamed the North London Central Mosque) was widely associated in the media with radical imam Abu Hamza, jailed in the UK for terrorist-related offences in 2006, and (at the time of writing) facing deportation to the USA for trial on terror-related crimes. Hamza was a powerful figure in the mosque, which was also visited by Richard Reid. A British citizen, Reid was convicted in the USA in 2003 for trying to blow up a transatlantic airplane in 2001 by detonating a bomb hidden in his shoe.

5 The choice of location is not accidental. Blackburn, as the central town in Jack Straw's constituency, had already been in the headlines following Straw's pronouncements on the niqab in 2006, discussed later in this chapter. The link is referenced explicitly within the programme.

6 The FCO website (Saudi Arabia profile) admits that 'Saudi Arabia is our largest export market in the region', and 'has long been a close ally of the UK', but is coy about mentioning the centrality of shady arms dealing in this relationship (see Saudi Arabia profile at:www.fco.gov.uk).

7 This programme attracted controversy when it was referred to the Crown Prosecution Service (CPS) by the West Midlands police, concerned that it might incite racial hatred. The CPS found insufficient evidence to bring charges and Ofcom subsequently confirmed the legitimacy of the programme's tactics.

8 These were misleadingly presented as indicating percentages of 'readers', whereas they were derived from the number of 'respondents'.

Chapter 11

Debating Contemporary Postcolonial Theory: The Limitations of a Culturalist Approach

Christopher Pawling

In this chapter I want to examine recent postcolonial theory and start by considering the critique of 'western' culture which has been developed in the work of figures such as Iain Chambers and Paul Gilroy. The positive aspects of this critique lie in its concern with rectifying the inbuilt philosophical biases of western thought and the challenge it poses to the assumption that the western Enlightenment lies at the centre of all human culture and civilization. Whilst I recognize these strengths, I will go on to argue that there remain inherent weaknesses in current postcolonial theory, particularly in its anti-rationalist bias and the way it tends to privilege a realm of the emotions over that of logical reason and the mind. From this perspective, I will be arguing that this influential strand of contemporary thought is in danger of abandoning the legacy of Marxism and other rational forms of Enlightenment-based theory. I will also be questioning the 'cultural turn' in recent postcolonialist work and the tendency to assume that the postcolonial world reproduces itself primarily at the level of independent, autonomous cultural production and consumption which transcends the determinations of economic reality. Through a short case study of the UK *Live 8* event in 2005, I will argue for a different approach to postcolonial culture: one that is more materially grounded and based on a recognition that we have not suddenly entered into a qualitatively different stage of historical development, where change is divorced from the dictates of the economy and the global marketplace.

Postcolonial thought and cultural imperialism

First then, I will consider the question which was central to the establishment of postcolonial studies as an intellectual discipline: namely, the issue of cultural imperialism and how it operates to secure its hegemonic position. It is generally accepted that western capitalism has maintained its domination by controlling key economic resources and also through periods of military intervention into the affairs of countries which attempt to embrace alternatives to capitalism. Economic and military powers remain important in maintaining imperialist and neo-imperialist domination, but they are not the only mechanisms for exerting political and cultural influence. In the contemporary world the mass media obviously also have a vital role to play in disseminating western, especially American-dominated, versions of 'freedom' and 'democracy'. The role of Fox and other Murdoch-dominated media outlets cannot be underestimated, both in the long term and at moments of heightened crisis such as the Iraq War, where an Anglo-American version of political reality is presented as the only 'rational' basis for interpretation and action.

However, in order to reflect adequately on the question of cultural domination, we need to go beyond considering just the manifest content of satellite broadcasting or even the Hollywood film industry. It has been argued, for instance, that one of the crucial mechanisms for reproducing western cultural hegemony, particularly in a postcolonial world, is the underlying discursive realm of the political 'subject' and subject formation, which lies at the heart of politics, philosophy and ideology in general. The French philosopher Louis Althusser pointed out that we come into this world as biological individuals, but that we are turned into social and political subjects through our identification with the discursive practices of the nation state. In the ideological institutions of the family and school and through the mass media, we are hailed or 'interpellated' by discourses which persuade us to recognize ourselves as the 'bearers' of particular values and identities (1971). Posthumanist critical theory has followed the work of Althusser and his contemporaries such as Derrida and Foucault, to argue that western culture has been grounded in a discourse which sees Western Man as the ideal model of the thinking, rational subject. The line of postcolonialist thought which derives from Derrida and Foucault criticizes western cultural theory as an 'anthropocentric' discourse, in that it is centred on the narrative of Western *Man* who brings wisdom from outside to those 'in ignorance' in the Third World. Hence, western power is bound up with a certain theory of knowledge or 'epistemology', which is based on a particular 'power–knowledge' relationship to the colonial Other who is deemed to be an inferior subject.

According to posthumanist theoreticians, an important mechanism for anchoring western cultural hegemony is the philosophical discourse which promotes the 'episteme' of the Cartesian subject, the individual thinker, observing and mastering the world through his/her (mostly his) thought: 'I think, therefore I am'. The drive for the 'will-to-knowledge' in western thought is seen by posthumanist thinkers as being a form of tyranny: 'the

Enlightenment's claim to know and its confident belief in progress are rejected as imperialising discourses which only empower the Subject who knows' (Haslett 2000: 265, 267). According to this view, the Cartesian philosophical discourse helps to reinforce a broader historical narrative in which Western Man situates himself at the centre of civilization and culture and where the rest of the world is pushed to the margins of historical and cultural development.

The process of reproducing western cultural domination at the discursive level of ideas and the production of knowledge is understood to have particular effects. As Leela Gandhi points out, it leads to an 'epistemological malaise at the heart of western rationality' (1998: 26). The void at the centre of this 'malaise' is caused by the exclusion of cultures which lie outside the western centre and by a refusal to recognize that the Other of western philosophical and political discourse might be a thinking, active subject, whose ideas have contributed to the development of humanity. Ultimately, the historical roots of this voiding process can be traced back to the impact of colonialization. As John Ellis explains, we cannot understand the development of western thought and culture unless we situate it in relation to the historical reality which lies behind that development, most noticeably the fact of slavery:

> At the basis of all our universal concepts, of the establishment of rationality and democracy, of the belief in progress and even the perfectibility of the human, lies the fact of the racially based slavery which enabled the enlightenment to unfold itself. It is an act of extraordinarily collective forgetting, of tremendous intellectual hypocrisy, that this has only recently been established as the structuring absence of Western philosophy. (2000: 68)

The posthumanist critique of western thought has been highly influential. As John Ellis suggests, the awareness that western civilization and philosophy might be the products of a culture which universalized its values at the moment when it was exploiting others must be central to any consideration of rationalism and the Enlightenment. At the same time I want to stress the need to be alert to the dangers of adopting a too simplistic critique of rationalism and hence of 'throwing out the baby with the bathwater'. The posthumanist strand of postcolonial thought is rather too ready to dispense with materialist explanations of the history of thought in assuming that philosophical discourse is pre-eminent in the grounding of political and cultural power. There are inherent problems in privileging the discursive realm at the expense of other dimensions of the power relations between western culture and its non-western Other. Thus, we should be careful not to reduce the entirety of colonial and postcolonial history to an 'epistemic violence' which is privileged analytically at the expense of the socio-economic and political infrastructure of colonialism (Parry 2004b: 75). Moreover, to go down this path is to assume that the Enlightenment and rationalism lie at the heart of an imperialism devoid of conflict and contradictions, and that any form of thought related to the Enlightenment could not form the basis for a critique and ultimate supersession of imperialism. We need to be careful that the necessary awareness of

the imperializing aspect of western culture does not lead us to reject Enlightenment thought *tout court*. After all, one of the most important precursors of modern postcolonial theory is Marxist theory and Marx was nothing if not a child of the Enlightenment.

Postcolonial thought and anti-rationalism: the example of Iain Chambers

One example of my concerns about the negative impact of posthumanist thought can be found in the work of Iain Chambers, arguably one of the key architects of postcolonial theory. I want to see Chambers's work not just as an individual contribution to debates about contemporary postcolonial culture, but also as an index of a wider tendency in critical theory at large. Indeed, I would argue that his works such as *Migrancy, Culture, Identity* (1994), *The Postcolonial Question* (1996) and *Culture After Humanism* (2001) should be seen as being representative of recent developments in critical theory. I am using 'representative' here in the sense understood by the Hungarian philosopher Georg Lukács: namely, to indicate a condensation of the philosophical tendencies of an historical moment and the development of a particular line of thought to its logical conclusion ([1937] 1962). Following Lukács, I would argue that 'Iain Chambers' acts as a signifier that does not just refer to a particular individual, but also denotes a set of theories and concepts which are 'typical' of the age. By this I do not mean that these ideas reflect a cross-section of opinion in the form of some kind of statistical 'norm'. Rather, they are 'typical' in the Lukácsean sense that they go beyond the ideas of the 'average' or 'common-sense' thought of the time, raising that thought to a new level of coherence. Hence, Chambers's writings can be seen as a 'typification' of contemporary thought to the extent that they offer a particularly clear expression of recent developments in cultural studies, acting as a logical summation or *terminus ad quem* of the 'posthumanist' branch of contemporary postcolonial theory.

I will take *Migrancy, Culture, Identity* as an example. In this book Iain Chambers mounts an attack from the viewpoint of postcolonial theory on what he terms 'the rationalist episteme of the "western cogito"' (1994: 120). Chambers's study of cultural identity in the postcolonial era explores phenomena such as world music in attempting to chart the way in which 'migration, marginality and homelessness have disrupted the West's faith in linear progress and rational thinking' (*ibid.*: cover blurb). However, this is not the first moment in which the 'logic' of western thought has been the object of Chambers's critique. If one returns to his writing on popular culture in the 1980s, prior to what one might term his 'postcolonial' period, one finds Chambers celebrating the metropolitan popular culture of the late twentieth century as both an accessible alternative to the dominant high culture of the age and as a radical 'epistemology', which challenges the hierarchical mode of thought in the western academy. For Chambers, popular culture embodies a different form of knowledge and 'expertise' from that of 'high theory' in that

it is 'experiential', drawing on 'the tactile, the transitory, the expendable, the visceral'. Popular culture 'does not involve an abstract research amongst privileged objects of attention, but involves mobile orders of sense, taste and desire'. Crucially, popular culture is 'not appropriated through the apparatus of contemplation, but, as Walter Benjamin once put it, through "distracted reception"' (1986: 12).

Thus Benjamin's aesthetic is embraced by Chambers as a device for undermining the 'rationalist' model of Marxist theory which insists on interpreting and 'placing' cultural phenomena in the context of a wider socio-historical framework. For Chambers, the form of knowledge which derives from the metropolitan popular culture of the postmodernist/postcolonial era signifies a crucial break with what he calls an 'older', 'in-depth' model of interpretation and explanation and replaces it with a 'newer, effervescent, flat theory', based on the surface traces left by transient cultural signs (*ibid.*: 214). In a world of contemporary popular culture, revolving around an aesthetics of bricolage and fragmentation, the 'old' rationalist search for a coherent, scientific account of culture is revealed to be a chimera:

> Theory and academic discourses are confronted by the wider, unsystematized, popular networks of cultural production and knowledge. The intellectual's privilege to explain and distribute knowledge is threatened; his authority, for it is invariably 'his', re-dimensionalized. (*ibid.*: 216)

From this perspective, the intellectual is seen as someone who interprets popular culture from a 'superior', 'detached' stance and thus commits a betrayal of a 'democratic' cultural studies. This view of the intellectual's role derives from those aspects of cultural populism in Chambers's work. The term 'cultural populism' designates what Jim McGuigan has characterized as 'an *uncritical* populist drift in the study of popular culture', an assumption that the culture of ordinary people is more important for the social and political analyst simply because it emerges from the heart of 'the people' themselves, in contradistinction to 'high' culture with a capital 'C'. Whereas the tradition of cultural criticism from Arnold to Leavis claimed to be able to discriminate between a 'refined' canon of great art and the 'cruder' world of the 'popular', cultural populists tend to reverse this binary, preferring the 'democratic', 'concrete' world of the demotic over the supposedly 'cerebral' world of its 'elite' counterpart (McGuigan 1992). As Francis Mulhern has commented, ultimately for cultural populists the 'metanarrative' of detached, abstract thought belongs to 'a pre-postmodern ethic of critical reason'. He sees Chambers and other cultural populists as renouncing this metadiscourse in favour of 'a new theory or format of knowledge', which Chambers describes as a 'popular epistemology' (2000: 142).

The 'public is an examiner', Chambers concludes, in words borrowed from Benjamin, but an absent-minded one' (1986: 12). The novelty and special value of its kind of critical intelligence is that it is the opposite of the familiar kind. Here is a protocol for the cultural studies subject – though 'studies'

hardly describes the format of engagement that Chambers offers to exemplify in *Popular Culture*. No more meta-discourse: to seek to explain the passing scenes of popular culture 'would be to pull them back under the contemplative stare, adopting the authority of the academic mind' (*ibid.*: 13). Such 'vanity' ignores the epistemological promise of ordinary distraction: an informal knowledge of the everyday, based on the sensory, the immediate, the pleasurable and the concrete' (*ibid.*; Mulhern 2000: 142).

Thus, for Chambers the popular culture of the contemporary world is not simply a form of artistic practice, but an aesthetic which forms the basis for a new *knowledge*, replacing the 'contemplative' thought of Marxism and other examples of a supposedly outmoded rationalism. Chambers's libertarian postmodernism elides the crucial distinction between, on the one hand, the *forms* of artistic practice or cultural creation, which may attempt to undermine 'bourgeois rationality' through devices such as montage and the 'fragment', and the *explanation/understanding* of those practices through critical reflection on the other. As Mulhern comments, this mode of 'engagement' with popular culture is hardly recognizable as a form of 'study' and the term cultural studies does not really seem appropriate for what Chambers or other representatives of 'cultural populism' are attempting. In his own version of Julien Benda's *trahison des clercs*, Chambers abandons the search for a critical overview and analysis of contemporary culture in favour of a form of demotic knowledge or 'popular epistemology' which is anti-rational and concrete, rather than rational and abstract, and which arises seemingly spontaneously from the ranks of the people. As he explains at the end of *Popular Culture: The Metropolitan Experience*, conceptualizing the world in the terms of contemporary popular culture means 'waking up from the rationalist dream of total intelligibility'. Chambers sums up his approach by quoting approvingly the words of the Italian postmodernist philosopher, Gianni Vattimo: 'rationalism is not the highest form of reason' (*ibid.*: 216).

To sum up the argument so far. In *Popular Culture: the Metropolitan Experience* and elsewhere in his publications of the 1980s, Chambers sets up a rather simple binary opposition between the 'contemplative stare' and 'authority' of abstract theory and the academy on the one hand, and the unmediated nature of popular culture on the other. The popular is both promoted as a 'concrete' alternative intellectual practice to high theory and is, simultaneously, 'drained of conceptuality', as Mulhern wryly observes (2000: 144). This contrast between the authority–authoritarianism of an abstract academic 'cogito' and the critical rebelliousness of concrete popular reason prefigures Chambers's later critique of western thought in his writing on postcolonial culture, from the late 1980s onwards. Running throughout Chambers's work – and arguably through 'cultural populism' in general – is a consistent preoccupation with a debilitating opposition between the protocols of logical, scientific reason and an instinctive, 'esoteric' realm of the 'experiential'.

Hence, in texts such as *Migrancy, Culture, Identity* (1994), one finds Chambers rejecting western Enlightenment thought in the process of

celebrating a postcolonial culture of 'marginality' and the 'diaspora'. Once again, the argumentation proceeds through a set of binaries, but this time the process of valorization focuses on the hybridized thought of a 'New Age' philosophy which, in the course of refusing a stable, monolithic cultural identity and subjectivity, also sets its face against 'western' logic and scientific rationality:

> Today in the West, out of the nebulous vectors and histories of 'New Age', there emerges a legitimation of syncretism that challenges and scrambles the binary categories that pass for knowledge and 'truth'. From fractals, ecology and chaos theory to world (and whole) music and alternative medicine (homeopathy, acupuncture, yoga and shamanism), there lies a hybrid constellation, balanced between official knowledge and occult folklore, vacillating between scientific innovation and the perennial philosophy of the esoteric. No doubt many details of this precarious archipelago can be confined to the brief space of an allegory, a symptom of unease with the jagged achievements of 'progress'. Yet in its implicit critique of the representative claims of scientific and technological rationalism, such a constellation and a set of practices are elements of an altogether more extensive disturbance. They represent part of a widening interrogation that also reappears in the crisis of Western anthropology, in the querying of accepted literary canons and historical protocols, and the critical dispersal of much radical, but undeniably Eurocentric thought. Coming out of regional chronologies and seemingly discrete crises, they all contribute to the general undoing of the privileged 'reason' of the self-centred subject. (Chambers 1994: 120)

This is a somewhat dense passage, but it can alert us to some of the features of what I would term an anti-rationalist branch of contemporary theory, in which there is a rather apocalyptic embracing of the 'crisis' in western thought. We should acknowledge that Iain Chambers is careful not to dispense with scientific thought entirely in his 'symptomatic' analysis of western culture. Nevertheless, the language of the passage tends to 'gush' in what is largely a celebration of 'New Age' ideas. Scientific rationalism is definitely forced to cede a good deal of ground in the encounter with phenomena such as homeopathy, shamanism, the occult, etc. Even 'radical', Enlightenment-based theory (a coded reference to Marxism), is subject to what Chambers calls 'critical dispersal', because of its 'Eurocentric' bias. But it is one thing to follow John Ellis in identifying the 'collective forgetting' of slavery as a 'structuring absence' of western thought. It is quite another to downplay the role of radical thought, especially Marxism, in *identifying* this lacuna and subjecting it to critique. It would be a poor history of anti-colonialism which refused to recognize the influence of figures such as Lukács, Gramsci and Sartre and other Marxists on the writings of such anti-colonialist thinkers as Senghor, Cesaire and Fanon, and on national anti-colonial struggles around the world.

A postcolonial history of western thought which fails to acknowledge the 'dialectic' of the Enlightenment, and its legacy in developing a critical

opposition to imperialism, as Chambers's work does, albeit in a coded fashion, will surely fail to take us very far. Crystal Bartolovich has observed that, 'Marxism is, as Sartre argued, a "living philosophy", and thus that it is continually being adapted and adapting itself "by means of thousands of new efforts" (Sartre [1961] 1968: 7). The very fact that many of the most brilliant, prominent and effective anticolonial activists have insistently pronounced themselves Marxists should give pause to postcolonialists who stand poised to dismiss Marxism as a "European" philosophy' (Bartolovich, in Bartolovich and Lazarus 2002: 11).

Bearing the pertinence of her point in mind, I am arguing that we are in danger of making a simple reversal of what Stuart Hall has identified as the old cultural imperialist binary of 'the West and the Rest' (Hall, in Hall and Gieben 1992: 275–32). In this model of culture, western thought was originally associated with the positive virtues of scientific rationalism, whilst its non-western alternative equated to philosophical negativity and the triumph of emotion over reason. But in recent postcolonial theory we are being presented with a *new* binary which is just as limiting as its predecessor and which seems to celebrate forms of thought such as shamanism and the occult *simply because* they offer alternatives to western scientific rationality. Thus, we are liable to end up with a culture of the emotions on the one hand and a culture of the mind on the other, which simply switches the poles of the old 'West and the Rest' opposition in the course of constructing a new binary with anti-rationality at its positive pole. This is what Leela Gandhi, drawing on Foucault, refers to as 'the orthodoxy of heterodoxy' (1998: 53). If we are ever to 'deconstruct' the limited interpretation of cultural history which we have inherited from colonialism in an effective manner, then we will need to move beyond such a simple reversal of polarities and embrace a more dialectical theory of the relationship between scientific and artistic truth, reason and emotion, in both western and non-western culture.

Paul Gilroy and *The Black Atlantic*

In the previous section I outlined the critique of Enlightenment-based philosophy that Iain Chambers has elaborated. I argued that this posthumanist version of postcolonial theory has been influential in marginalizing rational-based tendencies in radical philosophy, such as Marxism. Arguably we can see something of the same process at work in the writing of Paul Gilroy, whose book, *The Black Atlantic* is seen as a milestone of contemporary postcolonial criticism (1993a). In this text Gilroy explores the relationship between the history of black subcultures in the West and the experience of slavery. One of the key arguments in *The Black Atlantic* is that African-derived black subcultures are based on a 'principle of negativity' which is 'opposed to the formal logic and rational calculation characteristic of modern western thinking' (*ibid.*: 68).

For Gilroy, the black diasporic culture of the West Indies, Britain and the United States is ultimately a modern descendant of slave culture and the forms

of resistance which accompanied that culture. Gilroy argues that at the heart of slave culture lies 'a willingness to risk death' which allows the slave to escape bondage, even if it means committing suicide. Indeed, Gilroy comments that the slave '*actively* prefers the possibility of death to the continuing condition of inhumanity on which plantation slavery depends' (*ibid.*: 63; my emphasis). So it is important for Gilroy to recognize that black cultural forms have cultivated 'a distinctive rapport with the presence of death and suffering' (*ibid.*: 203). In this embracing of death, the 'discourse of black spirituality' which originally derives from the experience of slavery is seen to possess a 'a utopian truth content that projects beyond the limits of the present' (*ibid.*: 68). Moreover, the association of an 'apparent preference for death' in slave culture with an artistic activity like song-making is 'highly significant' in Gilroy's eyes, since it 'joins a moral and political gesture to an act of cultural creation and affirmation' (*ibid.*).

Now this 'willingness to risk death' is understandable as a final alternative to bondage, but Gilroy goes on to imply that there is a universal ontological dimension to the 'inclination towards death', which embraces all black African diasporic cultures at all times. Hence, the death-drive creeps in as an active component of contemporary black subculture and although Gilroy never embraces the extremes of gangsta rap, his assertion that anti-rationalism is a necessary reaction to the black experience of oppression inevitably opens the door to a somewhat nihilistic aesthetic. Moreover, the 'inclination towards death' takes on a more universal dimension, in that it is articulated as 'a principle of negativity that is opposed to the formal logic and rational calculation characteristic of modern western thinking' (*ibid.*).

However, it is one thing to explain a phenomenon such as gangsta rap as a desperate cry of anger at the plight of young black people in the ghettos. It is entirely another to celebrate the 'desire for death' as a potentially utopian component of black subculture. In an article entitled 'Journey to Death: Gilroy's *Black Atlantic*', Laura Chrisman has argued that Gilroy is too fatalistic in associating black culture with the death-drive (1997). Chrisman points out that the slaves practised other forms of resistance apart from suicide, such as 'the regular sabotaging of plantation machinery and the practice of abortion'. Both of these practices are, she argues, 'complex examples of the performance of a scientific rationality, which is presumably the reason for Gilroy's disinclination to consider them. As technological and calculated practices, they do not bear out his contention of black subjectivity's scepticism towards rationality. In deploying knowledge of, and making use of, scientific reasoning, they refute his contention that slave identity is 'opposed to the formal logic and rational calculation of modern western thinking' (Chrisman, in Owusu 2000: 463). Chrisman goes on to observe that one might see the contemporary practice of graffiti artistry in black subculture as a legacy of the sabotaging of the machinery of slavery on the plantation. The irony and wordplay of hip hop can also be seen as a creative alternative to the more death-driven aesthetics of gangsta rap. This, she suggests, is a more 'ludic' and 'trickster' culture, a 'scatological' art which is, nonetheless, rooted in a form

of 'reasoning', rather than a destructive nihilistic reaction to contemporary alienation.

Writing towards the end of the 1990s, Laura Chrisman points out percep-tively that Gilroy's formulations in *Black Atlantic* 'mesh neatly' with an 'Anglo-American academic climate' of that decade, 'which has seen the rise in popularity of concepts of fusion, hybridity and syncretism as explanatory tools for the analysis of cultural formation'. Chrisman concludes her critique of Gilroy with the following comments:

> The 1990s is also a decade in which, broadly speaking, postmodernist intel-lectual concerns with language and subjectivity have infused both academia and 'New Left' politics to create a dominant paradigm of 'culturalism' for the analysis of social relations, at the risk of abandoning the tenets and resources of socio-economic analysis. Aesthetics and aestheticism can func-tion both as explanation and solution to social and political processes. For these reasons, Gilroy's book is a 'sign of the times'; for these reasons too, perhaps, it has become so popular. (*ibid.*: 453)

I would argue that these remarks about the dangers of abandoning socio-economic analysis do not just apply to the 1990s and that Chrisman's warn-ing continues to be relevant ten years later, if not more so. Wedded to the theoretical demands of a postmodernist 'culturalism', postcolonial theory runs the risk of assuming that change takes place almost *exclusively* at the cultural level. In the 'old days' of cultural studies, when Marxist theory still had some influence, it was generally held that one could chart a 'dialectical' relationship between the socio-economic 'base' of society and its cultural and ideational 'superstructure', an interaction which was 'overdetermined', if only 'in the last instance', by the movements of the former. Thus cultural production did not develop independently of the economic environment. As the German play-wright Bertolt Brecht expressed it so pithily: 'erst kommt das Fressen, dann kommt die Moral' ('First comes eating, then comes morality') (cited in Jameson 1998: 131).

This materialist theoretical position has been reversed in recent years. Now the cultural realm is seen by postcolonial theoreticians such as Gilroy and Chambers as the primary site of domination, or any potential resistance to that dominance. Culture, especially music, is supposedly where identity is 'constituted', in the sense of being 'produced', by culture and the economy necessarily takes a back seat. Crystal Bartolovich has pointed out that the problem with much of the writing on postcolonial culture is that it scorns what it sees as a 'a "leaden-footed" pursuit of the path of political economy' and any attempt to 'follow the money' (in Bartolovich and Lazarus, 2002: 5). However, as Bartolovich observes: 'The contest of cultures with which post-colonial studies has been so preoccupied...cannot simply be divorced from rigorous critique of the imbalances of global political economy...' (*ibid.*: 12). The following section will explore the limitations of the culturalist overempha-sis on this 'contest of cultures' and its consequent failure to understand the

imperatives of postcolonial economic reality by focusing on the fate of world music at the *Live 8* extravaganza in 2005.

World music and the example of *Live 8*

One example of the reduction of postcolonial theory to a 'contest of cultures' can be found in Iain Chambers's book, *Migrancy, Culture, Identity*. In analysing the impact of world music, Chambers argues that the popularity of a singer such as the Senegalese musician, Youssou N'Dour represents a sea change in the relationship between African culture and the West. He goes on to suggest that the emergence of world music and its adoption by western youth signify a 'new space for musical and cultural differences'. Thus:

> [A]ny obvious identification with the hegemonic (western) order, or assumed monolithic market logic, is weakened and disrupted by the shifting, contingent contacts of musical and cultural encounters. This represents the instance of a musical and cultural conversation in which the margins are able to reassess the centre while simultaneously exceeding its logic. (1994: 79)

For Chambers the advent of world music represents a decentring and undoing of the old imperialist centre–periphery relationship and the notion that 'economics determines cultural hierarchies' (*ibid.*: 78). The recognition of artists such as Youssou N'Dour in countries like Britain highlights a cultural revolution of transformation at the level of consciousness, which overrides the economic and political imperatives of the old imperial centre, thus 'exceeding its logic' and initiating a new 'hybridized' culture. However, while one would not want to underestimate the importance of world music in contemporary culture, Chambers's argument that it represents a *qualitatively* new stage in the relationship between the West and its 'Others' is rather dubious. In particular, I would want to question the implication that the emergence of world music constitutes a fundamental challenge to the logic of the global marketplace, or that shifts in the consumption patterns of western youth inevitably lead to a cultural revolution.

Let us take the case of world music a little further and consider the example of the *Live 8* Festival in Hyde Park in July 2005. The festival was organized by the Irish musician Bob Geldof, founder of the 1985 *Live Aid* concert which had aimed to use music to focus international attention on famine in Ethiopia. Geldof was supported by fellow humanitarian activists such as Bono, vocalist of the Irish band U2 and Peter Gabriel, formerly of the English progressive rock band, Genesis. Their aim for the 2005 Festival, with its logo of the continent of Africa shaped into a guitar, was to provide a musical focus for the global campaign 'Make Poverty History' (known as 'ONE' in the USA). *Live 8*'s multisite performances were to influence the economic summit on world trade and poverty being held by The Group of Eight leading industrialized nations [G8] and hosted that summer by Tony Blair and the British government in Gleneagles, Scotland. Geldof and his co-workers hoped to use

the concert both to highlight the political message of 'Make Poverty History', with an emphasis on trade justice for the countries of Africa, and to make money for the campaign from pledges which were donated while the main Hyde Park concert was being broadcast worldwide.

However, there were tensions about *Live 8*'s aims. On the one hand, organizers led by Bob Geldof were concerned to maximize both their media and 'live' audiences for the festival; while others such as Peter Gabriel were also concerned that the concert should provide a forum for world music. Ultimately, it was the former who largely won out. Hence, while Senegalese superstar Youssou N'Dour duetted with the English singer Dido performing the international hits, 'Seven Seconds' and 'Thank You' for global TV audiences from the main Hyde Park venue, the rest of African music was heavily under-represented. After strong lobbying by Peter Gabriel and N'Dour himself had failed to change Geldof's mind on wider African participation, a separate gig, *Africa Calling*, was organized at the site of the ecological trust, the Eden Project in Cornwall. Although this also included some of the same Hyde Park headliners, its main aim was to widen interest in the diverse range of African musicians and to highlight the fact that they could be active participants in their own cause. However, the total attendance at *Africa Calling* was only 5,000, with some performers receiving disappointingly small audiences.

What this example indicates is that the dominant relationship between centre and periphery was still operating, albeit in quite subtle ways. *Live 8* had aimed to focus world attention on Africa – yet world music had only made tiny inroads into the world of white-dominated celebrity rock/pop music. The *Guardian* journalist Patrick Barkham captured the sense of frustration among the majority of the African performers at the Eden Project in an interview with the hip-hop artist Emmanuel Jal. This bears quoting at length because it records a voice which was hardly heard in the dominant chorus of self-congratulation at the time:

'Don't be surprised to see my face this way, but I'll try to give you what I can', Emmanuel Jal, a Sudanese refugee, former child soldier and rising star of African hip-hop, told his audience in Cornwall – and tried to smile. When the 25-year-old got the call to fly to Britain for *Live 8*, he hoped to show millions of people 'what an African can offer when they have gone through hardship'. Instead, he ended up rapping in Arabic, Nuer and English before barely 50 people in the Mediterranean dome at the Eden Project. The hurriedly arranged *Africa Calling* was probably the most convivial concert in the world: dahlias outnumbered security staff and there was hardly a crash barrier in sight as 5,000 people swayed to a diverse bill of African beats. But despite flying visits from A-listers including Angelina Jolie, Dido and Youssou N'Dour, the voices of *Africa Calling* – from the Portuguese Fada of Mariza to the soulful guitar of and vocals of Ugandan Geoffrey Oryema – were hardly heard on the global TV stage. Jal, who has topped the charts in Kenya, where he is still a refugee, confronted Bob Geldof when he met him in the UK. 'He said to me you have to sell more than 4m records to

come and perform at Hyde Park', Jal said. 'He said that people in China will not want to listen to my music because they do not know me'. 'I like the spirit behind this – helping the poor – but when I look at him (Geldof) it looks like he is making history by using the poor people. Years ago he helped the Ethiopians but this time he has lost my respect.' Jal said he received calls from similar disillusioned Africans. 'Thousands of people will think this day is about making pop stars more famous and creating a name for themselves out of poor Africans. Africans are complaining why aren't African perform-ers there to represent them? The idea is good but making poverty history in a concert is not going to happen.' (*Guardian*, 4 July 2005)

Patrick Barkham's report cites the DJ Andy Kershaw describing the separation of *Africa Calling* from the main Hyde Park gig as a form of 'musical apartheid'. Peter Gabriel, who hosted *Africa Calling* disagreed with this assess-ment but was still moved to comment that 'Geldof had scored an own goal by not putting more African artists on the Hyde Park bill' and went on to suggest that the *Live 8* organizer was 'behind the times': 'I mentioned it to Chairman Bob and he was of the opinion that with billions of eyes watching the TV, unfamiliar artists from whichever country would probably switch people off. I don't agree' (*ibid.*).

Nonetheless, despite the seemingly reactionary nature of Geldof's response, I would argue that there was a kind of inevitability about his decision, given the aims and objectives of *Live 8*, which were largely focused on persuading those watching the concert on television to donate money. The logic of the global music market could not be overturned, even if it was not just the purchasing power of western audiences which was the only economic consid-eration: the demands of the South-East Asian market were also coming into play. The power of the western centre had been undermined to a degree, but the overall imperatives of the marketplace still operated to the extent that Chinese audiences, for example, were largely only familiar with the products of large western-based music corporations and well-marketed rock artists, such as Elton John.

Bob Geldof's riposte to Peter Gabriel unwittingly exposes the fallacy of Iain Chambers's argument about the supposed power of the cultural/discursive realm, even if the rationale offered was crude and insensitive: economics, in the form of powerful record companies and their ability to dominate the markets, *did* still determine cultural hierarchies. Although Geldof was attempting to exert political pressure through cultural means, his room for manoeuvre was restricted, in that the underlying determinations of the marketplace could not be ignored. Cultural power could not outweigh economic forces and, apart from an isolated figure such as Youssou N'Dour, world music did not have the global 'pulling power' to warrant its appearance on the main stage at Hyde Park or the global TV channels. Hence, the African 'periphery' would still suffer.

Concluding remarks

The Slovenian critic, Slavoj Žižek, has commented that the struggle for post-colonial culture does not take place in a socio-economic vacuum. On the contrary, this contest is enacted against the background of global capitalism. Moreover, the contemporary global capitalist system is also 'able to incorporate the gains of the postmodern politics of identities', to the extent that they do not 'disturb the smooth circulation of Capital' (1999: 216). Capital, he argues, is willing to tolerate a hybridized culture of 'difference', as represented by cultural phenomena such as world music. Indeed, as another commentator has pointed out, 'difference' is now seen as a major 'condition and stimulus of the market': hybridity, diaspora and postcoloniality are now 'fashionable and even marketable terms' (Hutnyk, in Werbner and Modood 2000: 118–19). However, the fact that capital is willing to embrace 'difference' in order to market cultural commodities does not mean that the imperatives of capital and those of economic and cultural equality are necessarily the same. Nor does it mean that just because some young people in Britain have become interested in world music, therefore a new cultural and political order is inevitably in the offing, despite Iain Chambers's assertion that 'we are all postcolonial now' (in Gilroy *et al.* 2000: 70). We cannot afford to ignore the realm of political economy in the determination of cultural interchange in the present world order, as the example of *Live 8* demonstrates.

Finally, to return to the underlying theoretical issues broached earlier in this chapter, we cannot afford to retreat into a theory of the postcolonial, as represented by figures such as Chambers and Gilroy, and thereby privilege a hyper-culturalist aesthetics of the emotions over the rationality of the mind. Certainly I would accept that the establishment and reproduction of western colonialism was bound up with the politics of subjectivity and 'epistemic violence'. Nevertheless, a postcolonial global order which is still based on inequality and exploitation will not be transformed by a fetishization of the emotions and the abandonment of rational, scientific critique.

Bibliography

Abbas, T. (2007) 'British Muslim Minorities Today: Challenges and Opportunities to Europeanism, Multiculturalism and Islamism', *Sociology Compass*, 1(2), 720–36.

Abidin, K. (2000) *Behind the Postcolonial. Architecture, Urban Space and Political Cultures in Indonesia*. London: Routledge.

Aboul-Ela, H. (2004) 'Comparative Hybridities: Latin American Intellectuals and Postcolonialists', *Rethinking Marxism*, 16(3), 261–79.

Achcar, G. (2008) 'Orientalism in Reverse', *Radical Philosophy*, 151, 20–30.

Ahmad, A. (1992) *In Theory: Classes, Nations, Literatures*. London: Verso.

Ahmad, F. (2006) 'British Muslim Perceptions and Opinions on News Coverage of September 11', *Journal of Ethnic and Migration Studies*, 32(6), 961–82.

Ahmed, S. (2000) *Strange Encounters: Embodied Others in Post-coloniality*. London: Routledge.

Akomfrah, J. (1993) 'Wishful Filming', *Black Film Bulletin*, 1(2), 14.

Aksoy, A. and Robins, K. (2000) 'Thinking across Spaces: Transnational Television from Turkey', *European Journal of Cultural Studies*, 3(3), 343–365.

Alessandrini, A. C. (ed.) (1999) *Frantz Fanon: Critical Perspectives*. London: Routledge.

Alim, H. (2005) 'Hip-Hop and Islam', *Al-Ahram Weekly*, 750 (7–13 July 2005) (at: http://weekly.ahram.org.eg/2005/750/feature.htm; accessed 8 April 2008).

Alim, S. (2006) *Roc the Mic Right: The Language of Hip Hop Culture*. London: Routledge.

Allen, G. (2000) *Intertextuality*. London and New York: Routledge.

Althusser, L. (1971) *Lenin and Philosophy and Other Essays* (trans. B. Brewster). London: Verso.

Anderson, B. (1996) *Imagined Communities: Reflections on the Origin and Spread of Nationalism*. London: Verso.

Ansari, H. (2004) *The Infidel Within: The History of Muslims in Britain, from 1800 to the Present*. London: C. Hurst & Co.

Anthias, F. and Yuval-Davis, N. (1992) *Racialized Boundaries*. London: Routledge.

Anwar, M. (1983) *Ethnic Minority Broadcasting*. London: Commission for Racial Equality.

Appadurai, A. (1996) *Modernity at Large: Cultural Dimension of Globalization*. Minneapolis: University of Minnesota Press.

Appiah, K. A. (1991) 'Is the Post- in Postmodernism the Post- in Postcolonial?', *Critical Inquiry*, 17(2), 336–57.

Appiah K. A. and Gates, H. L. Jr. (eds) (1995) *Identities*. University of Chicago Press.

Araeen, R. (ed.) (1989) *The Other Story: Afro-Asian Artists in Post-war Britain*. London: Hayward Gallery.

—— (2000) 'A New Beginning: Beyond Postcolonial Cultural Theory and Identity Politics', *Third Text*, 14(50), 3–20.

Ashcroft, B. (2001) *On Post-colonial Futures*. London: Continuum.

Ashcroft, B., Griffiths, G. and Tiffin, H. (1998) *Key Concepts in Post-colonial Studies*. London: Routledge.

Ashcroft, B., Griffiths, G. and Tiffin, H. (eds) ([1995] 2006) *The Post-colonial Studies Reader* (2nd edn). London: Routledge.

Attille, M. (1988) 'The Passion of Remembrance: Background', in K. Mercer (ed.) *Black Film, British Cinema*. London: ICA.

Atton, C. (2004) *An Alternative Internet. Radical Media, Politics and Creativity*. Edinburgh University Press.

Back, L. (1996) *New Ethnicities and Urban Culture: Racisms and Multiculture in Young Lives*. London: UCL Press.

Bailey, D. and Kobena, M. (eds) (1995) *Mirage: Enigmas of Race, Difference and Desire*. London: ICA and inIVA.

Baker, H. A., Diawara, M. and Lindeborg, R. H. (eds) (1996) *Black British Cultural Studies: A Reader*. Chicago University Press.

Bakhtin, M. ([1929] 1984) *Problems of Dostoevsky's Poetics* (trans. C. Emerson). Manchester University Press.

Barbrook, R. (1985) 'Community Radio in Britain', in Radical Science Collective (eds) *Making Waves, Politics of Communication*. London: Free Association Books.

Barham, P. (2005) 'Eden Calling. Discord Behind the Harmonies for Artists who Felt Snubbed', *Guardian*, 4 July.

Barnard, S. (1989) *On the Radio: Music Radio in Britain*. Milton Keynes: Open University Press.

Barthes, R. (2000) *Mythologies*. London: Vintage.

Bartolovich, C. (2002) 'Introduction: Marxism, Modernity and Postcolonial Studies', in C. Bartolovich and N. Lazarus (eds) *Marxism, Modernity and Postcolonial Studies*. Cambridge University Press.

Bartolovich, C. and Lazarus, N. (eds) (2002) *Marxism, Modernity and Postcolonial Studies*. Cambridge University Press.

BBC (2007) *From Seesaw to Wagon Wheel: Safeguarding Impartiality in the 21st Century*, June 2007.

BBC Online (October 2006) 'Have Your Say: Would Removing Veils Improve Community Relations?' (at: http://newsforums.bbc.co.uk/nol/thread.jspa?sortBy=1&forumID=1842&start=2205&tstart=0&edition=1&ttl=20080814160111#paginator; accessed 12 August 2008).

BBC Radio 4 (2005) *Start the Week*, January 10 2005 (at: www.bbc.co.uk/films/festivals/edinburgh/yasmin.shtml).

Beattie, T. (2008) 'Rowan Williams and Sharia Law', posted 12 February (at: www.opendemocracy.net).

Beauchamp-Byrd, M. J. and Franklin Sirmans M. (eds) (1997) *Transforming the Crown: African, Asian and Caribbean Artists in Britain 1966–1996*. New York: Caribbean Cultural Center.

Berkey, J. (2003) *The formation of Islam: Religion and Society in the Near East, 600–1800*. Cambridge University Press.

Bhabha, H. K. (ed.) (1987) *Identity*, ICA Documents 6. London: ICA.
(1990) *Nation and Narration*. London: Routledge.
(1994) *The Location of Culture*. London and New York: Routledge.
(2006) 'Another Country', in F. Daftari (ed.) *Without Boundary: Seventeen Ways of Looking*. New York: Museum of Modern Art.

Bhabha, H. K. and Comaroff, J. (2002) 'Speaking of Postcoloniality, in the Continuous Present: A Conversation', in D. T. Goldberg and A. Quayson (eds) *Relocating Postcolonialism*. Oxford: Blackwell Publishers.

Bianquis, T., Bearman, P., Bosworth, C. E., Donzel, E. van and Heinrichs, W. P. (eds) *Encyclopaedia of Islam: Online Edition*. Leiden: Brill.

Bodi, F. (2002) 'This is Radio Ramadan' (at: www.ihrc.org.uk/show.php?id=426; accessed 20 May 2007).

Bourdieu, P. (1991) *Language and Symbolic Power*. London: Polity Press.

Boyce, S. (1987) 'Sonia Boyce in Conversation with John Roberts', *Third Text*, 1(1), 55–64.

Brown, W. (2006) *Regulating Aversion: Tolerance in the Age of Identity and Empire*. Princeton: Princeton University Press.

Brunsdon, C. (2003) 'Lifestyling Britain: The 8–9 Slot on British Television', *International Journal of Cultural Studies*, 6(1), 5–23.

Bunt, G. R. (2000a) 'Surfing Islam: Ayatollahs, Shayks and Hajjis on the Superhighway', in J. K. Hadden and D. E. Cowan (eds) *Religion on the Internet: Research Prospects and Promises*. New York: Elsevier Science.

(2000b) *Virtually Islamic: Computer-mediated Communication and Cyber Islamic Environments*. Cardiff: University of Wales Press.

(2003) *Islam in the Digital Age: e-jihad, Online Fatwas and Cyber Islamic Environments*. London: Pluto.

(2006) 'CyberMuslimUK: Islam, UK Muslim Communities and Cyberspace', in G. Larsson (ed.) *Religious Communities on the Internet*. Stockholm: Swedish Science Press.

(2009) *iMuslims: Rewiring the House of Islam*. Chapel Hill & London: University of North Carolina Press and C. Hurst & Co.

Burbridge, B. and Chandler D. (eds) (2006) *Henna Nadeem: A Picture Book of Britain*. Brighton: Photoworks.

Cabral, A. (1973) *Return to the Source: Selected Speeches*. New York: Monthly Review Press.

Calhoun, C. (ed.) (1999) *Habermas and the Public Sphere*. Cambridge, MA: MIT Press.

Cannon, S. and Saeed, A. (2004) 'Jihad Musical? Musique Hip-Hop et Musulmans en Grande-Bretagne et France', in A. G. Hargreaves (ed.) *Minorités Ethniques Anglophones et Francophones: études Culturelles Comparatives*. Paris: Harmattan Presse.

Castle, G. (ed.) (2001) *Postcolonial Discourses. An Anthology*. Oxford: Blackwell Publishers.

Cesaire, A. (1972) *Discourse on Colonialism*. New York: Monthly Review Press.

Chakrabarty, D. (2005) 'A Small History of Subaltern Studies', in H. Schwarz and S. Ray (eds), *A Companion to Postcolonial Studies*. Malden, MA: Blackwell.

Chambers, E. (ed.) (1988) *Black Art: Plotting the Course*. Oldham, Wolverhampton and Liverpool: Oldham Art Gallery, Wolverhampton Art Gallery and Bluecoat Gallery.

Chambers, I. (1986) *Popular Culture: The Metropolitan Experience*. London: Methuen.

(1994) *Migrancy, Culture, Identity*. London: Routledge.

(1996) *The Post-colonial Question: Common Skies, Divided Horizons*. London: Routledge.

(2000) 'At the End of This Sentence a Sail Will Unfurl...Modernities, Musics and the Journey of Identity', in P. Gilroy, L. Grossberg and A. McRobbie (eds) *Without Guarantees: Essays in Honour of Stuart Hall*. London: Verso.

(2001) *Culture After Humanism: History, Culture, Subjectivity*. London: Routledge.

Chandler, D. (ed.) (1997) *Keith Piper: Relocating the Remains*. London: Institute of International Visual Arts and the Royal College of Art.

Chaturvedi, V. (ed.) (2000) *Mapping Subaltern Studies and the Postcolonial*. London: Verso.

Childs, P. and Williams, P. (1997) *An Introduction to Post-colonial Theory*. Harlow: Longman.

Chrisman, L. (2000) 'Journey to Death: Gilroy's Black Atlantic', in K. Owusu (ed.) *Black British Culture and Society*. London: Routledge.

Collie, L. (2002) *Captives: Britain, Empire and the World 1600–1850*. London: Jonathan Cape.

(2003) 'Into the Belly of the Beast', *Guardian*, 18 January.

cooke, m. and Lawrence, B. B. (eds) (2005) *Muslim Networks from Hajj to Hip Hop*. Chapel Hill: University of North Carolina Press.

Cottle, S. (1998) 'Making Ethnic Minority Programmes inside the BBC: Professional Pragmatics and Cultural Containment', *Media, Culture and Society*, 20(2), 295–317.

(ed.) (2000) *Ethnic Minorities and the Media. Changing Cultural Boundaries*. Milton Keynes: Open University Press.

Creeber, G. (2004) '"Hideously White": British Television, Globalisation, and National Identity', *Television and New Media*, 5(27), 27–39.

Crisell, A. (1997) *An Introductory History of British Broadcasting*. London and New York: Routledge.

Dahlgren, P. (1995) *Television and the Public Sphere*. London: Sage.

(2006) *The God Delusion*. London: Bantam Press.

Deburg, W. L. van (1992) *New Day in Babylon: The Black Power Movement and American Culture, 1965–1975*. University of Chicago Press.

Decker, J. L. (1994) 'The State of Rap: Time and Place in Hip-Hop Nationalism', in A. Ross and T. Rose (eds) *Microphone Fiends Youth Music and Youth Culture*. London and New York: Routledge.

Dent, G. (ed.) (1992) *Black Popular Culture: A Project by Michele Wallace*. Seattle: Bay Press.

Diawara, M. (1993) 'Power and Territory: The Emergence of Black British Film Collectives', in L. Friedman (ed.) *Fires Were Started: British Cinema and Thatcherism*. London: UCL Press.

(1996) 'Black British Cinema: Spectatorship and Identity Formation in *Territories*', in H.A. Baker, M. Diawara and R. H. Lindeborg (eds) *Black British Cultural Studies: A Reader*. Chicago and London: University of Chicago Press.

Dillon, M. C. (1995) *Semiological Reductionism: A Critique of the Deconstructionist Movement in Postmodern Thought*. State University of New York Press.

Dirlik, A. (1994) 'The Postcolonial Aura: Third World Criticism in the Age of Global Capitalism', *Critical Inquiry*, 20(2), 328–56.

Downey, R. (2006) 'Critical Imperatives: Notes on Contemporary Art Criticism and African Cultural Production', *Wasafiri*, 21(1), 39–48.

Dunant, S. (ed.) (1994) *The War of the Words: The Political Correctness Debate*. London: Virago.

Dyer, R. (1997) *White: Essays on Race and Culture*. London: Routledge.

Dyer, S. (2007) *Boxed In: How Cultural Diversity Policies Constrict Black Artists*. Manifesto Club's Artistic Autonomy Hub with a-n, the artists' information company (at: www.manifestoclub.com/aa-diversity).

Dyer, S., McAuslan, F. and Gausi, T. (2007) 'Why Are the Arts so White', *Time Out*, 17–23 October, 19–30.

Dyke, G. (2002) 'Diversity in Broadcasting: A Public Service Perspective'. Speech given at the Commonwealth Broadcasting Association conference in Manchester, 3 May.

Dyson, M. (1995) *Making Malcolm: The Myth and Meaning of Malcolm X*. New York: Oxford University Press.

Eagleton, T. (1998) 'Postcolonialism and "postcolonialism"', *Interventions. International Journal of Postcolonial Studies*, 1 (1), 24–6.

Easthope, A. (1999) *Englishness and National Culture*. London and New York: Routledge.

Egg, C. (1998) *An Original Man: The Life and Times of Elijah Muhammad*. New York: St Martin's Press.

Ellis, J. (2000) *Seeing Things. Television in the Age of Uncertainty*. London: I.B. Tauris.

Esposito, J. L. (1998) *Islam: The Straight Path*. (3rd edn). New York: Oxford University Press.

Everitt, A. (2003) *New Voices. An Evaluation of 15 Access Radio Projects*. London: Ofcom.

Fabian, J. (1983) *Time and the Other: How Anthropology Makes its Object*. New York: Columbia University Press.

Fanon, F. (1968) *Black Skin, White Masks*. London: MacGibbon & Kee.

(1970) *Toward the African Revolution*. Harmondsworth, Middlesex: Penguin Books.

([1961] 2004) *Wretched of the Earth*. New York: Grove Press.

Featherstone, M. (ed.) (1990) *Global Culture. Nationalism, Globalization and Modernity*. London: Sage.

(1996) *Undoing Culture: Globalization, Postmodernism and Identity*. London: Sage.

Featherstone, S. (2005) *Postcolonial Cultures*. Edinburgh University Press.

Fekete, L. (2002) *Racism, the Hidden Cost of September 11*. London: Institute of Race Relations.

Ferguson, N. (2003) *Empire: How Britain Made the Modern World*. London: Allen Lane.

Fisher, J. (ed.) (1994) *Global Visions: Towards a New Internationalism in the Visual Arts*. London: Kala Press.

Foreign and Commonwealth Office 'Saudi Arabia Country Profile' (at: www.fco.gov.uk/en/about-the-fco/country-profiles/middle-east-north-africa/saudi-arabia?profile=all; accessed 12 August 2008).

Forman, M. and Neal, M. A. (eds) (2004) *That's the Joint!: The Hip-Hop Studies Reader*. New York and London: Routledge.

Foster, H. (1991) 'YSR: Designer Movie?', *Screen International*, 820, 18.

Foucault, M. (1972) *The Archaeology of Knowledge*. London: Tavistock

Fowler, R. (1991) *Language in the News*. London: Routledge.

Fox-Howard, Y. (1997) 'Conflict resolution: a study of identity, social/economic exclusion, Islamophobia and racism'. Ph.D., University of Wales, Lampeter.

Friedman, L. (ed.) (1993) *Fires Were Started: British Cinema and Thatcherism*. London: UCL Press.

Fusco, C. (1995) 'Black Filmmaking in Britain's Workshop Section', in M. T. Martin (ed.) *Cinemas of the Black Diaspora: Diversity, Dependence, and Oppositionality*. Detroit: Wayne State University Press.

Gaborieau, M. (2008) 'Tablighi Djamaat', in T. Bianquis, P. Bearman, C. E. Bosworth, E. van Donzel and W. P. Heinrichs (eds) *Encyclopaedia of Islam: Online Edition*. Leiden: Brill.

Gabriel, J. (1998) *Whitewash. Racialized Politics and the Media*. London: Routledge.

Gandhi, L. (1998). *Postcolonial Theory: A Critical Introduction*. Edinburgh University Press.

Garcia Canclini, N. (2005) *Hybrid Cultures: Strategies for Entering and Leaving Modernity*. Minneapolis: University of Minnesota Press.

Gardell, M. (1996) *Countdown to Armageddon: Louis Farrakhan and the Nation of Islam*. London: Hurst & Co.

Garofalo, R. (1992) 'Popular Music and the Civil Rights Movement', in R. Garofalo (ed.) *Rocking the Boat: Mass Music and Mass Movements*. Boston: South End Press.

Geaves, R. (1999) 'Britain', in D. Westerlund and I. Svanberg (eds) *Islam Outside the Arab World*. Richmond: Curzon Press.

Giddens, A. (2000) *The Consequences of Modernity*. Cambridge: Polity Press.

(2002) *Runway World: How Globalization is Reshaping our Lives*. London: Profile.

Gill, J. and Tawadros, G. (2006) '"We Are the Martians..."', in Gill *et al.* (eds) *Alien Nation*, p. 11

Gill, J., Hoffmann, J. and Tawadros, G. (eds) (2006) *Alien Nation*. London and Ostfildern, Germany: Institute of Contemporary Arts (ICA), Institute of International Visual Arts (inIVA) and Hatje Cantz Verlage.

Gilroy, P. (1987) *There Ain't No Black in the Union Jack: The Cultural Politics of Race and Nation*. London: Hutchinson.

(1993a) *The Black Atlantic. Modernity and Double Consciousness*. London: Verso.

(1993b) 'Cruciality and the Frog's Perspective: An Agenda of Difficulties for the Black Arts Movement in Britain', in P. Gilroy (ed.) *Small Acts: Thoughts on the Politics of Black Cultures*. London: Serpent's Tail.

(1995) 'Unwelcome', *Sight & Sound*, 5 (2).

(2001) *Imagining Political Culture Beyond the Color Line*. Cambridge, MA: Harvard University Press.

(2004a) *After Empire: Melancholia or Convivial Culture?* Abingdon: Routledge.

(2004b) *Postcolonial Melancholia*. New York: Columbia University Press.

(2004c) 'Foreword', to Heike Raphael-Hernandez ed. *Blackening Europe: The African American Presence* London: Routledge, p. xix.

Gilroy, P., Hall, S. and Bhabha, H. (1991) 'Threatening Pleasures', *Sight & Sound*, 1(4), 17–19.

Girard, B. (1992) *A Passion for Radio*. Montreal and New York: Black Rose Books.

Glenaan, K. (2004) *Yasmin*. Parallax Independent/Channel 4 Films.

Goatley, M. (2006) *The Community Radio Sector: Looking to the Future*. London: Department of Culture, Media and Sport.

Goldberg, D. T. and Quayson, A. (eds) (2002) *Relocating Postcolonialism*. Oxford: Blackwell Publishers.

Goldthorpe, J. E. (1996) *The Sociology of Postcolonial Societies*. Cambridge University Press.

Goode, L. (2005) *Jürgen Habermas: Democracy and the Public Sphere*. London: Pluto Press.

Goodhart, D. (2004) 'Discomfort of Strangers', *Guardian*, 24 February.

Grayson, P. (2007) 'Positive Discrimination Patronizes Black Artists', *The Times*, 30 May, p. 16.

Habermas, J. ([1981] 1987) *The Theory of Communicative Action, vol. 2: Lifeworld and System*. Cambridge: Polity Press.

([1962] 1989) *The Structural Transformation of the Public Sphere*. Cambridge: Polity Press.

Haddour, A. (ed.) (2006) *The Fanon Reader. Frantz Fanon*. London, Pluto Press.

Hakes, N. (2004) 'Rebel Radio, Interview with DJ Lepke, Ranking Miss P and Mike "The Bike" Williams', 16 February. Published on the CD cover notes of *Tune in if yu Rankin*, Dread Broadcasting Corporation. London: Trojan Records.

Hall, C. (1996) 'Histories, Empires and the Post-colonial Moment', in I. Chambers and

L. Curti (eds) *The Postcolonial Question. Common Skies, Divided Horizons.* London and New York: Routledge.

Hall, S. (1982) 'The Rediscovery of "Ideology": Return of the Repressed in Media Studies', in M. Gurevitch, J. Woollacott, T. Bennett, and J. Curran (eds) *Culture, Society and the Media.* London: Methuen.

—— (1990) 'Cultural Identity and Diaspora', in J. Rutherford (ed.) *Identity: Community, Culture, Difference.* London: Lawrence & Wishart.

—— (1991) 'The Local and the Global: Globalization and Ethnicity', in A. D. King (ed.) *Culture, Globalization and the World System: Contemporary Conditions for the Representation of Identity.* Binghamton, NY: State University of New York.

—— (1992) 'The West and the Rest: Discourses and Power', in S. Hall and B. Gieben (eds) *Formations of Modernity.* Cambridge: Polity.

—— (1993) 'Culture, Community, Nation in Cultural Studies', *Journal of Cultural Studies*, 7(3): 349–63.

—— (1996a) 'New Ethnicities', in H. A. Baker, M. Diawara and R. H. Lindeborg (eds) *Black British Cultural Studies: A Reader.* Chicago and London: University of Chicago Press.

—— (1996b) 'When was the "Post-colonial"? Thinking at the Limit', in I. Chambers and Curti, L. (eds) *The Postcolonial Question. Common Skies, Divided Horizons.* London and New York: Routledge.

—— (1996c) 'Who Needs Identity?' in Hall, Stuart and Paul du Gay eds. *Questions of Cultural Identity*, London: Sage, pp. 1–17

—— (1997) 'The Spectacle of the "Other"', in S. Hall (ed.) *Representation: Cultural Representation and Signifying Practices.* London: Sage.

—— (1998) 'A Rage in Harlesden', *Sight & Sound*, 8(9), 24–7.

—— (2007) 'Living with Difference', *Soundings*, 37, 148–58.

Hall, S., Connell, I. and Curti, L. (2007) 'The "Unity" of Current Affairs Television', in A. Gray, J. Campbell, M. Erickson, S. Hanson and H. Wood (eds) *CCCS Selected Working Papers: vol. 2.* London: Routledge.

Hall, S. and du Gay, P. (eds) (1996) *Questions of Cultural Identity.* London: Sage.

Hargreaves, A. and McKinney, M. (eds) (1997) *Post-colonial Cultures in France.* London: Routledge.

Harman, C. (2007) 'The Crisis in Respect', *International Socialism*, 117 (at: www.isj.org.uk/index.php4?id=396&issue=117; accessed 14 September 2008).

Haslett, M. (2000) *Marxist Literary and Cultural Theories.* London: Macmillan Press.

Havens, T. (2002) '"It's Still a White World Out There": The Interplay of Culture and Economics in International Television Trade', *Critical Studies in Media Communication*, 19(4), 337–98.

Hebdige, D. (1996) 'Digging for Britain: An Excavation in Seven Parts', in H.A. Baker, M. Diawara and R. H. Lindeborg (eds) *Black British Cultural Studies: A Reader.* Chicago and London: University of Chicago Press.

Hill, J. (1999) *British Cinema in the 1980s: Issues and Themes.* Oxford: Clarendon

Hoffmann, J. (2006) 'The Truth is Out There', in J. Gill, J. Hoffmann and G. Tawadros (eds) *Alien Nation.* London and Ostfildern, Germany: Institute of Contemporary Arts (ICA), Institute of International Visual Arts (inIVA) and Hatje Cantz Verlage.

Hoggart, R. (1959) *The Uses of Literacy.* London: Penguin.

Holohan, S. (2006) 'New Labour, Multiculturalism and the Media in Britain', in E. Poole and J. E. Richardson (eds) *Muslims and the News Media.* London: I. B. Tauris.

hooks, b. (1989) *Talking Back: Thinking Feminist, Thinking Black.* Boston, MA: South End Press.

Howe, D. (2003) 'Darcus Howe Denounces a New BBC Sitcom', *New Statesman*, 29 September (at: www.newstatesman.com/200309290007; accessed 07/07/10).

Huntington, S. P. (1993a) 'The Clash of Civilizations?', *Foreign Affairs*, 72(3), 22–49.

(1993b) 'If not Civilizations, What?: Samuel Huntington Responds to his Critics', *Foreign Affairs*, 72(5), 186–94.

Huq, R. (1996) 'Asian Kool? Bhangra and Beyond', in S. Sharma, J. Hutnyk and A. Sharma (eds) *Dis-orienting Rhythms: the Politics of the New Asian Dance Music*. London: Zed Books.

Husband, C. and Chouhan, J. (1985) 'Local Radio in the Communication Environment of Ethnic Minorities in Britain', in T. A. van Dijk (ed.) *Discourse and Communication: New Approaches to the Analysis of Media Discourse and Communication*. Berlin: Walter de Grutyer.

Hussain, S. (2004) *An Introduction to Muslims in the 2001 Census*. Selly Oaks: University of Birmingham, 7 September.

Hutnyk, J. (1996) 'Repetitive Beatings or Criminal Justice?', in S. Sharma, J. Hutnyk and A. Sharma (eds) *Dis-orienting Rhythms: the Politics of the New Asian Dance Music*. London: Zed Books.

(2000) 'Adorno at Womad: South Asian Crossovers and the Limits of Hybridity-Talk', in P. Werbner and T. Modood (eds) *Debating Cultural Hybridity*. London: Zed Books.

(2005) 'Hybridity', *Ethnic and Racial Studies*, 28(1): 79–102.

Hyder, R. (2004) *Brimful of Asia: Negotiating Ethnicity on the UK Music Scene*. Aldershot: Ashgate.

Jacobsen, J. (1997) 'Religion and Ethnicity: Dual and Alternative Sources of Identity among Young British Pakistanis', *Ethnic and Racial Studies*, 20(2), 223–44.

Jameson, F. (1981) *The Political Unconscious*. London: Methuen.

(1988) 'Cognitive Mapping', in C. Nelson and L. Grossberg (eds) *Marxism and the Interpretation of Culture*. London: Macmillan.

(1991) *Postmodernism or, the Cultural Logic of Late Capitalism*. London: Verso.

(1998) *Brecht and Method*. London: Verso.

Joppke, C. (2009) *Veil. Mirror of Identity*. Cambridge: Polity Press.

Julien, I. (1985) 'Interview with Jim Pines: Territories', *Framework*, 26/27.

(1991a) 'Introduction', in Julien and MacCabe *Diary of a Young Soul Rebel*.

(1991b) 'Soul to Soul', interview with Amy Taubin, *Sight & Sound*, 1 (4), 16.

Julien, I. and MacCabe, C. (1991) *Diary of a Young Soul Rebel*. London: BFI.

Kalra, V., Hutnyk, J. and Sharma, S. (1996) 'Re-Sounding (Anti) Racism, or Concordant Politics? Revolutionary Antecedents', in S. Sharma, J Hutnyk and A. Sharma (eds) *Dis-orienting Rhythms: the Politics of the New Asian Dance Music*. London: Zed Books.

Kant, I. (1952) *Critique of Judgment*. Oxford: Clarendon Press.

Karim, H. K. (ed.) (2003) *The Media of Diaspora: Mapping the Globe*. London: Routledge.

Kitwana, B. (1994) *The Rap on Gangsta Rap*. Chicago: Third World Press.

Landry, D. and MacLean G. (eds) (1996) *The Spivak Reader*. London: Routledge.

Lazarus, N. (1999) *Nationalism and Cultural Practice in the Postcolonial World*. Cambridge University Press.

Leeds City Council (2004) *Skills Audit: Beeston Hill and Holbeck Neighbourhood Renewal Area Report*. Leeds City Council.

Lewis, P. (2002) *Islamic Britain: Religion, Politics, and Identity among British Muslims* (2nd edn). London: I.B. Tauris.

(2006) 'Community Media: Giving a Voice to the Voiceless', in P. M. Lewis and S.

Jones (eds) *From the Margins to the Cutting Edge. Community Media and Empowerment*. Cresskill, NJ: Hampton Press.

(2007) *Young, British and Muslim*. London: Continuum International Publishing.

Lewis, P. and Booth, J. (1989) *The Invisible Medium: Public, Commercial and Community Radio*. London: Macmillan.

Lewis, R. and Mills, S. (eds) (2003) *Feminist Postcolonial Theory: A Reader*. Edinburgh University Press.

Leyens, J. P., Yzerbyt, V. and Schadron, G. (1994) *Stereotypes and Social Cognition*. London: Sage.

Lincoln, C. E. (1995) *The Black Muslims in America*. Grand Rapids, MI: William B Eerdmans.

Lincoln, C. E. and Mamiya, L. (1990) *The Black Church in the African-American Experience*. Durham, NC: Duke University Press.

Lipsitz, G. (1994) *Dangerous Crossroads: Popular Music, Postmodernism and the Poetics of Place*. London: Verso.

Livingstone, S., Lunt, P., and Miller, L. (2007) 'Citizens, Consumers and the Citizen-consumer: Articulating the Citizen Interest in Media and Communications Regulation', *Discourse and Communication*, 1(1), 63–89.

Local Radio Workshop (1983) *Nothing Local About it. London's Local Radio*. London: Comedia and Local Radio Workshop.

Loomba, A. (1998) *Colonialism/Postcolonialism*. London: Routledge.

Loomba, A., Kaul, S., Bunzl, M., Burton, A. and Esty, J. (eds) (2005) *Postcolonial Studies and Beyond*. Durham, NC: Duke University Press.

Lukács, G. ([1937] 1962) *The Historical Novel* (trans. H. Mitchell and S. Mitchell). London: Merlin.

Lusane, C. (1993) 'Rap, Race and Politics', *Race and Class*, 35(1), 41–56.

Lynch, K. (1960) *The Image of the City*, Cambridge, MA: MIT Press.

McCartney, J. T. *Black Power Ideologies: An Essay in African–American Political Thought*. Philadelphia, PA: Temple University Press.

McClintock, A. (1992) 'The Angel of Progress: Pitfalls of the Term "Post-colonialism"', *Social Text*, 31/32, 84–98.

Macdonald, M. (2006) 'Muslim Women and the Veil: Problems of Image and Voice in Media Representations', *Feminist Media Studies* 6 (1), 7–23.

McGuigan, J. (1992) *Cultural Populism*. London: Routledge.

McLoughlin, S. (2005) 'Mosques and the Public Space: Conflict and Cooperation in Bradford', *Journal of Ethnic and Migration Studies*, 31(6), 1045–66.

Macpherson, W. (1999) *The Stephen Lawrence Inquiry: Report of an Inquiry by Sir William Macpherson of Cluny*, Cm 4262–1. London: Stationery Office.

Malik, S. (2002) *Representing Black Britain: A History of Black and Asian Images on British Television*. London: Sage.

(2008) '"Keeping It Real": The Politics of Channel 4's Multiculturalism, Mainstreaming and Mandates', *Screen*, 49(3), 343–53.

Mandaville, P. (2001) *Transnational Muslim Politics: Reimagining the Umma*. London: Routledge.

(2007) *Global Political Islam*. London and New York: Routledge.

Mani, L. (1990) 'Contentious Traditions: The Debate on Sati in Colonial India', in K. Sangari and S. Vaid (eds) *Recasting Women: Essays in Indian Colonial History*. New Brunswick, NJ: Rutgers University Press.

Mariani, E. (2006) 'The Production of Islamic Knowledge on the Internet and the Role of States and Markets: The Examples of Yussef al-Qaradawi and Amru Khaled', in

G. Larsson (ed.) *Religious Communities on the Internet*. Stockholm: Swedish Science Press.

Marks, L. U. (2000) *The Skin of the Film: Intercultural Cinema, Embodiment, and the Senses*. Durham, NC and London: Duke University Press.

Marqusee, M. (1999) *Redemption Song: Muhammad Ali and Spirit of the Sixties*. New York: Verso.

Martin, M. T. (ed.) (1995) *Cinemas of the Black Diaspora: Diversity, Dependence, and Oppositionality*. Detroit: Wayne State University Press.

Marx, K. and Engels, F. (1982) *Textes sur le Colonialisme*. Moscow: Éditions du Progrès.

Massey, D. (1994) *Space, Place and Gender*. Cambridge: Polity Press.

Memmi, A. ([1957] 2003) *The Colonizer and the Colonized*. London: Earthscan Publications.

(2006) *Decolonization ant the Decolonized*. Minneapolis: University of Minnesota Press.

Mercer, K. (1988a) 'Recoding Narratives of Race and Nation', in K. Mercer (ed.) *Black Film, British Cinema*. London: ICA.

(1988b) 'Diaspora Culture and the Dialogic Imagination: The Aesthetics of Black Independent Film in Britain', in M. B. Cham and C. Andrade-Watkins (eds) *Blackframes: Critical Perspectives on Black Independent Cinema*. Cambridge, MA: MIT Press.

(ed.) (1988c) *Black Film/British Cinema. ICA Documents 7*. London: ICA and BFI.

(1994) *Welcome to the Jungle: New Positions in Black Cultural Studies*. London: Routledge.

Minh-ha Trinh, T. (1989) *Woman, Native, Other: Writing Postcoloniality and Feminism*. Bloomington, IN: Indiana University Press.

Mitchell, C. (1998) 'Women's (Community) Radio as a Feminist Public Sphere', *Javnost: The Public*, 5(2), 73–85.

(ed.) (2000) *Women and Radio-Airing Differences*. London: Routledge.

Mitchell, C. and Baxter, A. (2006) 'Organic Radio: The Role of Social Partnerships in Creating Community Voices', in P. Lewis and S. Jones (eds) *From the Margins to the Cutting Edge-Community Media and Empowerment*. Cresskill, NJ: Hampton Press.

Mitchell, T. (ed.) (2002) *Global Noise: Rap and Hip-Hop Outside the USA*. Middletown, CT: Wesleyan University Press.

Modood, T. (1992) *Not Easy Being British: Colour, Culture and Citizenship*. London: Runnymede Trust.

(2007) *Multiculturalism: A Civic Idea*. Cambridge: Polity Press.

(2008) 'Multicultural Citizenship and the Anti-*sharia* Storm' (posted 14 February, at: www.opendemocracy.net).

Modood, T., Berthoud, R., Lakey, J., Nazroo, J., Smith, P., Virdee, S. and Beishon, S. (1997) *Ethnic Minorities in Britain: Diversity and Disadvantage*. London: Policy Study Institute.

Mohanty, C. T. (2003a) 'Under Western Eyes: Feminist Scholarship and Colonial Discourses', in R. Lewis and S. Mills (eds) *Feminist Postcolonial Theory: A Reader*. Edinburgh University Press.

(2003b) *Feminism Without Borders: Decolonizing Theory, Practicing Solidarity*. Durham, NC and London: Duke University Press.

Moore-Gilbert, B. (2005) 'Spivak and Bhabha', in H. Schwarz and S. Ray (eds) *A Companion to Postcolonial Studies*. Malden, MA: Blackwell.

Moses, W. J. (1988) *The Golden Age of Black Nationalism 1850–1925*. Oxford University Press.

Mulhern, F. (2000) *Culture/Metaculture*. London: Routledge.

Negus, K. (1996) *Popular Music Theory. An Introduction*. Cambridge: Polity Press.

Nicholas, H. (2001) 'Dyke Attacks "Hideously White" BBC'. *Sunday Times*, 7 January, 3.

Nielsen, J. (2004) *Muslims in Western Europe* (3rd edn). Edinburgh University Press.

Ofcom (2004) 'New Voices on Access Radio', press release 19 March 2003 (at: www.ofcom.org.uk/static/archive/rau/newsroom/news-release/03/pr044.htm; accessed 10/06/07).

(2007a) *Adjudication of Ofcom Content Sanctions Committee – Channel 4 Television Corporation in Respect of its Service*. Channel 4, 24 May.

(2007b) *Communications Market Special Report: Ethnic Minority Groups and Communications Services*, 21 June.

(2008) *Second Public Service Broadcasting Review Phase One: The Digital Opportunity* (at: www.ofcom.org.uk/consult/condocs/psb2_1/; accessed 21/04/08).

(2009) Annual Report of Community Radio. London: Ofcom.

Office of Public Sector Information (2000) *Terrorism Act, Chapter 11, Section 57*. London: Office of Public Sector Information.

Oguibe, O. (2004) *The Culture Game*. London and Minneapolis: University of Minnesota Press.

O'Loughlin, B. (2006) 'The Operationalization of the Concept "Cultural Diversity"', *British Television Policy and Governance*, CRESC, Working Paper Series, Working Paper No. 27, Open University, November.

Parry, B. (2002) 'Directions and Dead Ends in Postcolonial Studies', in D. T. Goldberg and A. Quayson (eds) *Relocating Postcolonialism*. Oxford: Blackwell Publishers.

(2004a) *Postcolonial Studies. A Materialist Critique*. London: Routledge.

(2004b) 'The Institutionalization of Postcolonial Studies', in N. Lazarus (ed.) *Postcolonial Literary Studies*. Cambridge University Press.

Pearce, F. (1973) 'How to be Immoral and Ill, Dangerous and Pathetic All at the Same Time: Mass Media and the Homosexual', in S. Cohen and J. Young (eds) *The Manufacture of News*. London: Constable.

Perry, G. (2007) 'Positive Discrimination Patronizes Black Artists', *The Times*, 30 May, 16.

Phillips, T. (2004) 'Multiculturalism's Legacy is "Have a Nice Day" Racism', *Guardian*, 28 May.

Pines, J. (1988) 'The Cultural Context of Black British Cinema', in M. B. Cham and C. Andrade-Watkins (eds) *Blackframes: Critical Perspectives on Black Independent Cinema*. Cambridge, MA: MIT Press.

(ed.) (1992) *Black and White in Colour: Black People in British Television Since 1936*. London: BFI.

Pines, J. and Willemen, P. (eds) (1989) *Questions of Third Cinema*. London: BFI.

Poole, E. (2002) *Reporting Islam: Media Representations of British Muslims*. London and New York: I. B. Taurus.

Poole, E. and Richardson, J. E. (eds) (2006) *Muslims and the News Media*. London: I. B. Tauris

Quayson, A. (2000) *Postcolonialism. Theory, Practice or Process?* Cambridge: Polity Press.

Qureshi, K. (2000) 'Limited Talk', in C. Mitchell (ed.) *Women and Radio-Airing Differences*. London: Routledge.

(2006) 'Trans-Boundary Spaces: Scottish Pakistanis and Trans-Local/National Identities', *International Journal of Cultural Studies* 9(2), 207–26.

Raphael-Hernandez, H. (ed.) (2004) *Blackening Europe: The African American Presence*. London: Routledge.

Rigoni, I. (2005) 'Challenging Notions and Practices: The Muslim Media in Britain and France', *Journal of Ethnic and Migration Studies*, 31(3), 563–80.

Robinson, D. and Marsden, E. (eds) (2005) *Hew Locke*. Walsall: New Art Gallery.

Roddick, N. (1994) 'Welcome to the Multiplex', *Sight & Sound*, 4(6).

Rojek, C. (2007) *Cultural Studies*. Cambridge: Polity Press.

Rose, T. (1994) *Black Noise*. Hanover and London: Wesleyan University Press.

Rosler, M. (1997) 'Money, Power, Contemporary Art', *Art Bulletin*, 79(1), 20–4.

Ross, A. and Rose, T. (eds) (1994) *Microphone Fiends Youth Music and Youth Culture*. London and New York: Routledge.

Ross, L. (1998) 'Baby Mothers: Babies, Mothers, Fathers and the Dancehall', *Black Film Bulletin*, 6(2/3).

Roy, O. (2004) *Globalised Islam: The Search for a New Umma*. London: C. Hurst & Co.

Rutherford, J. (ed.) (1990) *Identity: Community, Culture, Difference*. London: Lawrence & Wishart.

Saeed, A. (2003) 'Muhammad Ali and the Politics of Cultural Identity', in A. Bernstein and N. Blain (eds) *Sport, Media and Society: Global and Local Dimensions*. London: Frank Cass.

(2004) '9/11 and the Consequences for British-Muslims', in J. Carter and D. Morland (eds) *Anti-Capitalist Britain*. Manchester: New Clarion Press.

(2006) 'Musical Jihad', *Soundings*, 33, 57–65.

(2007) 'Media, Racism and Islamophobia: The Representation of Islam and Muslims in the Media', *Sociology Compass* (1)2, 443–462.

Saeed, A., Blain, N. and Forbes, D. (1999) 'New Ethnic and National Questions in Scotland: Post-British Identities among Glasgow Pakistani Teenagers', *Ethnic and Racial Studies*, 22(5), 821–44.

Said, E. W. ([1978] 1991) *Orientalism. Western Conceptions of the Orient*. Harmondsworth, Middlesex: Penguin Books.

(1994) *Culture and Imperialism*. London: Vintage.

([1981] 1997) *Covering Islam. How the Media and the Experts Determine How We See the World*. London: Vintage.

Sangari, K. and Vaid, S. (eds) (1990) *Recasting Women: Essays in Indian Colonial History*. New Brunswick, NJ: Rutgers University Press.

Sartre, J. P. ([1961] 1968) 'Preface' to F. Fanon, *The Wretched of the Earth* (trans. C. Farrington). New York: Grove Press.

Scannell, P. (1996) *Radio, Television and Modern Life*. Oxford: Blackwell.

Schwarz, H. and Ray, S. (eds) (2005) *A Companion to Postcolonial Studies*. Malden, MA: Blackwell.

Shamash, J. (2000) Changing the Face of Broadcasting: Interview with George Alagiah, 24 April 2007. Connections (at: www.catalystmagazine.org/default.aspx.locid-0hgnew0tz&RefLocID=0hg01b001006001.Lang-EN.htm; accessed 20/06/07).

Sharma, S., Hutnyk, J. and Sharma, A. (eds) (1996) *Dis-orienting Rhythms: The Politics of the New Asian Dance Music*. London: Zed Books.

Sharpley-Whiting, D. T. (1998) *Franz Fanon: Conflicts and Feminisms*. Lanham, MD: Rowman & Littlefield.

Shohat, E. (1992) 'Notes on the "Post-colonial"', *Social Text*, 31/32, 99–113.

Shohat, E. and Stam, R. (1994) *Unthinking Eurocentrism: Multiculturalism and the Media*. London: Routledge.

Shomari, H. (1995) *From the Underground: Hip Hop Culture as an Agent of Social Change*. New Jersey: X Factor Publications.

Shortt, R. (2008) *Rowan's Rule*. London: Hodder & Stoughton.

Shukra, K., Back L., Keith, M., Khan, A. and Solomos, J. (eds) (2004) 'Race, Social Cohesion and the Changing Politics of Citizenship', *London Review of Education*, 2(3), 187–95.

Simon, C. (2004) 'Albert Memmi. Marabout sans Tribu', *Le Monde*, 16 June.

Sivanandan, A. (1988) 'The New Racism', *New Statesman*, 4 November, 8–9.

Skillset (Sector Skills Council for the Audio-Visual Industries) (2004) *Census*. London: Skillset.

(2007) *Radio Skills Strategy*. London: Skillset.

Skovgaard-Petersen, J. (2008) *The Global Mufti: The Phenomenon of Yusuf Al-Qaradawi*. London: C. Hurst & Co.

Slater, D. (1998) 'Post-colonial Questions for Global Times', *Review of International Political Economy*, 5(4), 647–78.

Sparks, C. (2004) *Globalization, Development and the Mass Media*. London: Sage.

Spivak, G. C. (1988) 'Can the Subaltern Speak?', in C. Nelson and L. Grossberg (eds) *Marxism and the Interpretation of Culture*. Basingstoke: Macmillan.

(1999) *A Critique of Postcolonial Reason. Toward a History of the Vanishing Present*. Cambridge, MA: Harvard University Press.

Sprinker, M. (ed.) (1992) *Edward Said: A Critical Reader*. Oxford: Blackwell.

Stabile, C. and Kumar, D. (2005) 'Unveiling Imperialism: Media, Gender and the War on Afghanistan', *Media, Culture and Society*, 27(5), 765–82.

Stallabrass, J. (2004) *Art Incorporated: The Story of Contemporary Art*. Oxford University Press.

Suleri, S (1995) 'Woman Skin Deep: Feminism and the Postcolonial Condition', in K. A. Appiah and H. L. Gates Jr. (eds) *Identities*. University of Chicago Press.

Swedenburg, T. (1989) 'Homies in the Hood: Rap's Commodification of Insubordination', *New Formations*, 17, 53–66.

Sylvester, C. (1999) 'Development Studies and Postcolonial Studies: Disparate Tales of the "Third World"', *Third World Quarterly*, 20(4), 703–21.

Tahir, A. (2005) *Muslim Britain: Communities under Pressure*. London and New York: Zed Books.

Tajfel, H. (1981) *Human Groups and Social Categories: Studies in Social Psychology*. Cambridge University Press.

Thompson, C. (2002) *The Future of Public Service Broadcasting – An International Perspective*, 29 January (at: www.bbc.co.uk/pressoffice/speeches/stories/thomson-carolinecbs.shtml; accessed 23/01/05).

Todd, R. (2004) 'Multiculturalism', in E. Cashmore (ed.) *The Encyclopedia of Race and Ethnic Studies*. London and New York: Routledge.

Traber, M. (1985) *Alternative Journalism. Alternative Media. Communication Resource, No. 7, October*. London: World Association for Christian Communication.

Travis, A. (2008) 'Row as Lords Committee Backs Cap on Immigration', *Guardian*, 1 April.

Trew, T. (1979) 'Theory and Ideology at Work', in R. Fowler, B. Hodge, G. Kress and T. Trew (eds) *Language and Control*. London: Routledge, Kegan Paul.

Tsagarousianou, R. (2002) 'Ethnic Community Media. Community Identity and Citizenship in Contemporary Britain', in N. Jankowski and O. Prehn (eds) *Community Media in the Information Age. Perspectives and Prospects*. Cresskill, New Jersey: Hampton Press.

Turner, B. S. (1994) *Orientalism, Postmodernism and Globalism*. London: Routledge.

Wainwright, L. (2005) 'Bibliography', in D. A. Bailey, I. Baucom and S. Boyce (eds)

Shades of Black: Assembling the 80s. Black Arts in Post-war Britain. North Carolina: Duke University Press and inIVA.

(2006) 'Canon Questions on the Art of Black Britain', in G. Low and M. Wynne-Davies (eds) *A Black British Canon?* Basingstoke: Palgrave Macmillan.

Wambu, O. and Arnold, K. (1999) *A Fuller Picture: The Commercial Impact of Six British Films with Black Themes in the 1990s.* London: BFI.

Ward, B. (1998) *Just My Soul Responding.* London: UCL Press.

Werbner, P. (2004) 'Theorising Complex Diasporas: Purity and Hybridity in the South Asian Public Sphere in Britain', *Journal of Ethnic and Migration Studies*, 30(5), 895–911.

Werner, C. (1998) *A Change is Gonna Come: Music Race and the Soul of America.* Edinburgh: Payback Press.

Wiktorowicz, Q. (2005) *Radical Islam Rising: Muslim Extremism in the West.* Lanham, MD and Oxford: Rowman & Littlefield.

Willemen, P. (1989) 'The Third Cinema Question: Notes and Reflections', in J. Pines and P. Willemen (eds) *Questions of Third Cinema.* London: BFI.

Williams, P. and Chrisman, L. (eds) (1993) *Colonial Discourse and Post-colonial Theory. A Reader.* Hemel Hempstead: Harvester Wheatsheaf.

Williams, R. (1981) *Culture.* London: Fontana.

(2008a) 'Archbishop's Lecture – Civil and Religious Law in England: a Religious perspective', 7 February (at: www.archbishopofcanterbury.org./1575).

(2008b) *Dostoevsky: Language, Faith and Fiction.* London: Continuum.

Williamson, J. (1988) 'Two Kinds of Otherness: Black Film and the Avant-Garde', *Screen*, 29(4).

Wood, R. (2008) 'Two Thirds of Newspaper Stories say British Muslims are a "Threat" or a "Problem"' (at: www.irr.org.uk/2008/september/bw000009.html; accessed 14/09/08).

Young, R. J. C. (2001) *Postcolonialism. An Historical Introduction.* Oxford: Blackwell Publishers.

(2003) Postcolonialism. A Very Short Introduction. Oxford University Press.

Žižek, S. (1997) 'Multiculturalism, or, the Cultural Logic of Multinational Capitalism', New *Left Review*, 1(225), 28–51.

(1999) *The Ticklish Subject: The Absent Centre of Political Ontology.* London: Verso.

Zook, K. (1992) 'Reconstructions of Nationalist Thought in Black Music and Culture', in R. Garofalo (ed.) *Rocking the Boat: Mass Music and Mass Movements.* Boston: South End Press.

Index